CHINESE BRUSH PAINTING

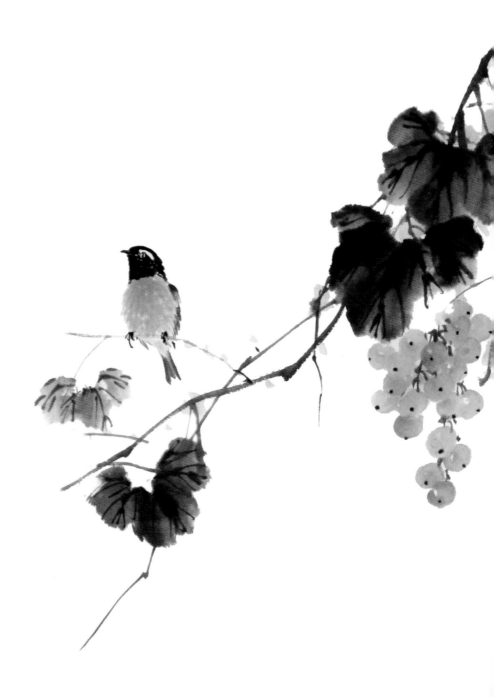

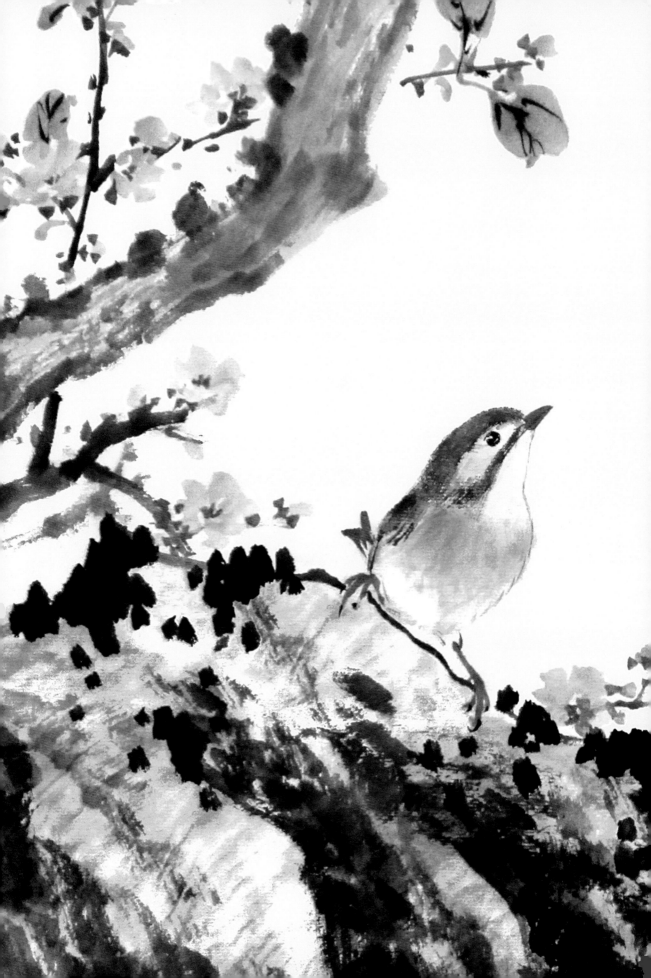

CHINESE
BRUSH
PAINTING

A Beginner's
Step-by-Step Guide

By Mei Ruo

Better Link Press

On page 1
Fig. 1 *The Bird Attracted by Ripe Fruit* (detail)
Height 66 by width 33 centimeters
The plump grapes on the twining vines attract a little bird. It stands on the twigs and looks into the distance. The yellow body and the green grapes form a refreshing scene.

On pages 2–3
Fig. 2 *The Lovebirds on the Wintersweet* (detail)
Height 33 by width 45 centimeters
The wintersweet grows on the cliff in the cold spell. Two lovebirds with beautiful feathers stand on the twigs of the wintersweet looking at each other from a distance, seems like they are whispering and sharing their secrets.

Fig. 3 *The Mandarin Ducks in the Lotus Pond* (detail)
Height 60 by width 97 centimeters
The mandarin ducks are the common ornamental birds in China. They are associated with love as they are often in pairs.

Text and Works: Mei Ruo
Photographs: Mei Ruo, Ding Guoxing, Quanjing

Translation: Kitty Lau

Interior Design: Li Jing, Hu Bin (Yuan Yinchang Design Studio)
Cover Design: Wang Wei

Copy Editor: Gretchen Zampogna
Editors: Wu Yuezhou, Cao Yue
Editorial Director: Zhang Yicong

Senior Consultants: Sun Yong, Wu Ying, Yang Xinci
Managing Director and Publisher: Wang Youbu

ISBN: 978-1-60220-034-0

Address any comments about *Chinese Brush Painting: A Beginner's Step-by-Step Guide* to:

Better Link Press
99 Park Ave
New York, NY 10016
USA

or

Shanghai Press and Publishing Development Co., Ltd.
F 7 Donghu Road, Shanghai, China (200031)
Email: comments_betterlinkpress@hotmail.com

Printed in China by Shanghai Donnelley Printing Co., Ltd.

5 7 9 10 8 6 4

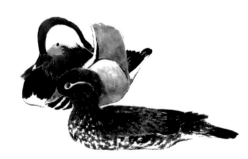

CONTENTS

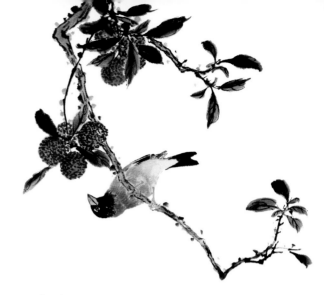

Fig. 4 *The Waxwing and Red Bayberries* (detail)
Height 36 by width 36 centimeters

The adorable waxwing resting on the twigs seems to be ready to try the red bayberries. The unique perspective and composition make the painting more interesting.

CONTENTS

Fig. 5 *Cricket Fighting* (detail)
Height 45 by width 97 centimeters
Cricket fighting is an ancient entertainment in China. The chrysanthemums in the painting denote the fall season. The two crickets on the left are lively though they are small.

On facing page
Fig. 6 *Magpies on Plum Blossoms* (detail)
Height 33 by width 45 centimeters
Magpies with plum blossoms is the common auspicious combination in Chinese culture to represent luck and blessings. The red of the plum blossoms and the black of the magpies form a significant contrast. The wings that are yet to be folded add more energy to the painting.

CONTENTS

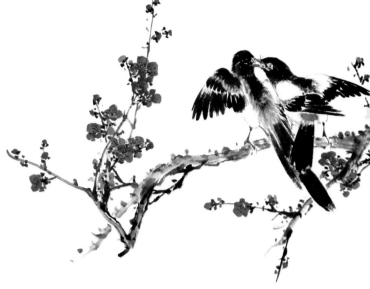

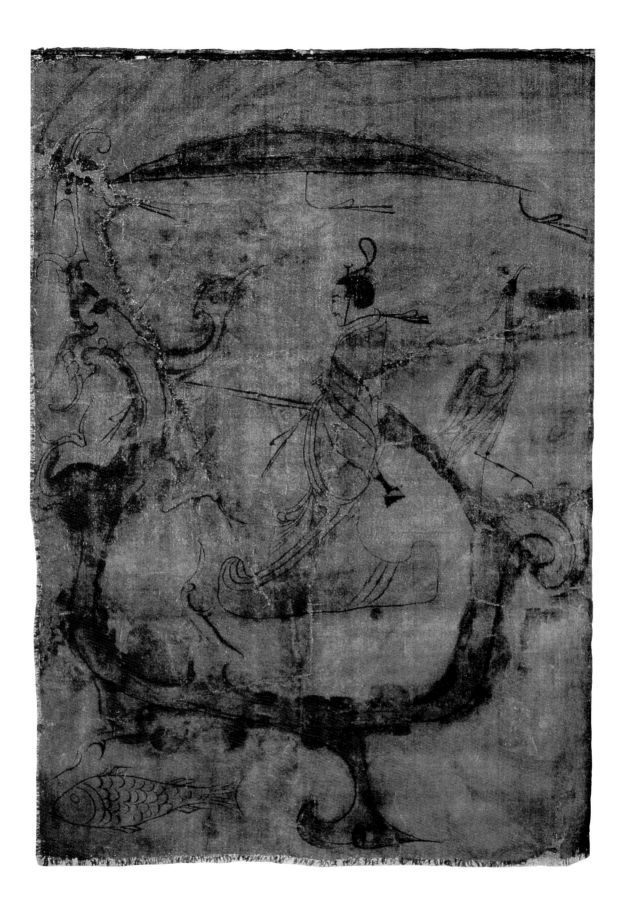

INTRODUCTION
Overview of Chinese Painting

Traditional Chinese painting, which originated in the Han Dynasty (206 BC–AD 220), is completely different from western painting in terms of style and concept. This long-established art form mainly comprises ink or color applied with a brush to a piece of silk or *xuan* paper, which is then mounted on a hanging scroll.

Chinese painting has a long history. Silk paintings can be traced back to the Warring States Period (475–221 BC), before paper had even been invented. The most famous of these is *A Man Riding a Dragon* (fig. 7). The line arrangement on the silk cloth has become one of the most common techniques and characteristics in Chinese painting nowadays.

Chinese painting falls into three categories: figure (fig. 8), landscape and bird-and-flower. The objects in figure and landscape paintings are comparatively straightforward, whereas those of bird-and-flower painting are much varied and include flowers, birds, fishes, insects, animals and still lifes.

The history of Chinese figure painting is very long. The earliest unearthed colored pottery from the New Stone Age already demonstrated figure painting, and prehistoric period rock art also showed many figure

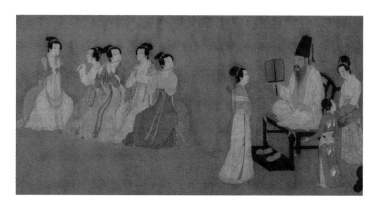

On facing page
Fig. 7 *A Man Riding a Dragon*
Warring States Period
Silk painting
Height 37.5 by width 28 centimeters
Hunan Provincial Museum

Unearthed from the Chu Tomb of Danziku, Changsha, Hunan Province, China in 1973. In this painting, a man in a robe holds a sword and stands sideways atop a dragon's body beneath a canopy. The dragon's head is tilted upward and its tail is curled, its body forming a boat. The fluttering robe and canopy tassels indicate the direction of the breeze, showing the dragon boat moving forward along with the breeze. The man is drawn vividly with a detailed face. The presentation of his robe is smooth, depicting its soft texture and elegance. This is a representative figure painting from ancient China.

Fig. 8 *Copy of Gu Hongzhong's* Night Revels of Han Xizai *(detail)*
Song Dynasty (960–1279)
Anonymous
Ink and color on silk
Height 28.7 by length 335.5 centimeters
Palace Museum, Beijing

This painting captures the activities at a dinner banquet of Han Xizai, an official of the Southern Tang Dynasty (937–975). The entire painting is divided into five scenes and the one on the left is the fourth scene. Han unties his robe and sits cross-legged on a chair to listen to an instrumental ensemble of five women. All the figures, whether main or supporting characters, are vividly and accurately depicted. The painting is colorful and neat with sophisticated line work. Different objects are portrayed in different techniques to illustrate the variations. This is one of the most precious paintings from ancient China.

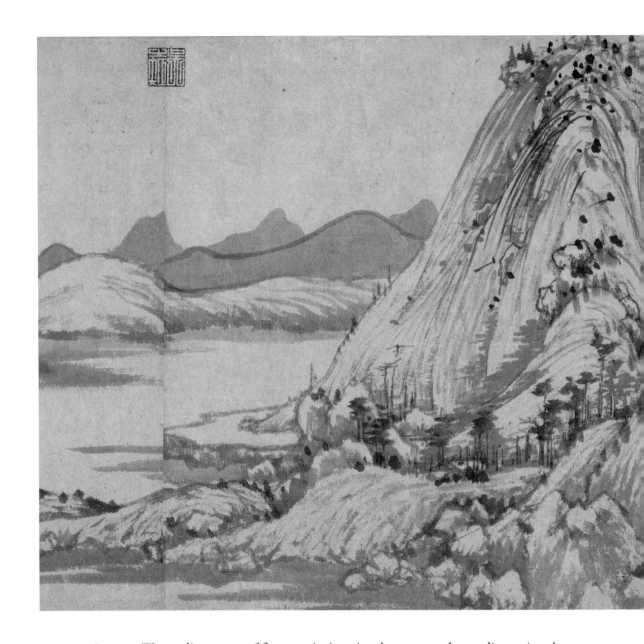

images. The earliest stage of figure painting simply presented two-dimensional lines. Until the period of Wei, Jin and Southern and Northern dynasties (220–589), the quality of figure painting had been pronouncedly advanced. In the Sui Dynasty (581–618), Tang Dynasty (618–907) and the Five Dynasties (907–960), figure paintings featuring fine brushwork and heavy color continued to progress in complexity. In the Song Dynasty (960–1279), line drawing was introduced. In the Yuan Dynasty (1279–1368), figure painting began to transform. The evolution continued in the Ming Dynasty (1368–1644) and Qing Dynasty (1644–1911), fusing with western realism and expressionism, and generating many new ideas and techniques.

Landscape painting (fig. 9) is the most representative form of Chinese painting. It first sprouted in the period of Wei, Jin and Southern and Northern

Fig. 9 *Dwelling in the Fuchun Mountains*
(detail)
Yuan Dynasty
Huang Gongwang (1269–1354)
Ink on paper
Height 33 by length 636.9 centimeters
Palace Museum, Taibei

This painting depicts the landscape around the Fuchun River of Zhejiang Province in China. The mountains are painted intricately with rich variations of brush and ink techniques and the river is properly arranged. It fully illustrates the scenery from the river shore to the mountain peak. The use of ink is elegant with a full range of dark, light, dry and wet brush techniques to allow various expressions. It is one of the top 10 most famous Chinese paintings, as well as the most representative art piece by Huang Gongwang, showing his ideal landscape scene painted after seriously studying nature.

dynasties and officially became a branch of Chinese painting in the Sui Dynasty. With unceasing development, it reached its first peak in the Five Dynasties and Northern Song Dynasty (960–1127). The unique skills, methods and styles it encompassed made it the most dominant form of Chinese painting in later ages. The second peak appeared in the Yuan Dynasty. Zhao Mengfu (1254–1322), a famous scholar, was the first person to advocate literati painting, which originated in the period of Wei, Jin and Southern and Northern dynasties. Literati painting focused on the unity of poetry, literature and painting, as well as sentiment. This vital new branch greatly enriched the creativity and presentation of Chinese painting. It has not been surpassed by others, even though the artists of the Ming and Qing dynasties explored various techniques and concepts.

Bird-and-flower painting has also gone through a lengthy evolution. In the

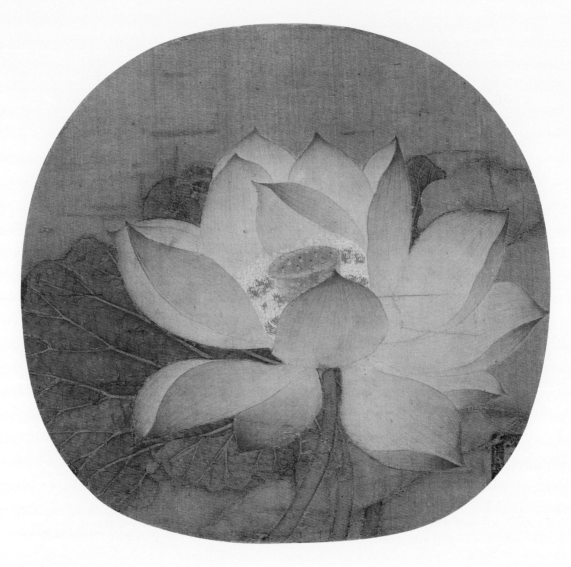

Fig. 10 *A Lotus Flower Blossoming from the Water*
Song Dynasty
Anonymous
Ink and color on silk
Height 23.8 by width 25 centimeters
Palace Museum, Beijing

A full-bloom pink lotus flower occupies the entire painting. The composition and color arrangement make the lotus flower very eye-catching against the green lotus leaves, fully depicting its noble character: "Growing out of the dirt and yet remaining pure; being cleansed by the water and yet not bewitched."

No outlines can be found on the lotus petals, and this promotes their soft and smooth nature. The shape, orientation, shade and lighting of each petal are neatly arranged; even the veins on the petals and the pollen on the stamens are illustrated in details. This proves that the artist had a high level of realistic painting skill.

period of Wei, Jin and Southern and Northern dynasties, flowers, birds, insects and animals were the most popular objects. Bird-and-flower painting became an independent genre in the Tang Dynasty, and the style reached its peak in the Song Dynasty as artists expanded their topics, advanced their skills and diversified their styles. In the Yuan Dynasty, the influence of literati painting helped make ink bird-and-flower the preeminent art form. Different schools and

styles flourished in the Ming Dynasty, and artists developed innovative techniques in the Qing Dynasty.

The styles of Chinese painting can be classified into *gongbi* (meticulous style) and *xieyi* (freehand style).

Gongbi-style painting retains the traditional realist style with meticulous technique (fig. 10). Line drawing is the backbone and emphasis of *gongbi* painting, which requires neat, delicate and rigorous skills, with the artist using the centered-tip stroke while painting. It is commonly painted on ripe silk or mature *xuan* paper. To make a perfect painting, first sketch, then finalize. Next smear alum solution onto the silk cloth or *xuan* paper. Use a fine, weasel-hair brush to outline the object and fill it with color. The ink and colors must be applied in several layers to create a unity of form and spirit.

Xieyi-style painting is freehand and emphasizes concepts, portraying a complicated object using a few strokes (fig. 11). It can be further broken down into great *xieyi* and slight *xieyi* styles. In this book, we will discuss more the slight *xieyi* style, which illustrates an object more realistically and with brighter colors.

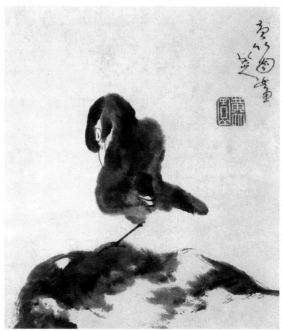

Fig. 11 *The Book of An Wan: Bird and Rock*
Qing Dynasty
Bada Shanren (Zhu Da) (c.1626–1705)
Ink on paper
Height 31.8 by width 27.9 centimeters
Sen-oku Hakuko Kan of Japan

Bada Shanren is famous for his unrestrained freehand ink wash painting, using simple technique to demonstrate the idea that less is more. *The Book of An Wan* consists of 22 paintings, his representative work produced in his later years. The main themes are flower, bird, landscape and calligraphy, which are presented with unique objects, in relaxed artistic conception, and with skillful use of ink and water.

This painting is the seventh piece of the book, and portrays a bird resting on a rock. The lowered head, protruded belly and cocked back make the body rich in variation. The bird seems like a secluded hermit, caring nothing about the world.

Whether the theme is figure, landscape or bird-and-flower, Chinese painting is an art form for expressing concepts and ideas. These three objects summarize the three main concerns of the universe: Figure painting portrays the relationships among people in human society; landscape painting presents the relationship between the unity of humans and nature; bird-and-flower painting illustrates various creatures in nature and their harmonized relationships with humans. These three categories demonstrate a philosophical idea derived from art: The complete universe is formed by unifying these three ideas, and they bring out the best of each other. This represents the true meaning of art.

Chinese artists tend to focus on humans and their harmony with nature. When painting nature, they abandon objective perspective and actual form. Instead, they capture the spirit of nature and internal law to express their subjective feelings and traditional Chinese cultural and philosophical ideas. Not limiting yourself to realistic presentation is a way to express freedom in art.

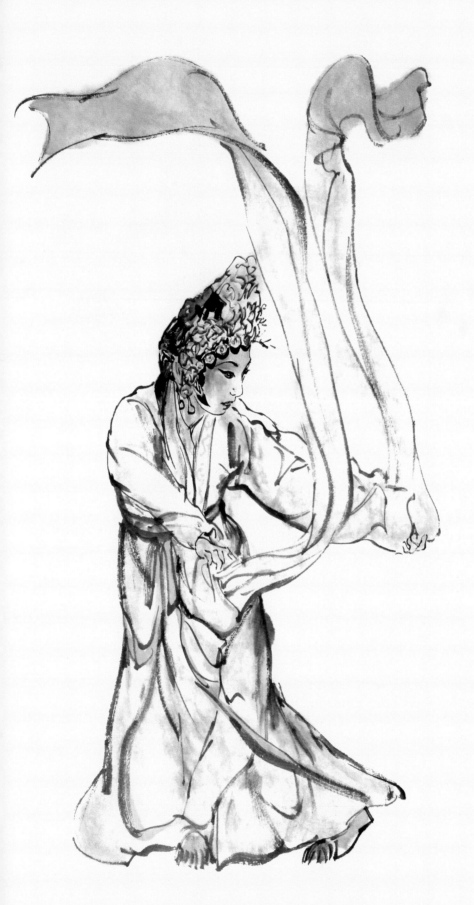

CHAPTER ONE
Tools and Materials

The development of Chinese painting techniques and unique styles is highly dependent on the art form's specific tools and materials. For example, the use of a fine and soft brush allows you to produce varied strokes. The use of silk cloth and paper creates a unique interplay between ink and surface, which develops into various painting techniques. In this chapter, we will introduce different types of tools and materials.

1. Types and Hair Sources of Brushes

Brushes can be made of goat or weasel hair or mixed. The size can be classified as big, medium or small (fig. 13).

Goat hair is soft and can absorb more water, which is appropriate for painting flowers and leaves, as well as coloring.

Weasel hair is hard and resilient, which is suitable for outlining leaf stems and tree trunks or branches.

Nowadays, it is more common to use a mix of goat and weasel hair, or even add nylon to make the brush more resilient and yet still absorbent.

The brush is composed of the tip, the belly (midsection), and the base (near the shaft).

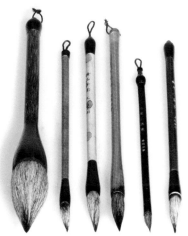

Fig. 13 Brushes.

2. Inksticks and Inkstones

The two common inkstick types are oil soot ink and pine soot ink. Oil soot ink is dark and shiny, which is suitable for painting, whereas pine soot ink is darker and dull, which is suitable for calligraphy. Modern artists tend to use bottled

On facing page
Fig. 12 *The Performer of Beijing Opera*
Height 67 by width 45 centimeters

This painting illustrates the Beijing opera performer in a squatting position. The use of ink vivdly displays the waving of the sleeves like flowing water. The composition is very simple and yet presents the movement.

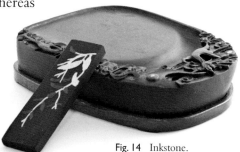

Fig. 14 Inkstone.

Fig. 15 *Lunar New Year Celebrations*
Height 137 by width 67 centimeters

"Lunar New Year Celebrations" is a popular Chinese painting theme. It is a tradition to have flowers and fruits for celebrations and offerings on the first day of the first lunar month, wishing for prosperity and blessings. In this painting, beautiful peonies, fragrant narcissi, and palm-shaped chayote are selected for the celebrations.

Fig. 16 Table cover. Fig. 17 *Xuan* paper.

ink to save time from ink grinding.

Inkstone (see fig. 14 on page 15) is usually made from aqueous rock as it is hard and smooth, making it easy for grinding and producing dense ink. There are several types, and the most famous one in China is *duan* inkstone.

3. Colors

The colors used for Chinese painting are different from western ones, and have different names. They can be made from plants or minerals. Colors derived from plants are gamboge, indigo, cyanine, eosin, rouge, etc. Colors derived from minerals are azurite, malachite, cinnabar, vermilion, titanium white, ocher, etc., among which azurite and malachite both come in three shades, from dark to light.

4. *Xuan* Paper (Rice Paper)

The most common type of Chinese painting paper is *xuan* paper (fig. 17), and can be further classified into raw *xuan* and mature *xuan* paper.

Raw *xuan* paper is not processed and has a higher ability to absorb water, allowing the ink to blur and produce special effects. This is suitable for *xieyi*-style painting. The most famous *xuan* paper is from Xuancheng in Anhui Province.

Mature *xuan* paper is treated with alum, making it less absorbent, which allows applying layers and layers of colors. This is appropriate for *gongbi*-style painting. There are various specifications of *xuan* paper. Select the proper one according to the desired size and technique.

5. Supplementary Tools

Water bowl is for washing brushes and dipping water (fig. 18).

Table cover is to be placed under the paper. Beginners can use felt or even newspaper (fig. 16).

Palette is used to mix colors. You can also use small plates.

Fig. 18 Water bowl.

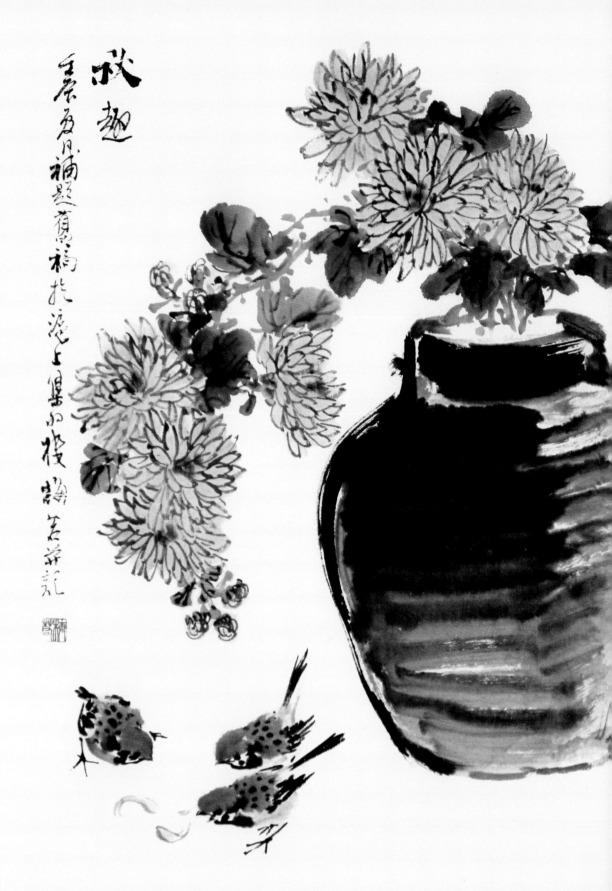

CHAPTER TWO
Chinese Painting Techniques

Like other types of painting, Chinese painting emphasizes concept and composition. Concept is the idea, and composition is the position, proportion and color arrangement within the painting. This chapter will further discuss how to use brush, ink, color, water and framing to help you understand the fundamentals and prepare for Chinese painting.

1. How to Hold the Brush

The first thing to learn before practicing Chinese painting is how to hold the brush. Having the correct grip can help you paint smoothly. When working on a large-scale painting, keep your elbow and waist above the table. When working on a small-scale painting, your arm can rest gently on the table.

Use your thumb, index finger and middle finger to hold the lower part of the brush handle about 3 centimeters from the tip. Place your index finger on the front and your thumb on the back. Have your middle finger press against the handle and let your ring finger and little finger rest naturally below the middle finger, folding toward your palm (fig. 20).

Fig. 20 The correct way to hold the brush.

2. How to Paint with the Brush

The brush is used to produce dots, lines and surfaces. In Chinese painting, a complete brushstroke should have three steps: entering the stroke, moving the brush along and exiting from the stroke. Different start and finish techniques, as well as intensity and flow of strokes, produce different results.

There are four basic brush strokes. *Zhongfeng* (centered-tip

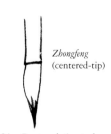

Zhongfeng (centered-tip)

Fig. 21 Centered-tip stroke.

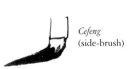

Cefeng (side-brush)

Fig. 22 Side-brush stroke.

On facing page
Fig. 19 *The Fall*
Height 67 by width 45 centimeters
The chrysanthemums bloom when the fall comes. This painting illustrates a few little birds pecking the fallen petals.

Fig. 23 Dotting and dyeing are usually done by using the centered-tip stroke. Dyeing is commonly used on landscape painting to present a misty scene in the mountains.

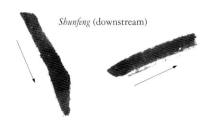

Shunfeng (downstream)

Fig. 24 Downstream stroke.

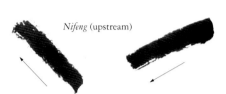

Nifeng (upstream)

Fig. 25 Upstream stroke.

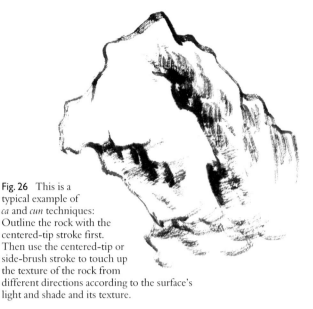

Fig. 26 This is a typical example of *ca* and *cun* techniques: Outline the rock with the centered-tip stroke first. Then use the centered-tip or side-brush stroke to touch up the texture of the rock from different directions according to the surface's light and shade and its texture.

stroke) (see fig. 21 on page 19) is to use the brush tip to paint along the center of the ink line; *cefeng* (side-brush stroke) (see fig. 22 on page 19) is to tilt the brush at an angle, with the tip against one side of the line, point or surface and with the belly of the brush pressed against the paper; *shunfeng* (downstream stroke) (fig. 24) is to paint from the top downward or from left to right; and *nifeng* (upstream stroke) (fig. 25) is to paint from the bottom upward or from right to left.

To paint a thin line, lift the brush up to form a lighter line. To paint a thicker line, press down on the brush. Lifting and pressing along with different speed can create different forms of dots, lines and surfaces. Pressing the brush into the paper or rotating the brush is called *dun* (pause).

Combining the above-mentioned techniques, Chinese painting brushwork can be divided into three main strokes: outlining stroke, *cun* stroke (texture stroke or touch up) and dotting and dying stroke. Outlining is to depict the shape of the object using the centered-tip stroke to create smooth lines. *Cun* stroke is to portray the texture and create 3-D effect of the object. It can be done with the centered-tip or side-brush stroke with dark or light ink. *Ca* is similar to *cun*, which means gently using the side-brush stroke to create broken and blurred texture, leaving a very light brush trace (fig. 26). Dotting and dyeing is to use the centered-tip stroke to paint a small area. If the dotting stroke or painted area is larger, it is called dyeing. It is very common in *xieyi*-style painting (fig. 23).

3. How to Use Water

Water plays an important role in mixing ink and color, and helps produce the unusual appeal of Chinese painting. The blending, thickness and five shades (dark, light, dry, wet and charred) of the color are totally related to water. Analyzing the appearance of water use is one way of evaluating the level of an artist and the value of an art piece.

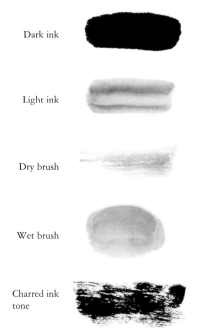

Dark ink

Light ink

Dry brush

Wet brush

Charred ink tone

Fig. 27 Five shades of ink (from top to bottom): dark, light, dry, wet and charred.

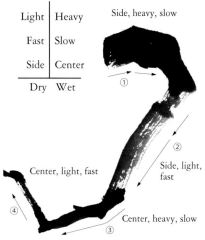

Light	Heavy
Fast	Slow
Side	Center
Dry	Wet

Side, heavy, slow

①

Side, light, fast

②

Center, light, fast

Center, heavy, slow

③

④

Fig. 28 ① Side-brush stroke: Start by pressing down and move slowly. ② Side-brush stroke: Start by lifting the pressure and move quickly. ③ Centered-tip stroke: Start by pressing down and move slowly. ④ Centered-tip stroke: Start by lifting the pressure and move quickly. Keep practicing to master the dry, wet, dark and light brush techniques.

4. How to Use Ink

In Chinese painting, black ink can be categorized into five shades: dark, light, dry, wet and charred (fig. 27). It's very important to master how to use these shades.

Dark: It has a small amount of water in the ink.

Light: It has more water in the ink turning it to gray.

Dry: It can either be dark or light but with less water in the brush.

Wet: It can either be dark or light but with more water in the brush.

Charred: It is very black with a shiny effect.

The wetness or dryness of the ink translates into the wetness or dryness of the brush. They are closely interdependent.

When practicing the brush strokes, remember these six words: light (lifting the pressure on the brush), fast (shortening the time of the stroke), side (using side-brush stroke), heavy (pressing down on the brush), slow (increasing the time of the brush) and center (using centered-tip stroke). When you dip the brush into water, it drips faster if the brush is held upright and slower if it is held at a slant. The ink can be easily absorbed by the paper when using the centered-tip stroke going heavily and slowly. This is called wet stroke. On the other hand, the ink cannot be thoroughly absorbed when the brush is slanted and moved lightly and quickly. This is called dry stroke or "flying white" (broken ink wash effect). Thus, we must learn how to manipulate brush and ink.

Referring to the picture, we can see the light and fast strokes are dry on the paper, whereas those heavy and slow strokes are wet on the paper. After practicing a few times, you should be able to control the level of wetness and shades on the paper (fig. 28).

5. How to Apply Color

Coloring in western and Chinese painting is significantly different. Western painting focuses on light. Besides painting the various colors of the objects, it also

focuses on the light reflected on them. For example, the light reflected on a white shirt can be yellow or green. It has to be painted accordingly to make it more realistic. This means that western painting does not emphasize the object's color but rather the light reflection.

Chinese painting emphasizes the categorization of the objects, using one color for each category. For instance, the face and hands in figure painting are grouped into one category and applied with one color; the plants and trees in landscape painting are grouped into categories and each category can be painted in the same tone. The object color can be applied according to the artist's subjective impression. For example, flowers can be black and yet still deliver the necessary vividness.

We all know that the primary colors are red, yellow and blue. Looking at the color wheel, we see there are colors between the primary ones. Those are secondary colors, such as orange, which is a mixture of red and yellow; green, a mixture of yellow and blue; and purple, a mixture of blue and red. The higher the proportion of one primary color added to the mixture, the closer the mixed color will lean toward that primary color (fig. 29).

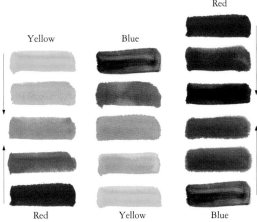

Fig. 29 Mix the primary colors of red, yellow and blue to form different colors.

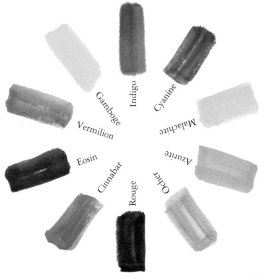

Fig. 30 The common Chinese painting colors.

The popular colors for Chinese painting are different from western painting. They are indigo, gamboge, vermilion, eosin, cinnabar, rouge, ocher, azurite, malachite and cyanine. Both azurite and malachite can be further classified into three shades, from dark to light (fig. 30).

We can use the basic color wheel as a reference to learn color mixing for Chinese painting. Gamboge is similar to yellow; indigo and cyanine are similar to blue; eosin and cinnabar are different shades of red; vermilion is similar to orange; rouge is similar to rosiness; ocher is similar to burnt umber. Azurite and malachite are usually used alone, not mixed with other colors. Mixing different colors develops a new color. When dipping a brush into one color and dipping the brush tip into another, we can see the gradient effect when the two colors blend on the *xuan* paper. On the next page is the list of the common color mixing we use in this book. It does not have a set color ratio. The higher the ratio of one color added, the more dominant that color will be. Keep practicing to help yourself find and analyze different chromaticity.

Eosin + titanium white = pink
Gamboge + titanium white = light yellow
Azurite + titanium white = light blue
Ocher + black = burnt umber
Gamboge + indigo = dark green
Vermilion + eosin = orange red
Gamboge + vermilion = golden yellow
Eosin + indigo/cyanine = purple
Ocher + rouge = brown

6. Framing

The life and the value of a Chinese painting rely heavily on the framing technique. A well-done frame can support and elevate a painting. If a piece of art is hung without proper framing, not only can the characteristics not be exhibited but the overall aesthetics will also be destroyed. The same principle applies when framing an oil painting.

The simplest method of preserving the painting is: First, spray some water onto the painting to soften the paper tissue. Then, set an iron to its lowest temperature and flatten the paper with heat while it is still wet. You can frame the flattened paper after that.

Chinese painting, however, is presented on *xuan* paper, which is thin and fragile. Framing correctly can strengthen the paper, extend the life of the art and encourage appreciation. To do an uncomplicated framing at home, only a wallpaper brush, small broom, paper knife, *xuan* paper, glue and ruler are needed.

Small broom

Glue

Wallpaper brush

1 Clean up a large piece of glass, tile floor or flat surface and place the painting upside down. Mix glue with water to make a diluted glue solution.

2 Spray some water on the back of the painting to soften the *xuan* paper fibers.

3 Use the wallpaper brush to apply the diluted glue solution from step 1 onto the back of the painting, starting from the center and brushing outward toward all sides. Be sure to brush gently to avoid tearing the *xuan* paper.

4 After applying the diluted glue solution to the entire painting, use a towel to clean up the glue outside of the painting's edge.

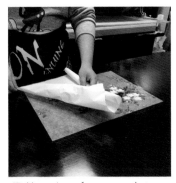

5 Use a piece of *xuan* paper that is larger than the painting as the supporting paper.

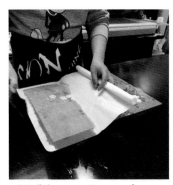

6 Roll the supporting paper from one side of the painting to the other side while using a small broom to flatten it.

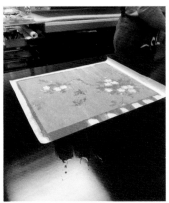

7 There should be no bubbles between the painting and the supporting paper.

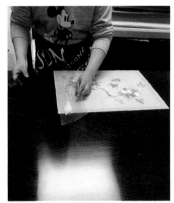

8 Apply a thick layer of glue at the border of the supporting paper. Place a piece of plastic or other smooth, hard surface such as ruler at the edge of the painting to stop the glue from spreading onto the painting.

9 Place the painting with the supporting paper on a clean and smooth surface or wall. Be sure to leave a gap for air to pass through for easy removal. When it is dry, trim the border 1 to 2 centimeters from the edge of the painting with the ruler and paper knife, being careful not to damage the art. Prepare a picture frame with proper size and put in the painting.

CHAPTER THREE
Introductory Lessons

A few strokes in a Chinese painting can generate rich meanings. You can start creating simple flowers, birds, fruits, fishes and shrimps after learning the basic techniques in the previous chapter. During the practice, do remember to observe these real objects in the nature to better understand their features and represent them in your painting.

1. How to Paint Flowers

Flowers are nature's ambassadors. They are colorful and have different structures. The blooming of flowers in different seasons provides incredible inspirations for artists of all ages. Sometimes they are presented anthropomorphically. In this section, we will introduce various traditional flower paintings. Once you have captured the basics, it will be easier to learn other flower paintings or create other combinations.

Plum Blossom
Plum blossom is chief of the top 10 flowers in China. It is a member of the Four Gentlemen along with orchid,

On facing page
Fig. 31 *The Lotus Pond*
Height 67 by width 45 centimeters
This painting fullly depicts the scene described by an ancient poem, "When the little lotus bud was born, the dragonfly was the first to welcome it." The pink lotus flower growing under the green leaves attracts the red dragonfly. The *xieyi* style promotes the enshrounding scene, forming a summer morning backdrop, which is very different from the realistic presentation of *gongbi* painting.

How to Paint Plum Branches

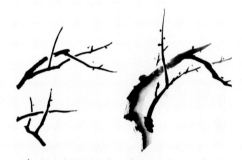

Paint 女-shaped crisscross branches with those in the foreground darker than the ones in the background.

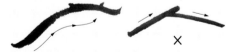

Each branch must be painted with curves, rather than ramrod straight.

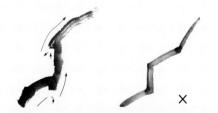

Remember to make pause-and-twist-back strokes at each end.

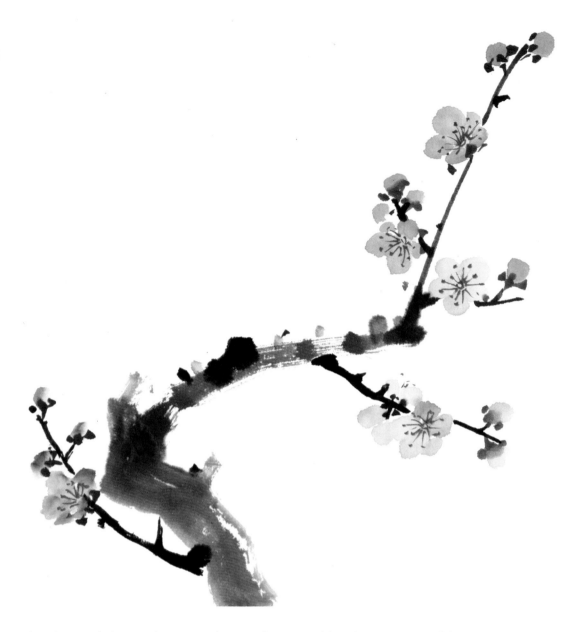

bamboo and chrysanthemum. Along with pine and bamboo, it's part of the group known as the Three Friends of Winter. Being a harbinger of spring and also blooming in the severe winter, plum blossoms represent purity, perseverance and humility. It is one of the most popular objects in Chinese painting.

There is a saying in China, "First learn how to draw plum blossoms when learning painting." It is based on the simple structure of plum blossom, which is composed of five round petals. After learning the basics of painting plum blossom, it is easy to paint other flowers like apricot blossoms, hall crabapples, and cherry and peach blossoms. Learning how to paint plum branches using 女-shaped crisscross method (女 is a Chinese character meaning "female") gives you a basis for painting the branches of other woody plants (see the previous page).

1 Paint a thick branch from top to bottom and make sure it is the right thickness, length and shade. If you miss a portion, do not draw on it again; simply add outlines to the side.

2 Paint a lateral branch from left to right and a twig on top. Leave empty spaces for plum blossoms.

3 Paint smaller twigs. Pay attention that the thinner ones are darker and thicker ones are lighter. Leave empty spaces for flowers.

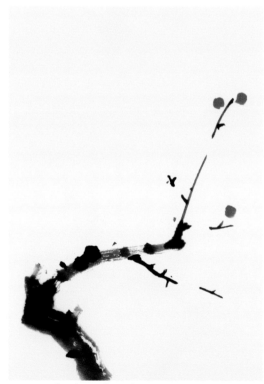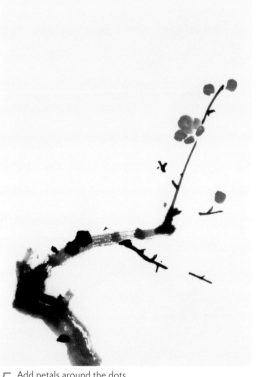

4 Paint a few dots as flower buds using a mixture of titanium white and eosin.

5 Add petals around the dots.

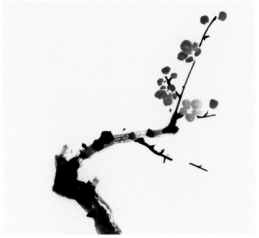

6 Be sure the flowers face different directions.

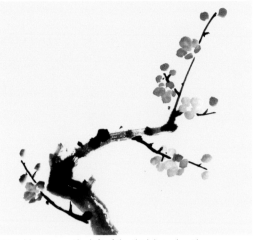

7 Add a twig on the left of the thick branch with some flowers and buds on it.

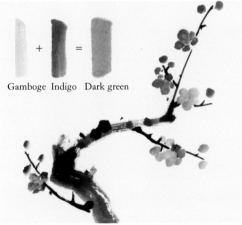

Gamboge Indigo Dark green

8 Add dark green at the center of the flowers.

9 To paint the receptacle, add three dots on the lower left, under and on the lower right of the buds, forming the shape of the letter Y.

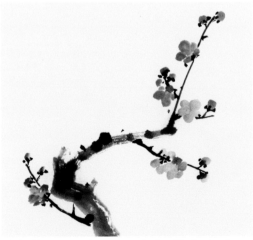

10 Use rouge to draw receptacles for all buds using the method mentioned in step 9.

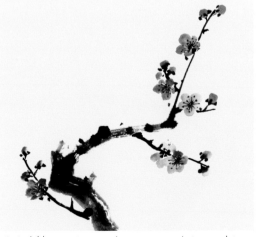

11 Add some stamens using rouge or eosin to complete.

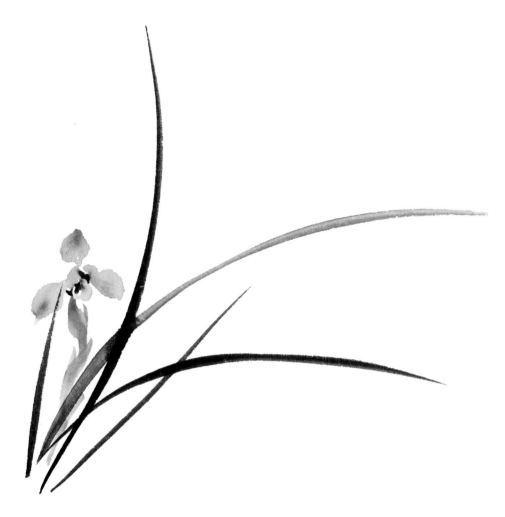

Orchid

The orchid has been cultivated in China for more than 1,000 years. It has
many leaves. The flower is simple and elegant, not trying to be glamorous, not
competing for beauty. It does not fear the severe cold. "Born in the deep valley,
it continues to deliver fragrance though no one is around." Along with the plum
blossom, bamboo and chrysanthemum, it is one of the Four Gentlemen. Plum
blossom represents a man of nobility and purity as it fights against the severe
weather; orchid symbolizes a man of prominence as it gives off delicate fragrance
in the deep valley; bamboo stands for a man of modesty as it seeks no fame;
and chrysanthemum signifies solitude as it survives in the coldness. The Four
Gentlemen are commonly used for analogy and are popular themes in Chinese
literature and painting.

How good an orchid painting is largely depends on how well the leaves are
painted. This lesson will show you how to paint orchid leaves in five strokes.
Orchids generally consist of six petals, three inner ones and three outer ones.
Outer petals include one dorsal sepal in the center and two lateral sepals, while
inner petals include one labellum in the center and two inner sepals on two sides.
There's a stigma enclosed by the sepals. It's crucial to master the morphology of
the petals in orchid painting.

How to Paint Orchid Leaves and Stamens

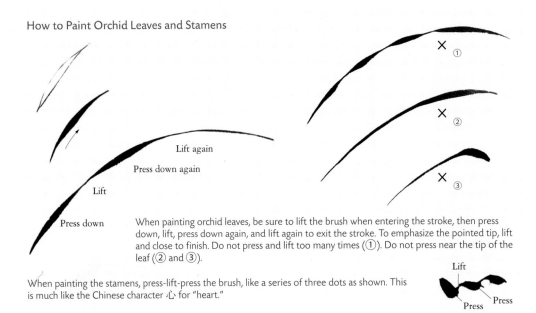

Lift again

Press down again

Lift

Press down

When painting orchid leaves, be sure to lift the brush when entering the stroke, then press down, lift, press down again, and lift again to exit the stroke. To emphasize the pointed tip, lift and close to finish. Do not press and lift too many times (①). Do not press near the tip of the leaf (② and ③).

When painting the stamens, press-lift-press the brush, like a series of three dots as shown. This is much like the Chinese character 心 for "heart."

Lift

Press

Press

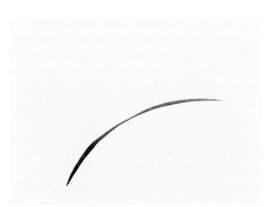

1 When painting orchids, be sure to paint the leaves first using either ink or dark green. Paint from the lower left to top right and press in the middle.

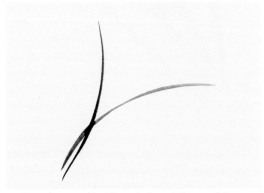

2 Paint the second leaf from the lower left to top left, crossing the lower part of the first leaf. Be sure to leave a slightly larger space between the two leaves.

3 Paint the third leaf, starting from the space between the first and second leaves and going toward the right.

4 Paint the fourth leaf on the leftmost going upward and the fifth leaf on the rightmost also going upward. The five leaves are done.

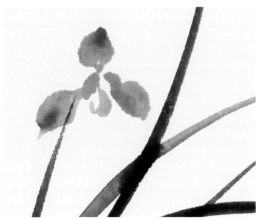

5 Add two inner petals on top of the fourth leaf using dark green (with more indigo).

6 Dip the brush into dark green (with more gamboge) and brush tip into rouge or ochre to paint one dorsal sepal and two lateral sepals. Then add the labellum of the orchid at the lower center.

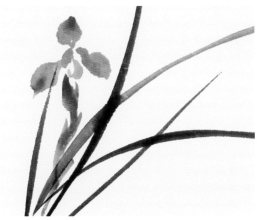

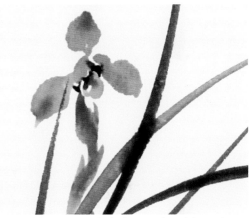

7 Dip the brush into dark green (with more gamboge) and the brush tip into rouge to paint the stem.

8 Paint the stamens with 心 character-shaped dots. Enhance them with rouge dots.

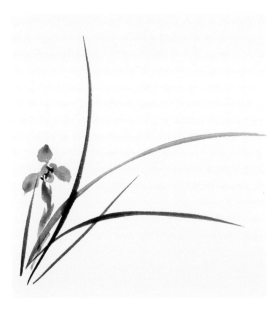

9 The orchid is complete.

Bamboo

Bamboo, as one of the Four Gentlemen, symbolizes purity and humility. It has a long and straight stem and is green all year round. It carries an unyielding faith that makes it a popular topic for literati of all ages. It is also a traditional theme for Chinese bird-and-flower painting.

Since both orchid and bamboo are very significant in Chinese painting history and highly developed, the brush and ink process for these two is highly refined. They are the fundamentals of the Chinese painting basic techniques. Once you manage to paint them, you have passed the basic training.

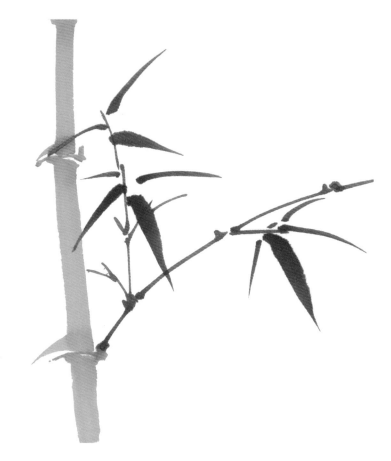

How to Paint Bamboo Stems, Nodes and Leaves

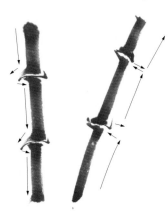

In bamboo painting, the first step is to paint the stalks, and you need to leave blanks for the nodes between sections. You can use the downstream stroke to paint from the top to bottom or use the upstream stroke to paint from the bottom to top. Follow the arrows on the left picture for the directions of the strokes. Flick the brush to the left at the node and then slide it to the right. Pause and then continue downward. Flick the brush again to the left at the node. Continue to paint the stalk from the top to bottom, repeating to complete in like manner in one breath. If you use the reverse stroke, go from the bottom upward.

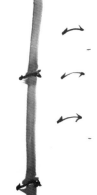

Paint the nodes as shown. Take note of the three techniques illustrated on the right.

When painting leaves, we need to paint in one resolute stroke with slight pressure. The leaves are often arranged in the form of the Chinese character 人 or 个 (① and ②). Make sure there is variation in the width of the leaves. Remember to continuously adjust the brush when painting leaves and to use centered-tip strokes. Do not make the heads of the leaves start from the same spot (③).

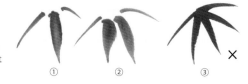

① ② ③

1 Paint bamboo stems with the centered-tip stroke in dark green going from the top downward. Flick the brush at the end and lift the brush to go downward.

2 Continue to paint the other two sections in one breath. Be sure that the stalk is gently curved, not too straight.

3 Outline the nodes with darker green.

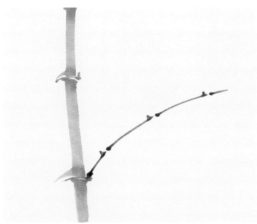 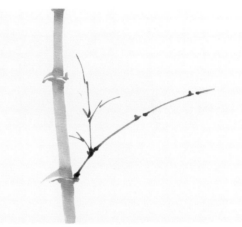

4 Paint the stem outward from the node.

5 The stems of bamboo typically grow from alternate sides of the stalk. After a primary stem grows out of a node (sometimes several primary stems sprout from a node), it branches out into secondary and even smaller stems. So continue to paint the smaller branches extending out from the stems. The angle between all the stems and smaller branches should be no less than 30 degrees.

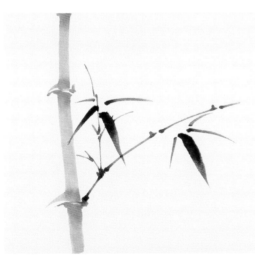 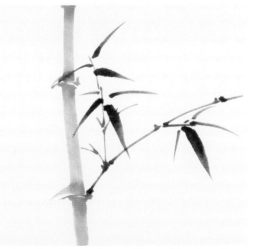

6 Add dark-green leaves, a bigger one in the middle and smaller ones on its two sides. The quantity of leaves depends on the size of the stems.

7 Paint three leaves at the top of the small branch on the left. Add more small branches to connect the leaves. The bamboo is complete.

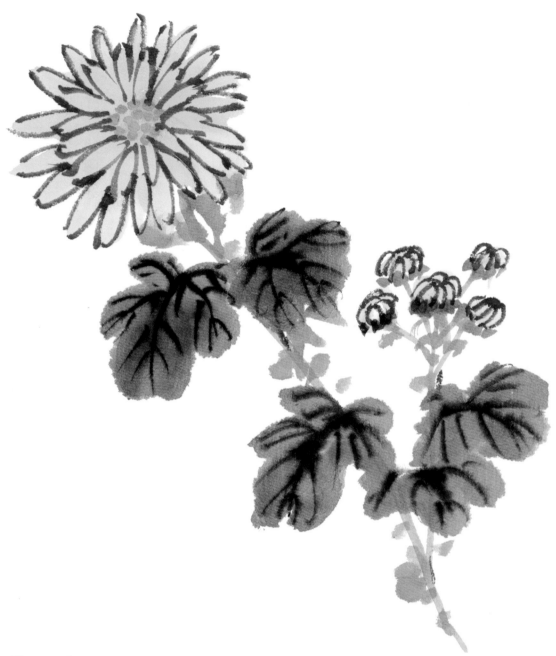

Chrysanthemum

Chrysanthemums blooming loftily in the late fall are an everlasting theme in Chinese painting. One of the most famous poems by Tao Yuanming (365–427) of the Eastern Jin Dynasty (317–420) includes the line: "While picking asters 'neath the Eastern fence, my gaze upon the Southern mountain rests," which was sung through ages and has lifted chrysanthemums to a very high status, and they represent nobility of character.

Chrysanthemum is large in shape, rich in color, wide in variety and assumes thousands of postures. This is well-presented in Chinese painting. In this session, we will introduce the special painting techniques of the chrysanthemum's petals.

How to Paint Chrysanthemum Petals and Leaves

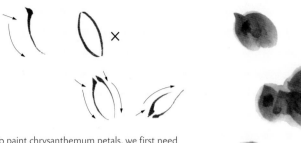

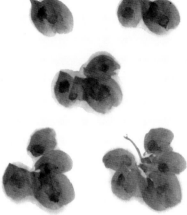

To paint chrysanthemum petals, we first need to learn "double-outline method." Using the centered-tip stroke, start with slight downward pressure and lift gradually toward the end of the stroke. The start is like a nail head and the end is like a rat's tail. Thus, it is also called "nail-head rat-tail stroke." The petal is to be done with two strokes.

Each chrysanthemum leaf has five oblong lobes, and is slightly long and rounded with pointed ends, which is different from other common plants. Be sure to select the right brush size and press down on the brush so the base of the brush is close to the paper. Use six strokes to create a leaf.

1 Follow the instructions above and paint a few petals with light ink. Be sure to have variations in the shape of lines.

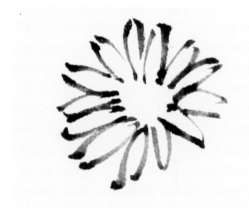

2 Outline the first circle of petals and leave the center for stamens.

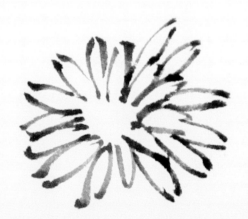

3 Then outline the second circle of petals. The second circle of petals should be placed between the petals of the first layer, not placed above them. (The right figure is a wrong example.)

4 Finish the second circle of petals. Paint the petals in contrasting shapes and orientations to avoid a mechanical look.

5 Add dark-green dots as the stamens.

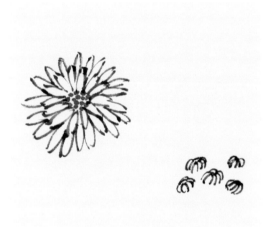

6 Paint several buds at the lower right.

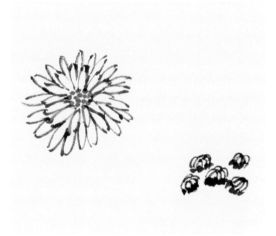

7 Add dark-green dots as the receptacles of the small buds.

8 Paint the dark-green stems.

9 Paint the dark-green leaves using the centered-tip stroke.

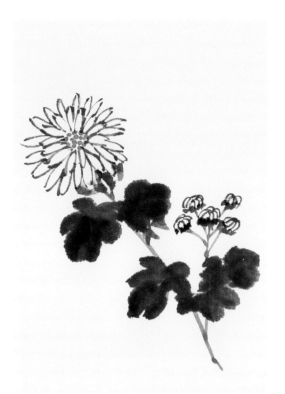

10 Be sure to press and lift the brush when painting the leaves. Every leaf requires five to six strokes.

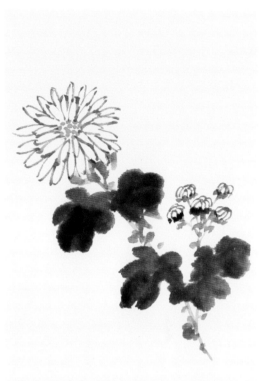

11 Add some dots onto the stems for small leaves.

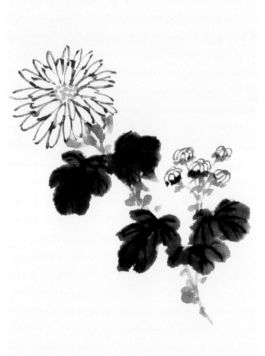

12 Outline the leaf veins with dark ink.

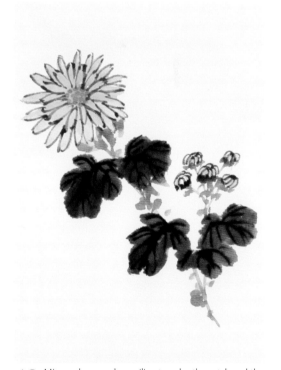

13 Mix gamboge and vermilion to color the petals and the buds. Be sure not to leave blank space in between. The chrysanthemum is complete.

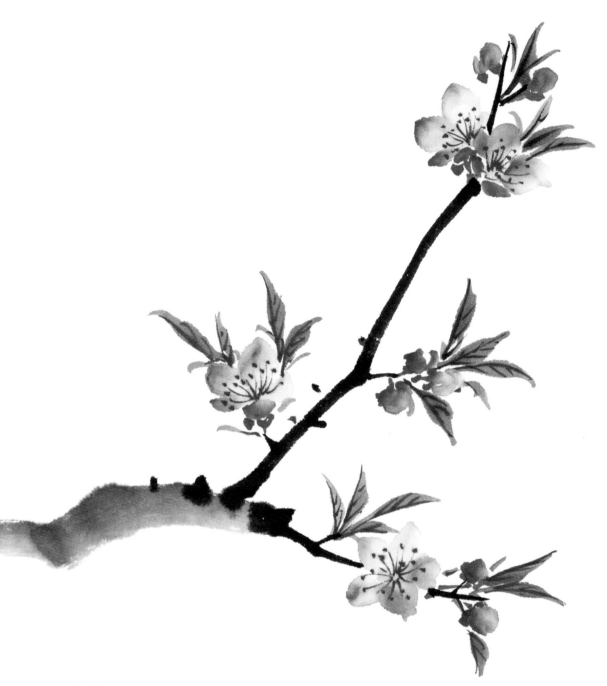

Peach Blossom

Peach blossom is in the rose family (Rosaceae). Peach trees are beautiful in posture and their flowers are attractive in color. They have been a very popular theme for literati and painters since ancient times. Cao Zhi (192–232), a famous poet in the Three Kingdoms Period (220–280), wrote in a poem: "The lady from the south is charming; her beauty is like peach and plum blossom." We can see that peach blossoms have long been a symbol of beauty.

The painting techniques of peach blossoms and plum blossoms (see page 27) are similar with the exception that the petals of peach blossoms are pointed.

How to Paint Peach Blossom Petals

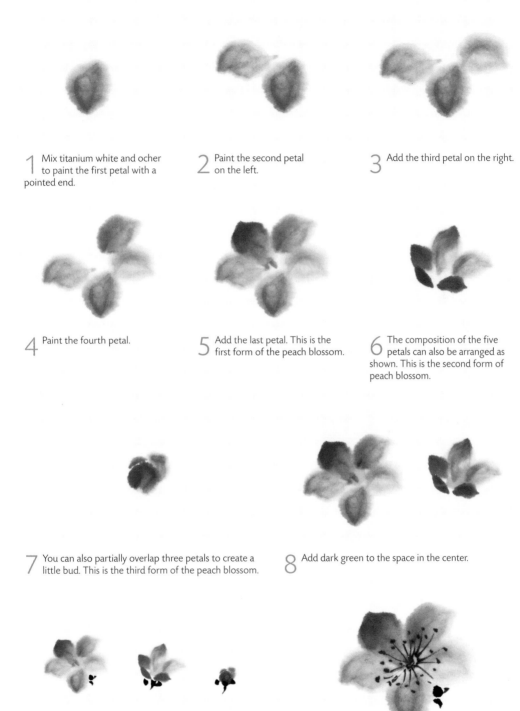

1 Mix titanium white and ocher to paint the first petal with a pointed end.

2 Paint the second petal on the left.

3 Add the third petal on the right.

4 Paint the fourth petal.

5 Add the last petal. This is the first form of the peach blossom.

6 The composition of the five petals can also be arranged as shown. This is the second form of peach blossom.

7 You can also partially overlap three petals to create a little bud. This is the third form of the peach blossom.

8 Add dark green to the space in the center.

9 Make some receptacles in the pattern of the letter Y.

10 Add stamens using eosin or rouge. The peach blossom is complete.

How to Paint Peach Leaves

Peach leaves are long, fatter in the middle and thinner at the two ends. To paint one, enter the stroke by slightly lifting the brush, press down as you continue and lift the brush gradually to exit the stroke. Compose several strokes together to get a tuft of peach leaves.

1 Paint from left to right with slightly dark ink to create a thick branch.

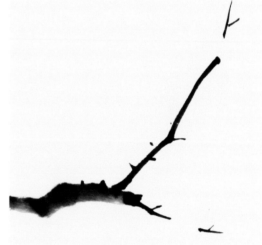

2 Continue to paint the thinner branches toward the right and top right. The thicker branches are lighter in color than the thinner ones. Be sure to leave spaces for flowers.

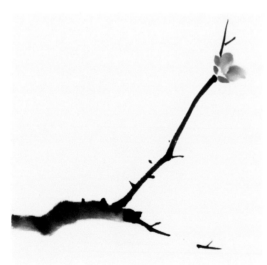

3 Follow the the second form of peach blossom petal painting to create your first flower (see step 6 on page 41).

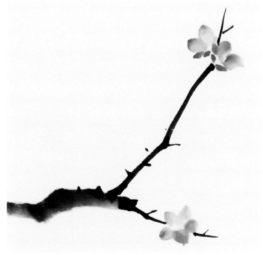

4 Add a blossom similar to the one created in step 3. Paint the third blossom at the lower right using the first form of peach blossom petal painting (see steps 1 to 5 on page 41).

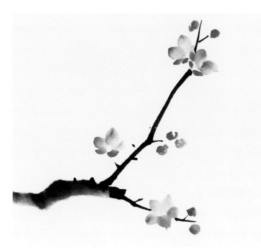

5 Continue to add more blossoms and small buds.

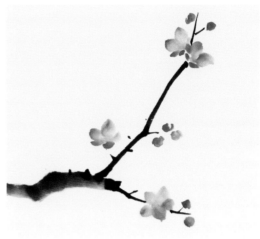

6 Add dark green to the space at the center of the blossoms.

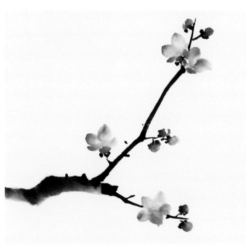

7 Paint the rouge receptacles.

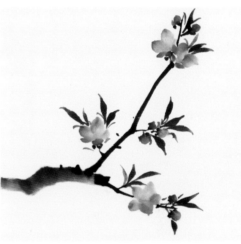

8 Dip the tip of the dark-green brush with rouge and paint the leaves next to the blossoms and thin branches.

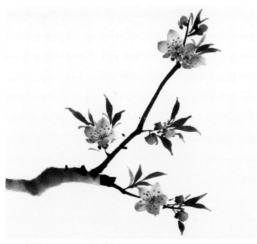

9 Add stamens to the blossoms.

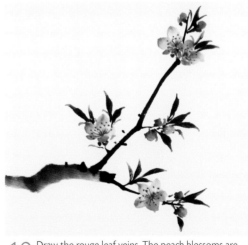

10 Draw the rouge leaf veins. The peach blossoms are complete.

Camellia

Camellia belongs to Theaceae family. Its petals are bowl-shaped, either single-layered or multi-layered. The beautiful shapes of the tree, the sheen on the dark-green leaves, and the diverse colors of its flowers make it very popular. They usually blossom in shades of red, purple, ivory and yellow. Some even have mixed colors. *Gongbi*-style painters like to draw multi-layered petals while the *xieyi*-style painters prefer to draw single-layered petals. Each has its own charm.

You can refer to plum blossom painting techniques (see page 27) for camellia blossom painting.

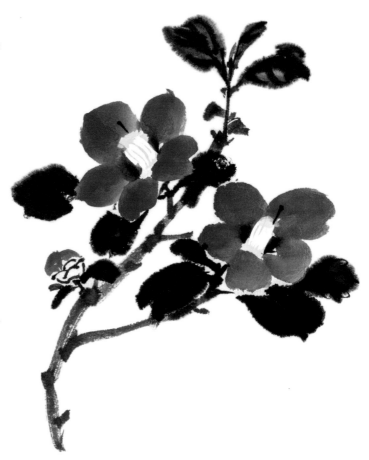

1 Paint the petal with two strokes by mixing vermilion and rouge, leaving no white space in between. This creates a bigger petal than that of the plum blossom.

2 Add another petal on the right.

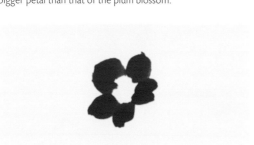

3 Every camellia blossom has five petals.

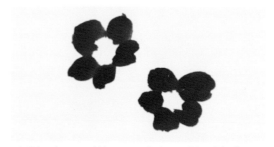

4 Paint the second blossom to the lower right of the first one.

5 Add stripe-shaped pistils to the space at the center of the blossoms using titanium white.

6 Highlight the pistils by dotting rouge on their two sides. Paint gamboge dots as stamens.

7 Use ink to paint the branches by referring to the painting technique of plum branches.

8 Dip the brush into water and brush tip into ink to paint each leaf with two strokes.

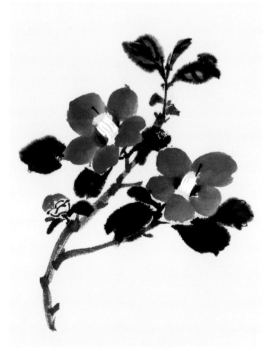

9 Paint the receptacles, and then outline the leaf veins with dark ink. Flip the paper over and add gamboge at the pistils. You can see the gamboge behind the titanium white pistils when you flip the paper back to the front. This helps create and highlight the stripe-shaped gamboge stamens. The camellias are complete.

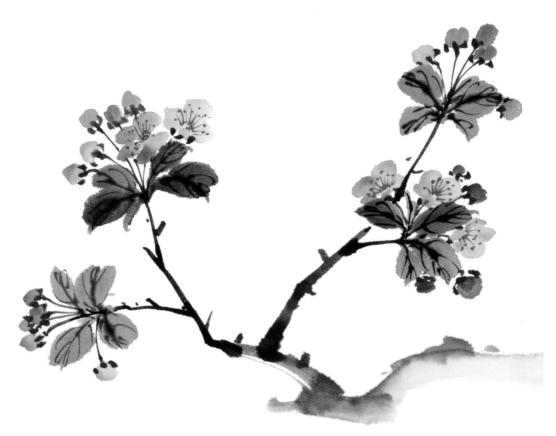

Hall Crabapple Blossom

Hall crabapple blossom is pink with a charming shape, growing on top of the tress and bending downward. It flutters in the breeze, creating uniquely beautiful scenes along rivers. In Chinese culture, the hall crabapple blossom represents the wanderer's pining for home, and expresses a sense of melancholy. In ancient Chinese literature, Lady Yang (719–756), one of the Four Beauties of ancient China, is known as the talking hall crabapple blossom, acknowledging her thoughtfulness and understanding nature. Nowadays, the hall crabapple blossom is a symbol of beauty.

The petal painting technique of the hall crabapple blossom is similar to that of the plum blossom (see page 27) and its leaf painting technique is similar to camellia leaf (see page 44).

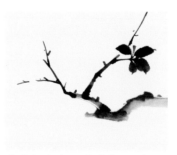

1 Paint the thick branch in light ink with centered-tip stroke from right to left.

2 Use dark ink to paint thin branches. Be sure to leave spaces for blossoms.

3 Paint the leaves in dark green by referring to the painting of camellia leaves.

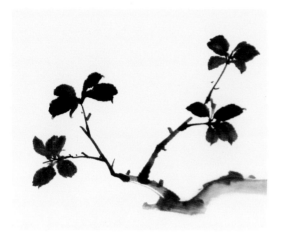

4 Pay attention to the different orientations of the leaves.

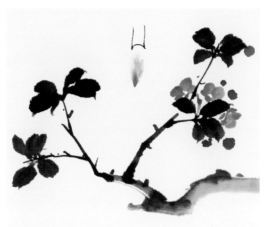

5 Dip the brush in titanium white and its tip in eosin to paint the petals and buds, with a method like the one used to paint plum blossoms.

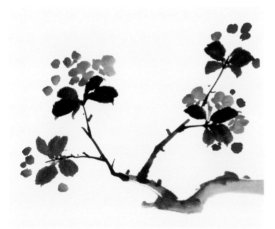

6 Continue to add more petals and buds. Be sure to leave some space between the buds and leaves for receptacles and leaf stalks.

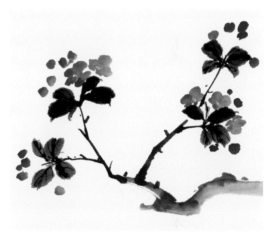

7 Add dark green (mixed with more gamboge) to the center of the petals. Draw the leaf veins with dark ink.

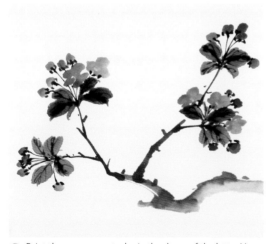

8 Paint the rouge receptacles in the shape of the letter Y. Then add the thin pedicels.

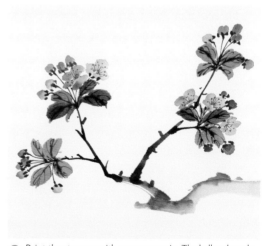

9 Paint the stamens with rouge or eosin. The hall crabapple blossoms are complete.

Sweet Osmanthus

In the middle of fall, the fragrance of osmanthus is everywhere. The little golden blossoms appear all around the treetops in a flash overnight, looking like stars from afar. They are a popular topic in ancient poetry.

Osmanthus is blooming under the pavilion,
Fragrance is floating at the year end.
Leaves are forming multiple green layers,
Blossoms are exhibiting a million yellow spotlights.

This short poem by Zhu Xi (1130–1200), a famous scholar in Song Dynasty, portrays the beautiful scene of sweet osmanthus blooming in fall. Osmanthus is also an auspicious symbol. In Chinese literature, a person who is on the crest of a wave can be known as "the selected osmanthus."

Refer to the painting technique of plum branches (see page 27) for sweet osmanthus branches and the painting techniques of hall crabapple (see page 46) and camellia leaves (see page 44) for osmanthus leaves. Its blossoms are small with four-lobed sympetalous corolla, so we can simply outline the cluster while painting.

1 Paint the branches with ink from top downward. If there are many branches, you can refer to the painting technique of plum branches.

2 Refer to the painting techniques of hall crabapple and camellia leaves to paint the osmanthus leaves with ink in two strokes.

3 Continue to add more leaves.

4 Pay attention to the different orientations of the leaves. The leaves are basically done.

5 Mix gamboge and vermilion to paint the blossoms, roughly creating the cluster.

6 Add more flower clusters among the leaves and on branches.

7 Outline the leaf veins with ink. The sweet osmanthus is complete.

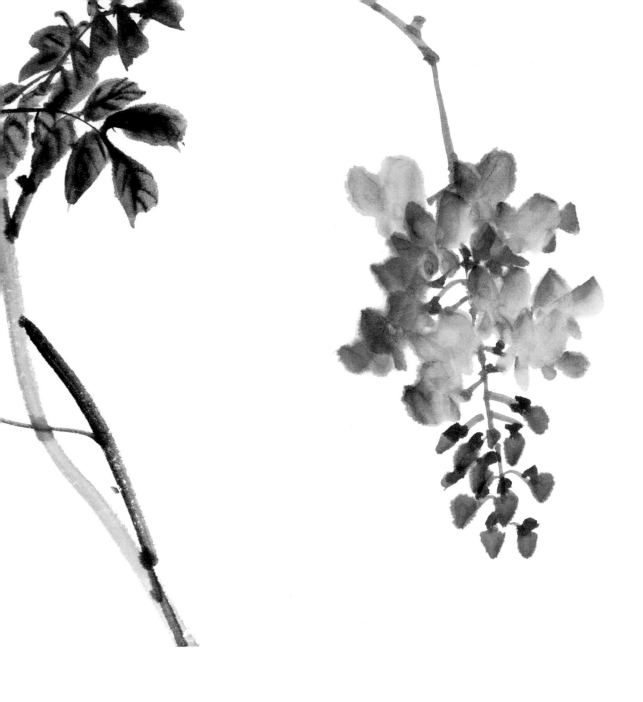

Wisteria

Wisteria is a deciduous climbing vine that blooms in spring. The indigo corolla
of the beautiful purple flower is like a butterfly. In his poem, Li Bai (701–762),
a famous poet in the Tang Dynasty, wrote: "The Wisterias climb up the tall tree;
the vines grow in the warm spring." Spring is the best season for wisteria, and
large bunches of the flower hang from branches like glorious purplish-blue
floating clouds. This attractive scene is a popular theme in bird-and-flower
paintings of all ages.

1 Prepare purple by mixing eosin with indigo or cyanine. Dip the brush into titanium white and brush tip into the purple to paint two bigger petals.

2 Then paint the smaller petals below. The composition is like a butterfly.

3 Paint two more wisterias to form an inverted triangle.

4 Repeat the steps to add three wisterias in a triangle at the lower right.

5 Create another three wisterias to form a tilted triangle.

6 Paint the dark-purple spikes at the bottom. (The purple turns brighter when you mix eosin with cyanine and darker when you mix eosin with indigo.)

7 Add a few more wisterias to form a more stunning composition.

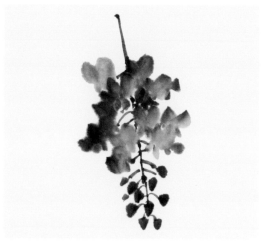

8 Paint the dark-green stems.

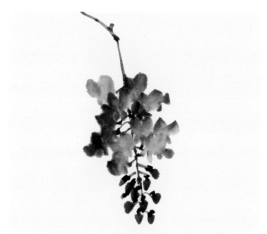

9 Extend the stem to the top of the picture. Use gamboge to dot stamens and rouge or ochre for receptacles.

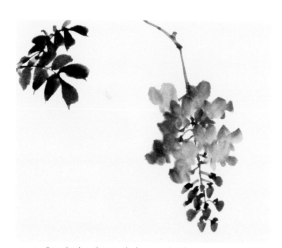

10 Dip the brush into dark green (with more gamboge) and brush tip into rouge to paint the leaves in pairs to form a cluster.

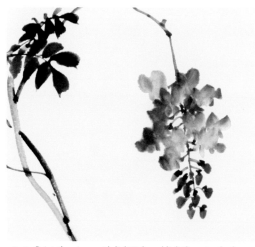

11 Paint the vines with light ink and link them to the leaves.

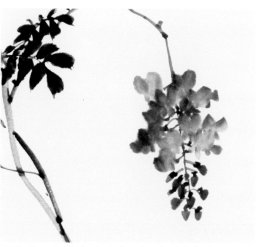

12 Draw the leaf veins before the ink of the leaves becomes dry.

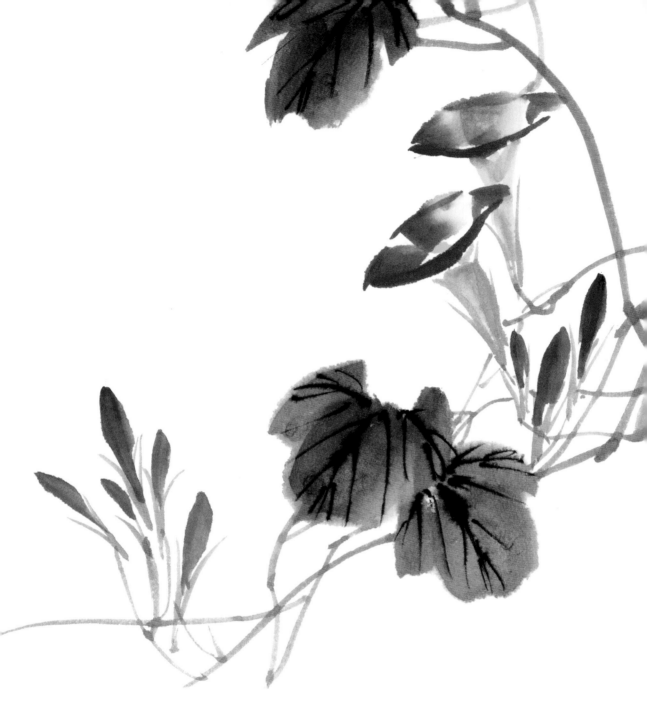

Morning Glory

The morning glory is sowed in spring and blooms in summer or autumn. It is a very popular ornamental plant. The flower is like a trumpet and comes in different colors like blue, crimson, pink, purple or mixed. The petal edge varies depending on the species.

How to Paint Morning Glory Leaves

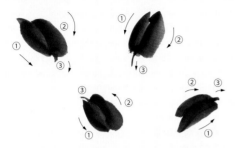

① Enter the stroke gently. Press down on the brush belly and lift to exit the stroke to form a leaf with a fat midsection and two ends tapering to a point.
② Paint the second stroke, overlapping the first stroke somewhat.
③ Dot the leaf stalk.

The figure on the left shows the four leaves in different orientations. After practicing, you can incorporate the different leaf forms to produce a leaf branch (see above). The simplest composition of a leaved branch is a stem topped by three leaves. Be sure the leaves are in different orientations to give a sense of perspective.

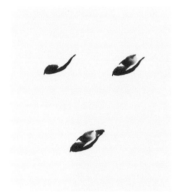

1 Paint the edge of the petal in the foreground with eosin or rouge. Add another three strokes on top to paint the petal in the background, thus finishing the mouth of the morning glory.

2 Repeat the above step to paint another flower at the top right.

3 Use the centered-tip stroke to paint the stripe-shaped buds at the lower left and right of the picture.

4 Paint the tubular parts of the flowers when the eosin or rouge on the brush tip becomes lighter.

5 Paint the dark-green receptacles. Be sure they are needle-shaped.

6 Paint the dark-green leaved branch consisting of three leaves.

7 Add the second leaved branch on the right.

8 Paint a leaved branch on top.

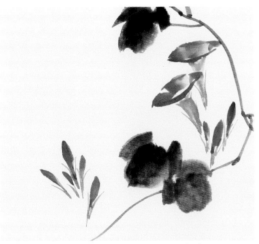

9 Add dark-green vine and connect it with the leaves.

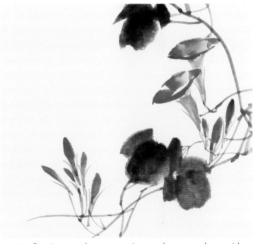

10 Continue to draw more vines and connect them with the flowers and leaves.

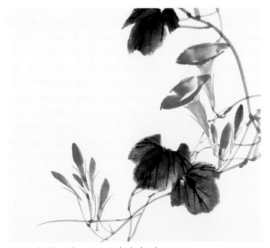

11 Outline the veins with dark ink.

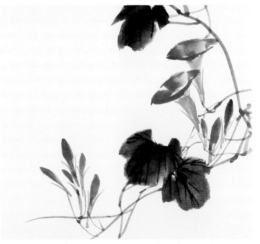

12 Dot gamboge stamens to complete the morning glories.

Lotus

Lotus is an aquatic plant. It can be single or double-petalled, and the number of petals can range from 10 to dozens. The color can be red, pink, white, purple and can have patterns and trims. Its rich manifestations make it the only flower that is paint-worthy in all stages of its life, from sprouting to withering.

Painters of all ages tirelessly portray lotus not only because of its charm but also of its unique character: "Growing out of mud and yet remains pure; being cleansed by the water and yet not bewitched." Its purity was highly respected by the literati of the past dynasties.

The beginner should become acquainted with the morphology of the lotus to be able to paint it. You should first learn how to outline and dot a stem and a leaf, before going on systematically to learn the techniques of painting the flower and leaves of the lotus.

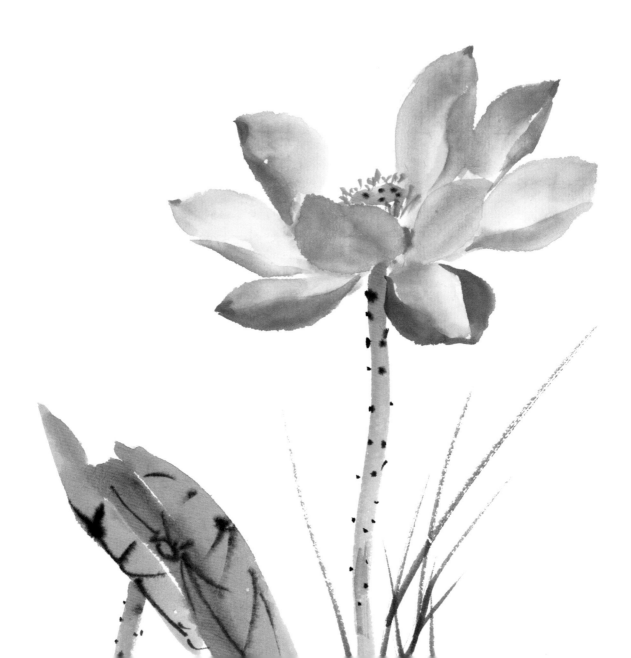

1 Soak the brush in the titanium white and dip the tip in eosin to paint the petal in two strokes. You can refer to the petal painting techniques of peach blossoms. The lotus petal is an enlarged version of peach blossom petal.

2 Paint the second petal.

3 Use the side-brush stroke to complete the second petal.

4 Repeat the steps to paint a third petal that is thinner.

5 Complete the third petal as shown.

6 Paint the fourth petal.

7 Complete the fourth petal.

8 Paint the fifth, sixth and seventh petals.

9 Complete the petals in step 8.

10 Paint the eighth petal with two strokes, one on each side.

11 Add a stroke in the middle to complete the eighth petal. The lotus flower is done.

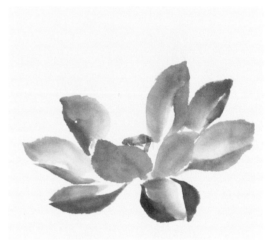

12 Paint the seedpod in dark green in the center.

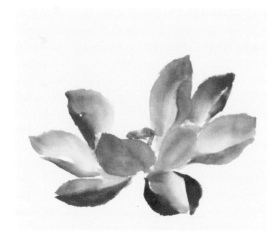

13 Dilute dark green (with more gamboge) with water to touch up the petals from the center of the flower outward.

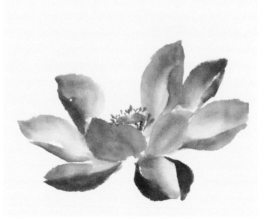

14 Mix gamboge with vermilion to paint the stamens.

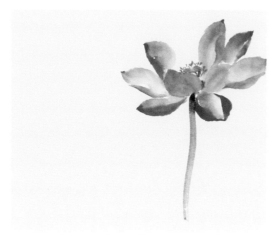

15 Use the centered-tip stroke to paint the dark-green stem.

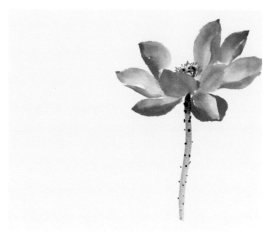

16 The lotus has long, hollow, tubular stems with bristles down on its surface. Use ink dots to represent the bristles. This is one of the *xieyi*-style painting techniques.

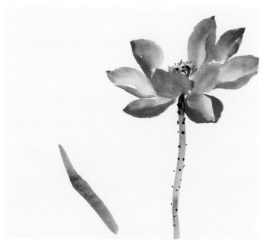

17 Paint a dark-green curled leaf on the left.

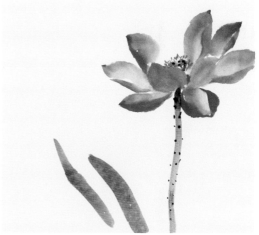

18 Paint another leaf on the right, face-to-face with the first leaf in step 17.

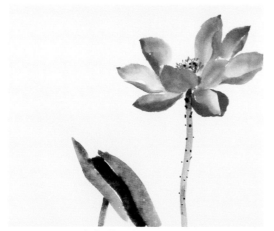

19 Complete the leaf by adding dark green (with more indigo) between the two curled leaves. Paint the stem with one stroke below.

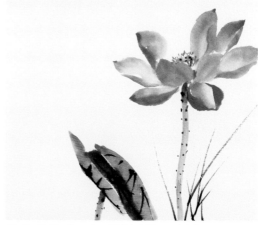

20 Outline the veins with ink. Add some ink dots to represent the bristles. Paint a cluster of dark-green (with more indigo or ink) water plants on the right. The lotus is complete.

Iris

Iris is large and beautiful with jade green leaves and a pleasant fragrance. It has a very long history and can be found on the ancient Greek and Egyptian reliefs. It was also a courtyard plant in the Northern and Southern Dynasties (420–589) in China.

Iris has a wide range of colors such as purple, yellow and white. It has six petals, three inside and three outside. The outer ones are bigger than the inner ones. The angles between the petals are around 120 degrees. The veins are curved, which is an important characteristic of painting a beautiful iris.

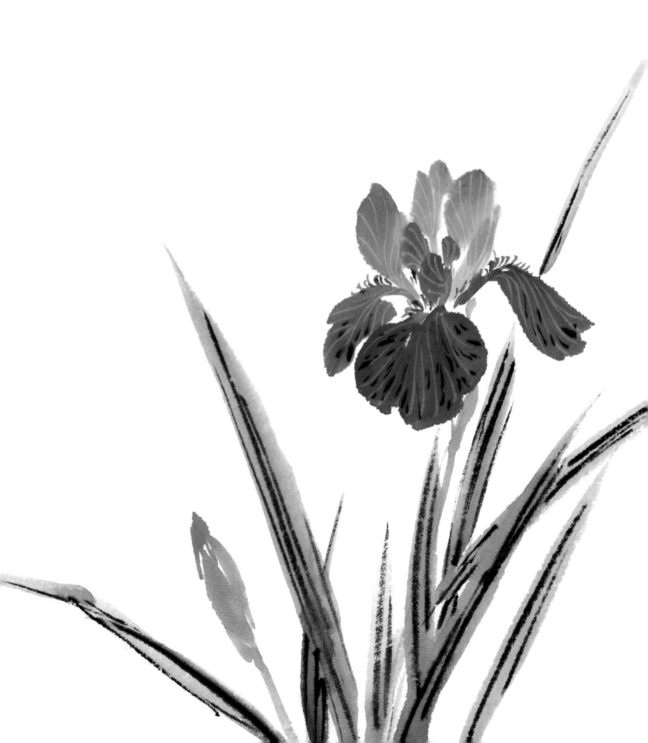

1 Paint the three smallest indigo petals from top downward.

2 Paint the three larger upturned petals from top downward.

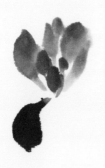

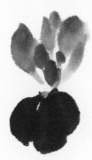

3 Paint the three outer sepals turning downward. As shown, the first sepal requires two strokes due to the size and it is darker than the petals.

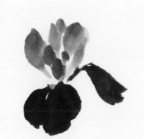

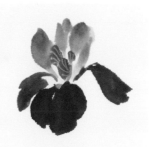

4 Add two strokes on both sides as the other two sepals.

5 Add white veins before the petals and sepals dry. The veins are to show the orientation of the petals and sepals.

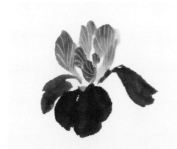

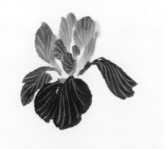

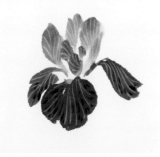

6 Continue to add the veins on the petals and sepals. The veins on those petals facing upward are more complicated; the veins near the stamens are close to each other; those near the edge are more separated.

7 Add ink dots among the white veins on the sepals following the orientations.

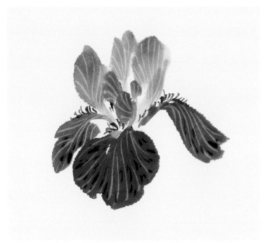

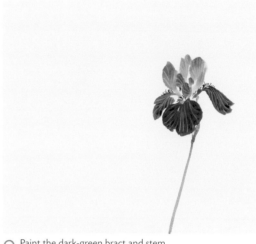

8 Mix gamboge and vermilion to paint the stamens. Be sure the strokes are curving inward.

9 Paint the dark-green bract and stem.

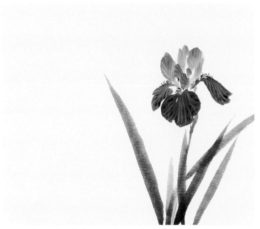

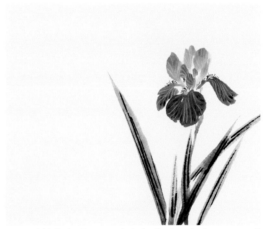

10 Paint the dark-green leaves by referring to the painting technique of orchid leaf (see page 31). Be sure the iris leaves are thicker and straighter.

11 Add the leaf veins with dark ink when the leaves are still wet.

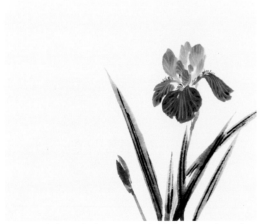

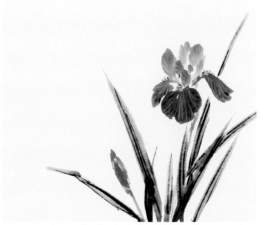

12 To balance the layout, paint the dark-green calyx and stem on the left.

13 Dot the small indigo bud above the calyx. Paint another leaf on the left and add veins with ink. The iris is complete.

Chinese Narcissus

The traditional arrangement of narcissus requires only a bowl of water with a few pebbles. This is enough for it to bloom and deliver fragrance. The simple flower with the green leaves is like a fairy wearing a green dress, gracefully standing on the ripples, and creates a refined scene. Narcissus blooms in winter and is commonly used to celebrate the Chinese New Year as a symbol of unity and blessings.

Narcissus usually has six petals. Surrounding the stamens is a bowl-shaped corona. Its leaves are long and slim.

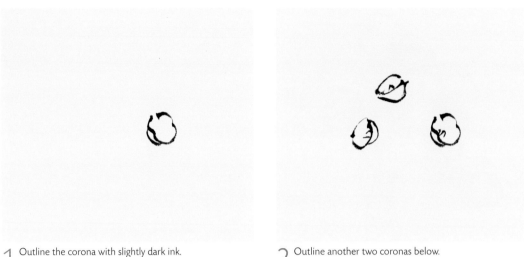

1 Outline the corona with slightly dark ink.

2 Outline another two coronas below.

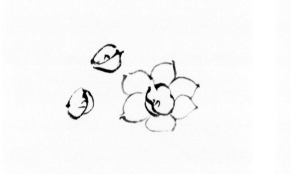

3 Use the "nail-head rat-tail stroke" to outline the petals with light ink. Each flower has six petals.

4 Keep using the "nail-head rat-tail stroke" to outline the petals of the middle narcissus. Pay attention to the orientation and be sure the petals are overlapping to create a three-dimensional perspective.

5 Complete the petals of the third narcissus.

6 Outline the small bud on the lower left of the three narcissi.

7 Outline the stem.

8 Continue to use the "nail-head rat-tail stroke" to outline the leaves.

9 Be sure the leaves are intertwined to portray the dancing motion.

10 Dye the dark-green stem. Dye the petal edges with lighter green to emphasize the purity of the white narcissi.

11 Color the leaves with lighter malachite.

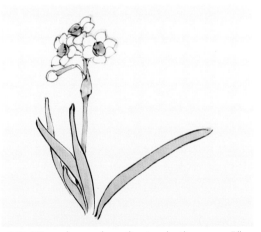

12 Mix gamboge and vermilion to color the coronas. Fill the bulging part on the stem with ochre. The narcissi are complete.

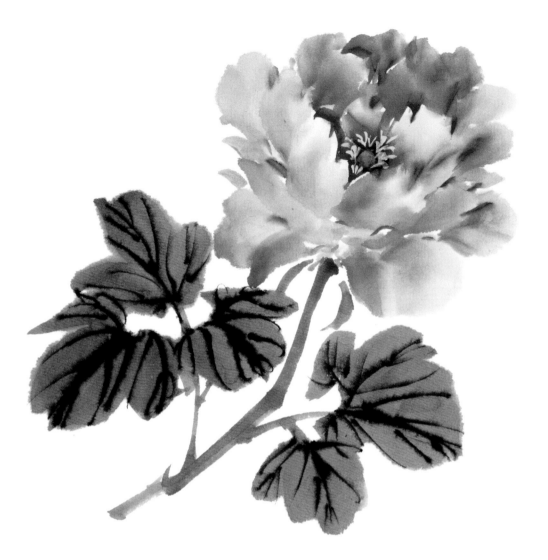

Peony

The peony is known as the King of Flowers due to its magnificent combination of large flowers, bright colors and graceful leaves and stems. In his poem, Liu Yuxi (772–842), a literatus in the Tang Dynasty, wrote: "Only peony is the real beauty and its beauty seizes the whole country." This exhibits the attractiveness of the peony that makes it one of the most popular themes in Chinese art and literature.

The petals of a peony are complicated. We need to paint from the center, layer by layer. Every layer must be consistent and symmetrical (with an almost equal numbers of inner and outer layers).

How to Paint Peony Leaves

You can refer to the painting techniques of the morning glory leaf (see page 53) to paint peony leaf. Group three morning glory leaves to form a peony leaf.

1 Dip the brush into titanium white and brush tip into eosin to paint the petal with two strokes.

2 Add the second petal on the left using two strokes.

3 Repeat the steps to add two petals, one on each side, from down to up. This is the first layer of petals.

4 Use thicker eosin to paint inner petals.

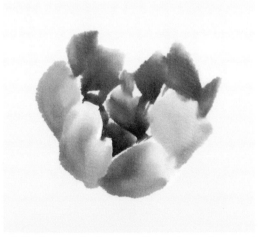

5 Paint the outer petals. Be sure to leave a gap between the dark and light petals.

6 Continue to paint the surrounding petals spreading around the edge on the top. This is the second layer of petals.

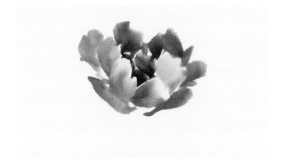

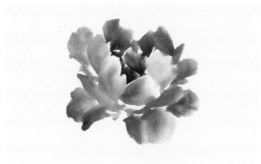

7 Add the third layer of petals on the outside of the first row. Make sure these petals are flatter.

8 Paint the fourth layer of petals spreading downward. Make sure they are in different orientations.

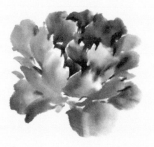

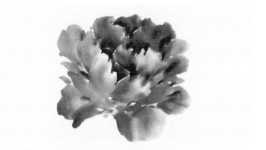

9 Use the side-brush stroke to add thicker eosin dots onto the spaces between the layers to mimic the notch of the petals and enhance the three-dimensional effect.

10 Add slightly darker green (with more gamboge) into the empty spaces between the petals.

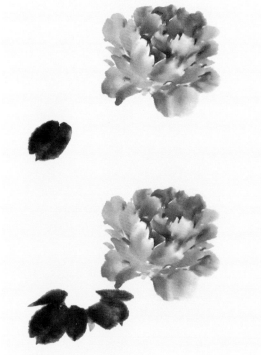

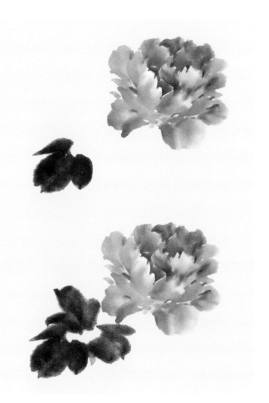

11 Paint dark-green leaves.

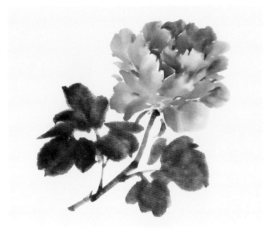

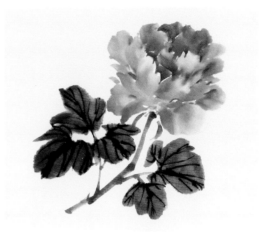

12 Paint the two branches of leaves on the right in a different orientation. Mix dark green and rouge to paint the stem attached to the leaves.

13 Outline the leaf veins with dark ink.

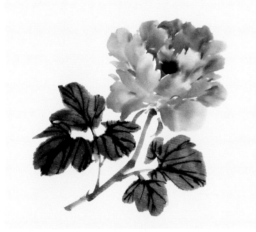

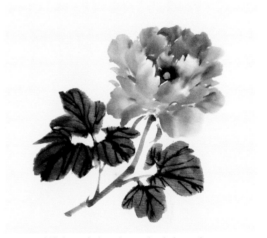

14 Mix rouge with ink to form dark purple to dot the stamens. This can enhance the stamens in the next step.

15 Add light-malachite dot on the dark-purple stamens as the pistils.

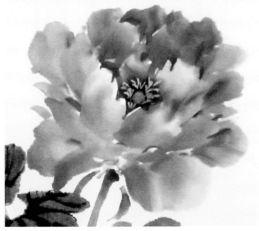

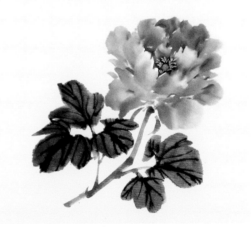

16 Mix the gamboge and titanium white to paint the stigmas.

17 The peony is complete.

2. How to Paint Fruits and Vegetables

There are various themes in bird-and-flower painting, including fruits and vegetables. Painting these common objects from a general impression alone won't achieve artistic effect. There are color and morphological variations even in one fruit. For example, watermelons and tomatoes may both be round, but they are round in their own distinctive ways. To do artistic justice to vegetables and fruits with masterly ease, one must supplement painting skills with real life experience of these plants.

To give a painting of vegetables and fruits a sense of mass, artists generally use side-brush strokes and dry brushes. The high-water content of vegetables and fruits also entails a more relaxed brush manner, which helps give an impression of substance and bulk.

Long Turnip

A long turnip has white skin and is cylindrical with branching stems and no hair. It is important to capture its surface texture and shape.

1 Outline the top of the long turnip with a brush tipped with medium-shade ink.

2 Paint the head of the turnip.

3 Draw a line from the lower side of the head to the far end of the first line.

4 Connect the ends of the two lines. Draw the root to complete the shape of the turnip.

5 Create texture by touching up the surface of the turnip sideways in side-brush strokes.

6 Use dark green (mix gamboge and indigo) to paint the leaf stems.

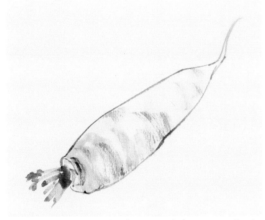

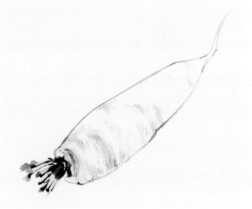

7 Dip a brush saturated with water in dark green to color the head of the turnip.

8 Outline the leaves with ink.

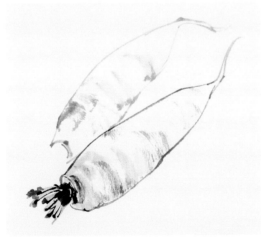

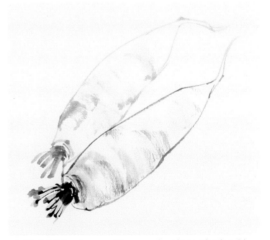

9 Repeat the above steps to produce another turnip. Outline the shape with ink and use side-brush strokes to create the texture. Be sure this turnip is lighter in color than the first one to emphasize the depth.

10 Paint the stems and leaves and outline with ink. Add light green around the head. Apply titanium white on the surface to complete.

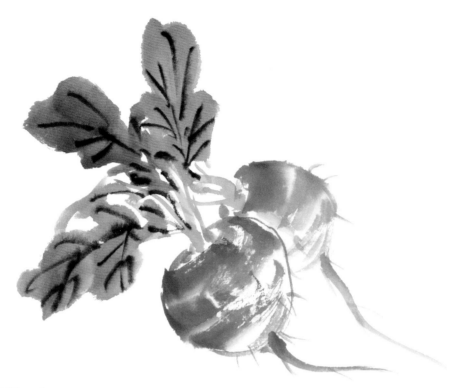

Red Turnip

The red turnip has quite a different shape from the white one. It is rounded with broader leaves. Be sure to use the side-brush stroke for painting or you will lose the texture.

1 Paint across the paper with a brush saturated with clear water and tipped with a little eosin in one side-brush stroke in an arc shape.

2 Add another side-brush stroke on top of the water area, and then add one more stroke below. The second and third strokes slightly overlap the preceding one. This is the left half of the turnip.

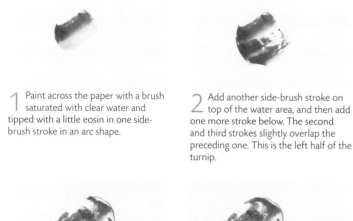

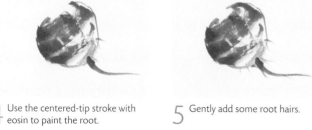

4 Use the centered-tip stroke with eosin to paint the root.

5 Gently add some root hairs.

3 Outline the right side of the turnip with eosin, taking care to make it curved. Paint from right to left using three overlapping strokes to finish the right half. Complete the turnip bulb.

6 Add one more red turnip by following the steps described in the previous steps. Note that it is only half visible, which lends a sense of perspective. Add the root and root hairs.

7 Paint the leaf stems with a brush dipped in dark green and tipped with rouge.

8 Dip the brush into dark green and brush tip into ink to paint the big leaves in five or six long strokes.

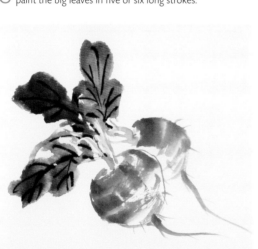

10 Outline the leaf veins in ink. The red turnip is complete.

9 Paint two more leaves. Pay attention to their orientations to keep the overall balance.

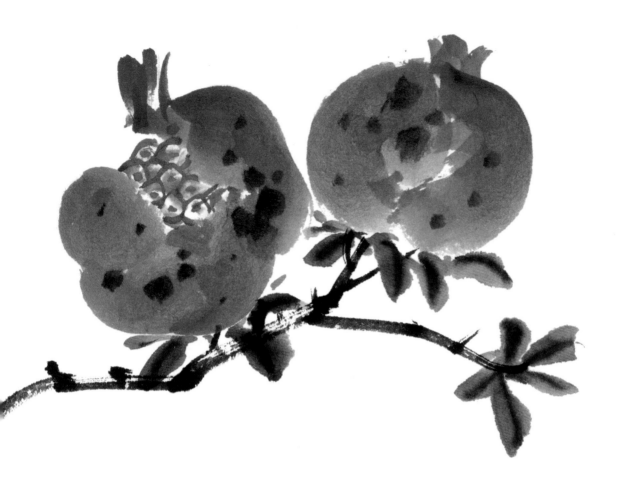

Pomegranate

Pomegranate is rounded with thick skin and with a firm calyx on top. The seeds are pink and translucent like crystals.

In Chinese culture, pomegranate's numerous seeds make it an auspicious symbol of having many children. It is always used as a lucky pattern for decoration.

1 Mix ocher and rouge to paint the pomegranate with one stroke. Keep the brush tip pointing outward and the water in the center to mimic the smooth surface of the pomegranate skin; otherwise the edge will be watery and look rough.

2 Add the second stroke below.

3 Add the third stroke on the right to form the basic shape of the pomegranate.

4 Mix ocher and rouge to paint the calyx.

5 Fill the portion on the right side of the calyx. Leave the center empty for the seeds.

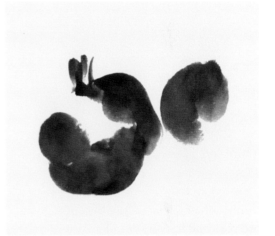

6 Paint the left side of the second pomegranate on the right.

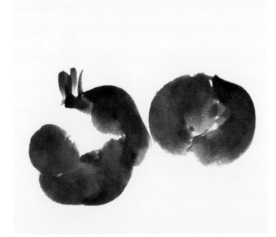

7 Then paint the right half without leaving an opening as it is a whole pomegranate.

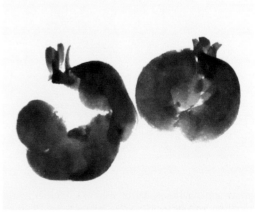

8 Add the calyx to finish the second pomegranate.

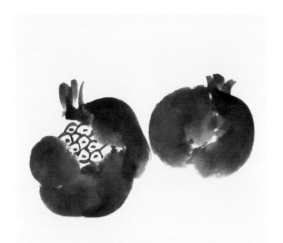

9 Paint eosin hexagons. Outline the seeds and add red dots in their centers.

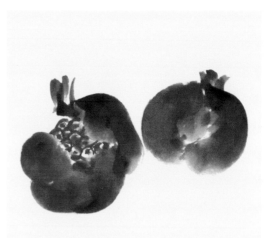

10 Mix eosin and water to color the seeds. Leave some empty space as highlight to make them look crystal.

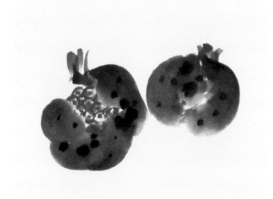

11 Add some ink dots on the skin and be sure they are different sizes and shades.

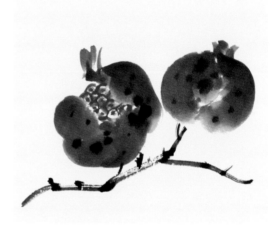

12 Use ink to add a branch connecting the two pomegranates.

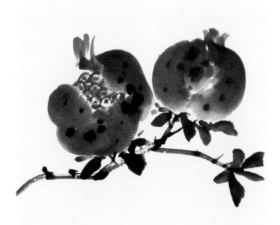

13 Dip the brush into dark green and brush tip into some ink to paint the leaves using the centered-tip stroke.

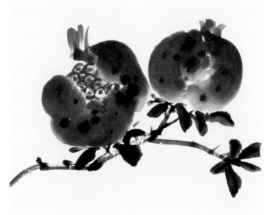

14 Draw the leaf veins with dark ink to complete.

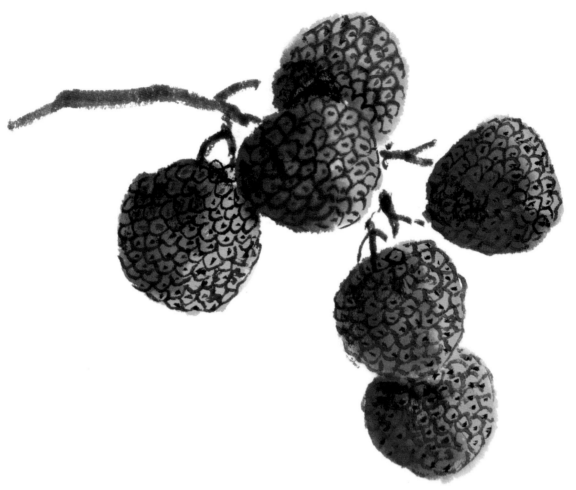

Lychee

The lychee has a rough, red scale-like skin and translucent flesh. It is very popular because of its delicious flavor. In his poem, Tang Dynasty poet Du Mu (803–853) wrote: "The clouds of dust from the horse made the Lady smile; others knew not the arrival of lychees." This refers to Emperor Xuanzong's (682–762) commands to delivery lychees all the way from the south to please his beloved concubine Lady Yang, one of the Four Beauties of ancient China.

1 Dip the brush into water and eosin to paint a heart shape.

2 Repeat the step to paint three more lychees.

3 Fill the other half with dark green, proportionally smaller than the red area.

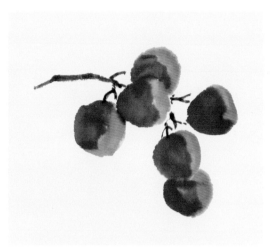

4 Repeat the steps to add more lychees, overlapping them to enhance the perspective effect.

5 Draw the branches with ink to connect all the lychees.

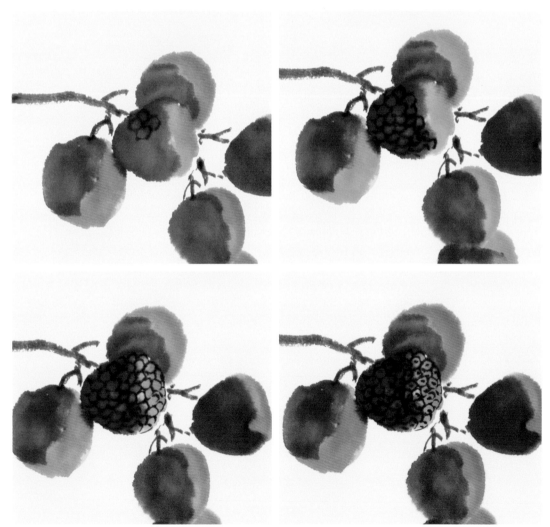

6 Outline the skin texture with rouge hexagons, attaching them to one another. Add rouge dots in the center of the hexagons. This is similar to the painting technique of pomegranate seeds (see page 74).

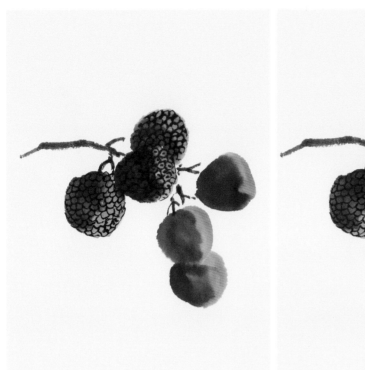

7 Finish the skin texture of all the lychees.

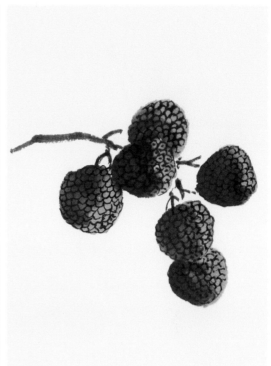

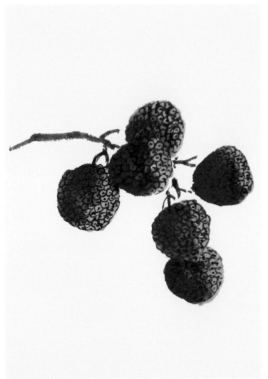

8 Add dots on all the lychees.

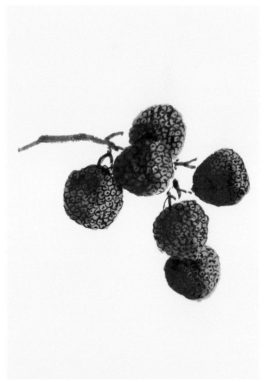

9 Add rouge around the overlapping area to enhance the three-dimensional effect. The lychees are complete.

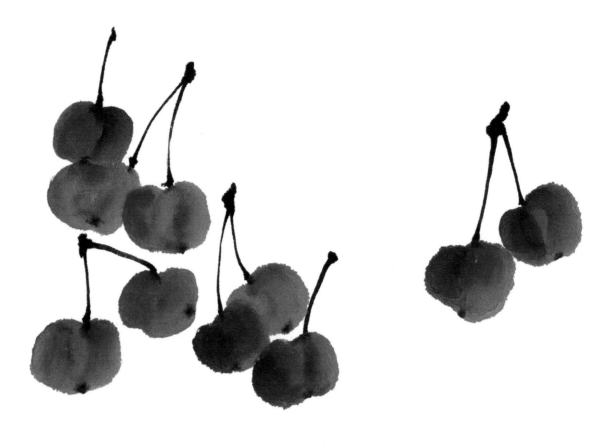

Cherry

People have loved the cherry since the ancient time for its beauty: It is bright and glittering in color, like a beautiful piece of agate. It is used in many Chinese poems to express emotions. Jiang Jie (1245–1305), a poet of the Southern Song Dynasty (1127–1279), wrote: "Time leaves people behind when cherries turn red and plantains turn green." The red cherries and green plantains fully depict the sentiment toward the departure of spring in early summer.

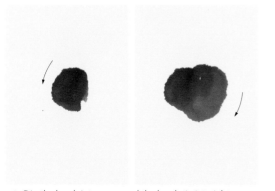

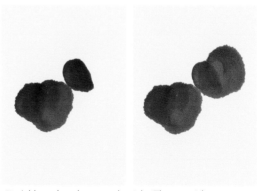

1 Dip the brush into rouge and the brush tip into ink to paint the oval cherry with two strokes.

2 Add another cherry on the right. They are right next to each other as a pair.

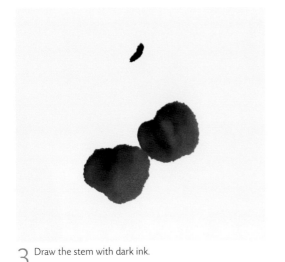

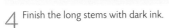

3 Draw the stem with dark ink.

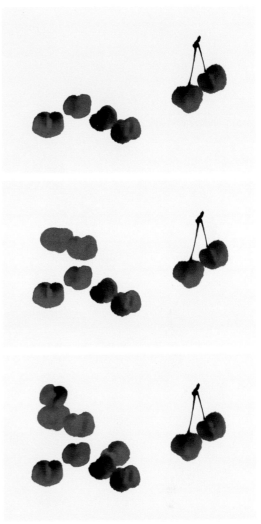

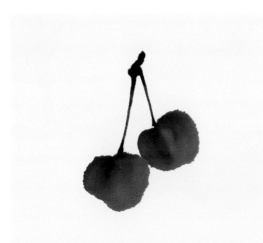

4 Finish the long stems with dark ink.

5 Paint a few more cherries on the left. They can share a stem or be scattered. Be sure to create picturesque disorder.

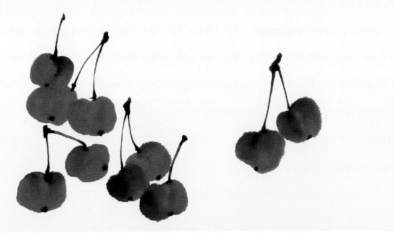

6 Draw the long stems with dark ink in various orientations. Add a dot at the bottom of each cherry as the stigma scars. The cherries are complete.

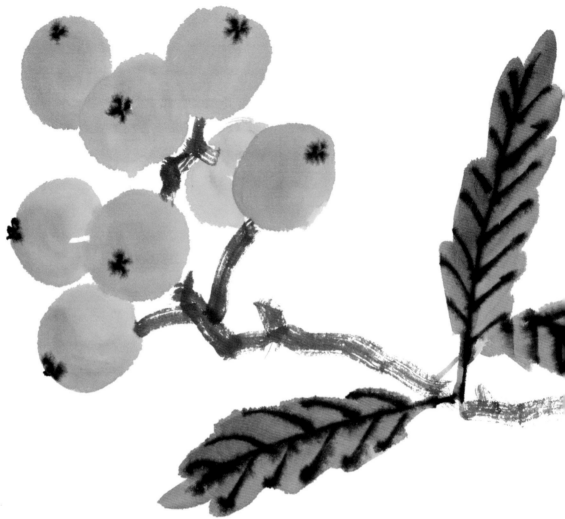

Loquat

The loquat fruit is rounded or oval, soft, juicy and delicious. The golden fruits cluster on evergreen trees and serve as an auspicious symbol in China. Loquats appear in many songs and poems. The fruits are also called "gold nuggets," representing wealth and abundance. Every loquat fruit can have more than one seed, thus symbolizing having many children, health and longevity.

1 Mix gamboge and vermilion to paint the loquat fruit with two strokes in circle.

2 Add the second loquat fruit on the right.

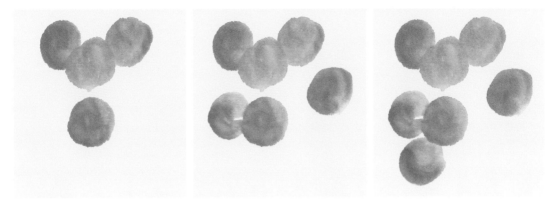

3 Repeat the steps to create more loquat fruits. Pay attention to their positions.

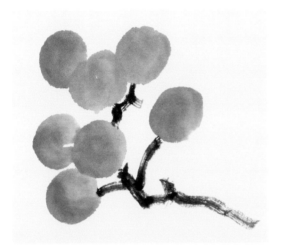

4 Mix ocher and ink with less water to paint the stem with a centered-tip stroke. Be sure the stems are thick enough.

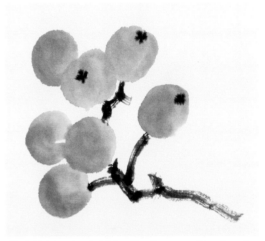

5 Add dots using dark ink as the stigma scars. Every loquat fruit needs five or six dots, and you can produce a better effect if you let the dots bleed together.

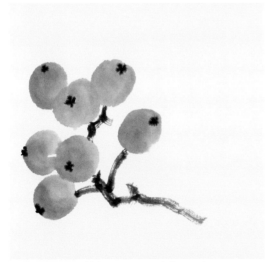

6 Continue to add the stigma scars following the orientations of loquat fruits, as in the painting technique of the cherry (see page 80).

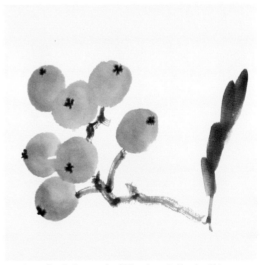

7 Paint the dark-green leaf. The shape is like the Chinese instrument *pipa*. Use four strokes to paint the left half of the leaf from the top downward.

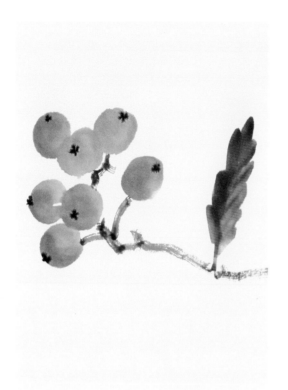

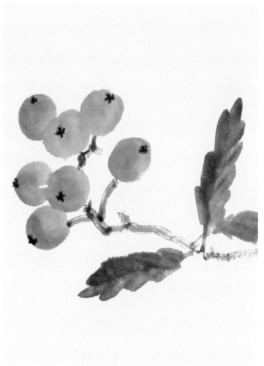

8 Use five strokes to paint the right half of the leaf from the top downward.

9 Repeat the steps to paint the other two leaves in different orientations. The rightmost leaf is only partially shown.

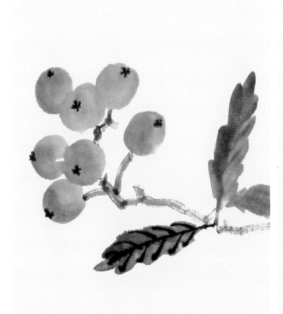

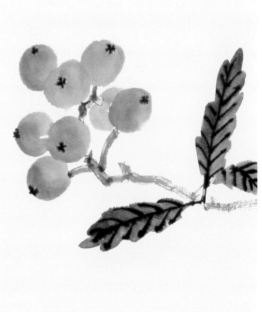

10 Use the centered-tip stroke to draw the leaf veins with dark ink. The loquats are complete.

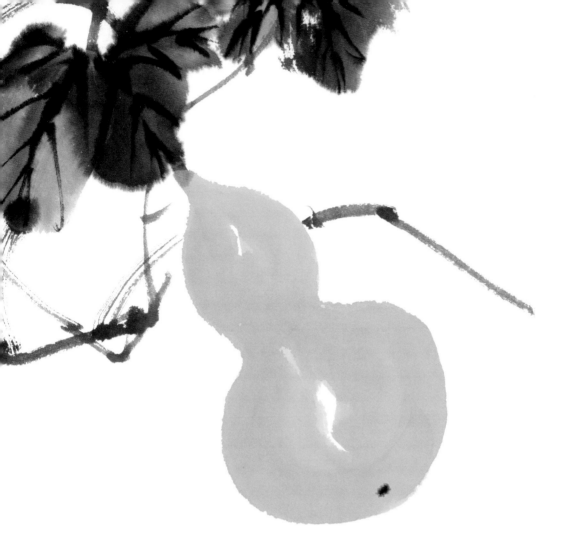

Bottle Gourd

In Chinese, a bottle gourd is homophonous with blessings, and so represents wealth and peace. It is an auspicious symbol in the traditional culture. In the old days, the rich would plant bottle gourds to repel evil spirits. Other people would hang them under the roof as a propitious object to keep them safe and peaceful.

The bottle gourd is a popular theme in Chinese painting since the fruit and broad leaves form a nice composition to let the painters demonstrate their ink wash painting skills.

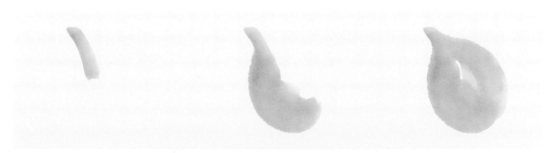

1 Mix gamboge and vermilion to paint the upper half of the bottle gourd with three strokes.

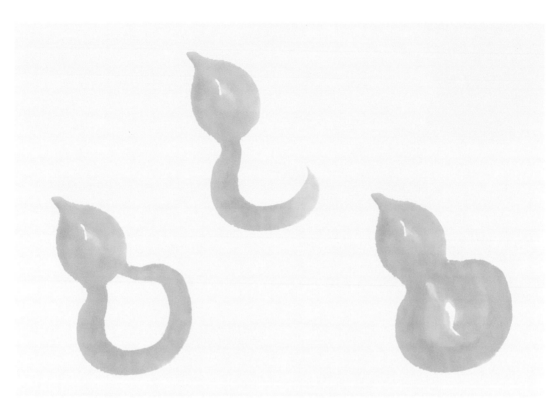

2 Paint the lower half of the bottle gourd with two strokes to form a circle. Fill the empty space with one stroke to finish the basic shape of the gourd.

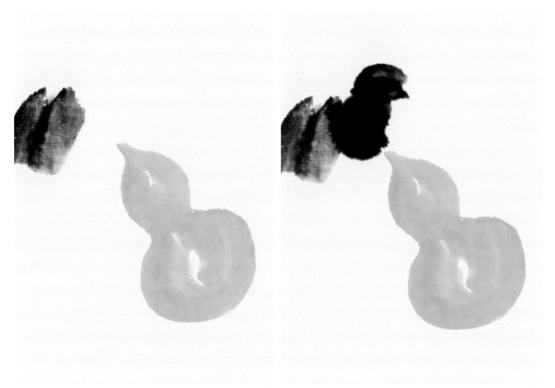

3 The leaf is palm-shaped and has five lobes. Refer to the leaf painting techniques of morning glory (see page 53) and paint the left two lobes with light ink first, then the middle lobe with dark ink, and the right two lobes with dark ink last.

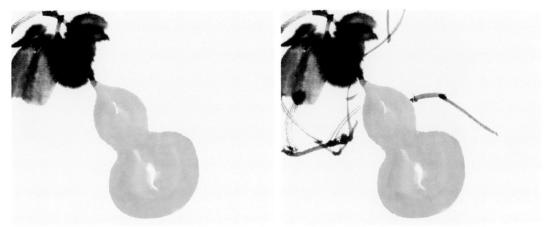

4 When painting the vines, pay attention to the shades of the ink as well as the flow of the line. They do not have to be entirely realistic.

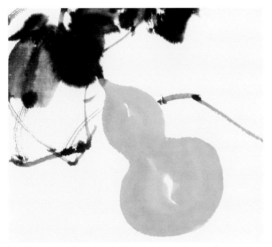

5 You can add another leaf on top according to the composition of the picture.

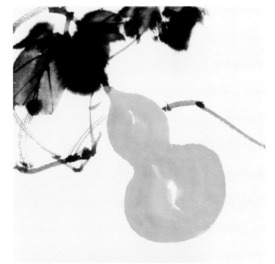

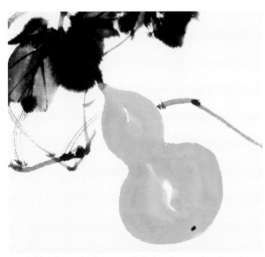

7 Add a dot at the bottom of the bottle gourd as the stigma scar to show the orientation and enhance the three-dimensional effect.

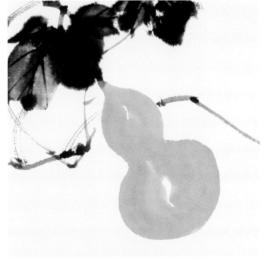

6 Outline the leaf veins with dark ink.

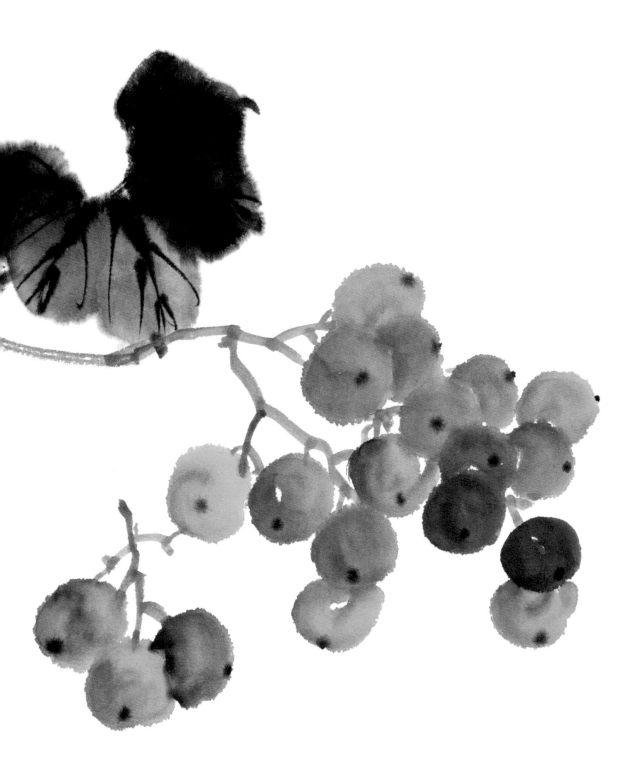

Grape

The grape is a popular fruit that comes in green or purple with translucent flesh. It is a common theme in Chinese painting. Since it grows in a cluster, it represents harvest and wealth, and a bunch of grapes is a symbol of having many children, so grapes are an auspicious motif in Chinese tradition.

1 Dip the brush into dark green and rouge to paint a round grape with two strokes, left and right. You can either leave a white dot in the middle or not.

2 Repeat the step to paint a few more grapes.

3 Add more grapes. Pay attention to the color variation and composition of the picture.

4 Paint another three grapes that are grouped together at the lower left.

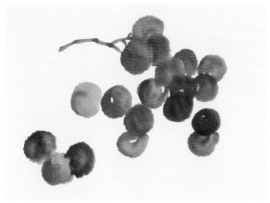

5 Mix ocher and ink to paint the stems to connect all the grapes.

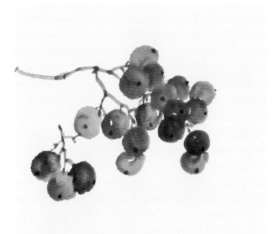

6 Add dots using ink for the grapes' stigma scars. Take the main stem as the center; add the dots on the right for the grapes on the right side and vice versa.

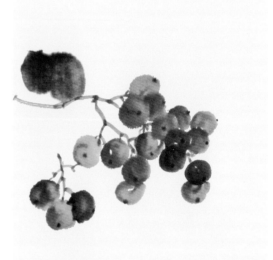

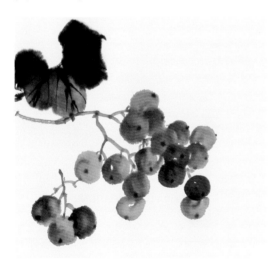

8 Outline the leaf veins with dark ink to complete.

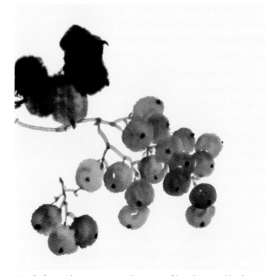

7 Refer to the painting techniques of bottle gourd leaf (see page 85), use ink to paint the leaves to form a stark contrast to the purple and green grapes.

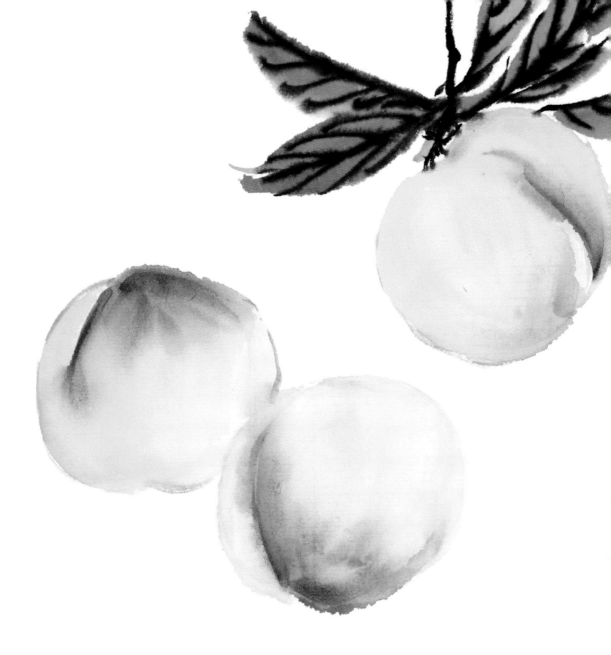

Peach

The peach has more than 3,000 years of cultivation history in China. It is juicy and delicious with a sweet smell and sweet-and-sour taste. There are many myths and legends about peaches in China. For example, the Queen Mother of the West invited all the gods to her birthday celebration. The main dish was peaches from her peach garden. These peach flowers needed 3,000 years to bloom and the peaches required 3,000 years to fruit. They had the power of immortality. The peach, therefore, is a symbol of prosperity and longevity, commonly used as an auspicious motif.

You can refer to the painting techniques of the loquat (see page 82) and the cherry (see page 80) with some adjustments to paint a peach.

1 Refer to the two-stroke painting techniques of other fruits to paint the rounded peach. Note that the two halves are uneven. Mix titanium white and gamboge to paint the right half and then the left half of the peach. Leave a depression between the halves.

2 Repeat the step to paint another peach on the upper left.

3 Add the third peach using the same technique.

4 Make an eosin stroke at the depression.

5 Use the centered-tip stroke to paint the top and bottom of the peach with eosin as the blush on the surface.

6 Outline a light eosin line along the edge. Be sure to leave a portion without an outline.

8 Outline the leaf veins with dark ink to complete.

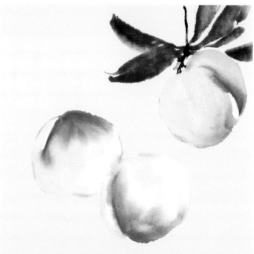

7 Add some leaves above the peach on the top right. Draw the branches with ink.

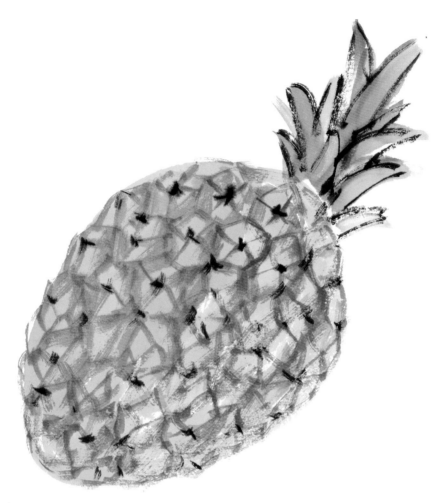

Pineapple

The pineapple is a tropical fruit with golden flesh and a sweet smell. Its juiciness and deliciousness make it a popular fruit around the world.

You can refer to the painting techniques of lychee skin (see page 77) to paint the pineapple skin.

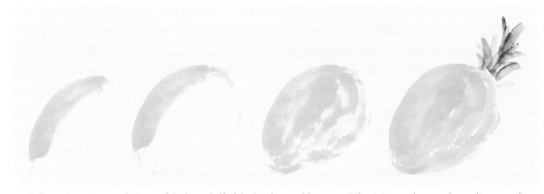

1 Refer to the painting techniques of the lower half of the bottle gourd (see page 85), mixing gamboge and vermilion to outline the oval shape of the pineapple first. Paint two strokes on the left side and one stroke on the right side. Color the oval and leave some white space. Use the centered-tip stroke to paint the dark-green leaves on top.

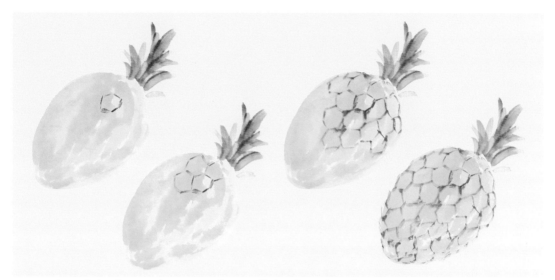

2 Mix ocher and ink, referring to the painting techniques of lychee skin, and draw hexagons attached to one another like a beehive. The hexagons in the center are regular whereas the side ones are flatter to portray a curved surface.

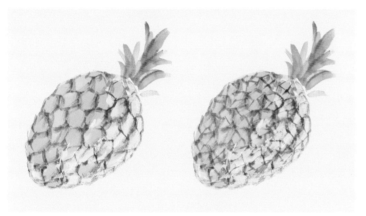
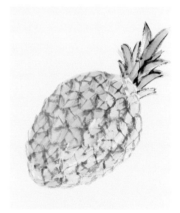

3 Touch up sideways with the remaining ocher on the surface to make it look rougher and create a more three-dimensional effect.

4 Outline the leaves with dark ink to highlight their shapes.

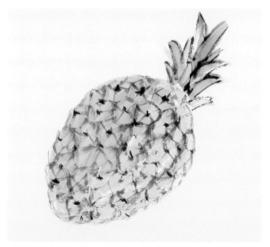
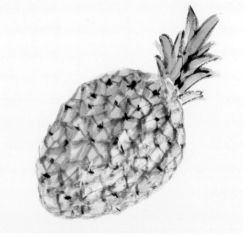

5 Mix ink and ocher to dot on the hexagons to mimic the thorns on the skin.

6 Add some dark green on the surface to manifest the greenish-yellow color of the pineapple.

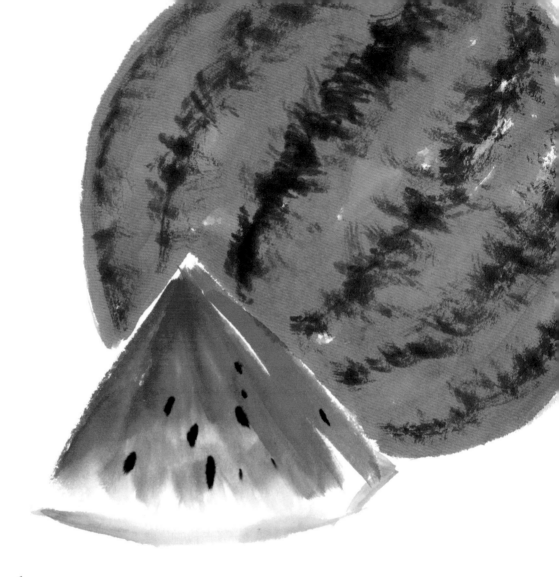

Watermelon

The watermelon is big and round with shiny skin and a striped rind. Its flesh is red, and its seeds are mostly black and oval-shaped. It grows on a trailing vine and one vine can have several fruits. Having a numerous quantity of seeds, the watermelon is used as a symbol of growth and having many children.

In this case is the illustration of the whole watermelon as well as a slice.

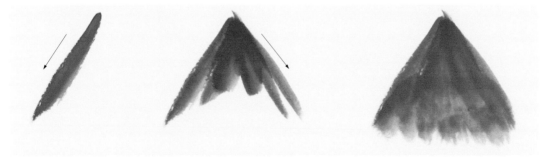

1 Dip the brush with eosin and use the centered-tip stroke to outline the triangular section with two strokes on each side. Fill the middle by pressing the brush into the paper. Add more strokes at the bottom. This is a triangular watermelon section.

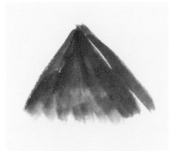 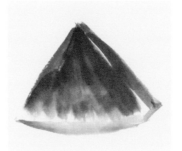 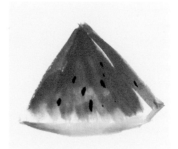

2 Add another stroke on the right. This is another facet of the section. Keep the two facets well-defined by not letting the paint bleed too much.

3 Then paint the dark-green rind. Draw one stroke at the bottom first and then the stroke on the side. Be sure to create an angle to enhance the three-dimensional effect.

4 Use dark ink to dot the seeds in a pattern radiating down from the tip of the triangular section.

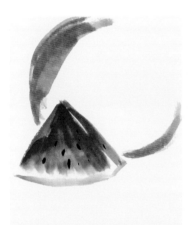 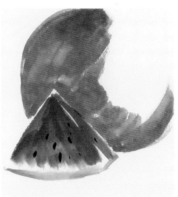 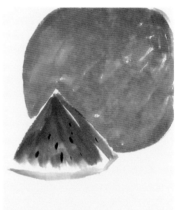

5 Paint the dark-green watermelon at the back. You don't need to fill the whole thing because of the overlapping perspective. Keep the brush tip outward and the brush belly inward to outline the watermelon with two strokes. Fill the watermelon with green. Remember to leave highlight and shade the ink tones to enhance the three-dimensional effect.

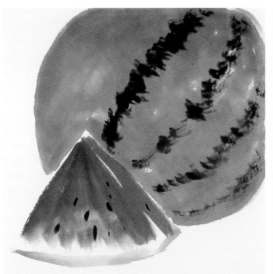 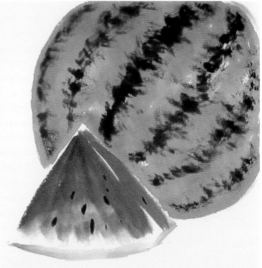

6 Paint the stripes with ink and touch up the veins on the rind in side-brush strokes. You can also use touch-up strokes to paint the striped veins directly to create a more natural effect. The watermelons are complete.

Bell Pepper

The pepper is a common vegetable on the dining table, and grows in various shapes and colors. The illustration here shows large, cylinder-shaped bell peppers with grooves and concavities on top.

1 Paint the dark-green (with more gamboge) stalk first.

2 Paint the dark-green (with more indigo) top. Be sure to leave the highlight.

3 Outline the bell pepper with two strokes up and down.

4 Fill it with dark green.

5 Add another stroke on top and leave some empty space in between with the strokes.

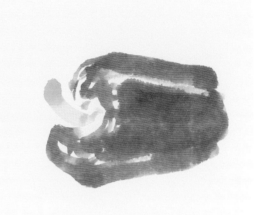

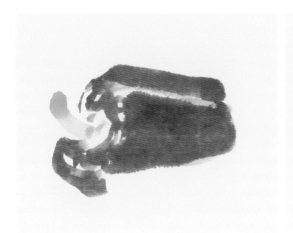

6 Add two more strokes at the bottom. The grooves of the bell pepper are well-defined.

7 Follow the previous steps to paint the dark-green stem. Mix vermilion and eosin to outline the top and left side of the red bell pepper.

8 Add two strokes on the right of the red bell pepper. Be sure to leave highlight.

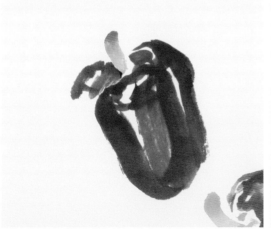

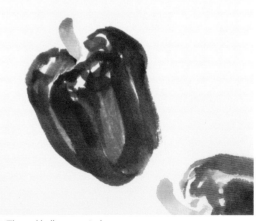

9 Add two strokes on the left, leaving the groove and the highlight. The red bell pepper is done.

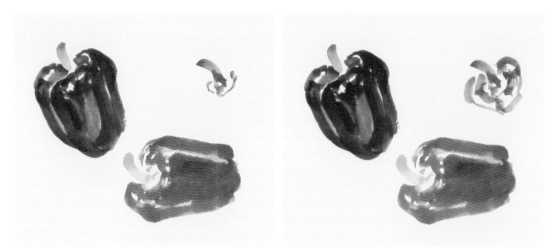

10 Create the third bell pepper on the right. Draw the green stalk and outline the top with a few strokes. Be sure to leave some highlight.

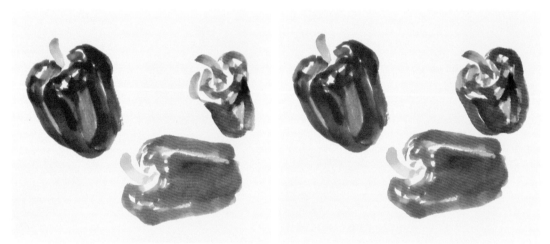

11 Use two strokes to outline the bell pepper first. Then add one stroke on either side to finish the green bell pepper.

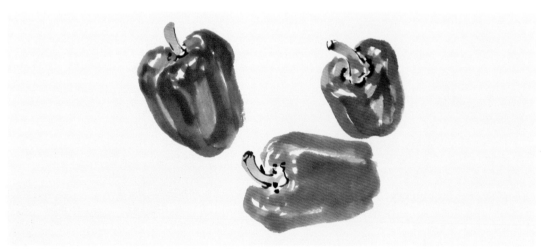

12 Outline the stems and calyxes with ink. Do not fill with color. Leave some gaps to make them look more natural.

Pumpkin

The pumpkin's orange-yellow color is delightful. It has a ribbed surface with grooves and the stem is strong. It grows on endless vines and has lots of seeds, and so is a traditional auspicious symbol of having many children, and continuous luck and wealth. The sweetness of its flesh denotes a happy life. In China, lots of handicrafts are made in the shape of pumpkins.

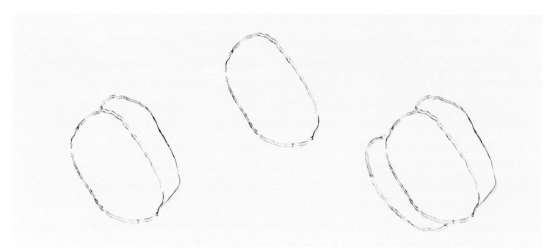

1 Use a slightly dry brush to outline the pumpkin section by section. Make an oval in the middle first and then the two sides.

2 Continue to outline the whole pumpkin with the slightly dry brush.

3 Use the charred brush to create the texture with touch-up strokes.

4 Paint the stalk with the charred brush. Refer to the painting technique of the bottle gourd leaf (see page 85) and paint the dark-green leaves at the bottom.

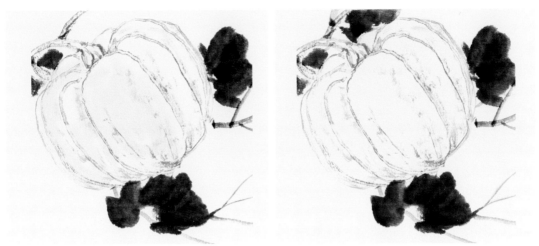

5 Add more leaves on the right and top left. Draw the vines with ink around the leaves to emphasize the intertwining effect. Add another leaf on the right of the stalk.

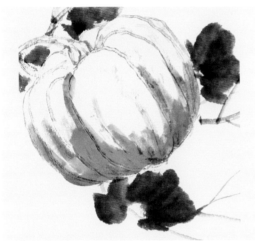

6 Mix gamboge and vermilion to paint the bottom of the pumpkin.

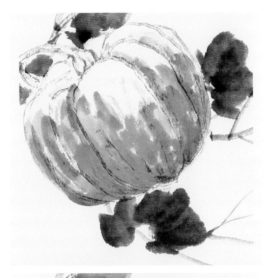

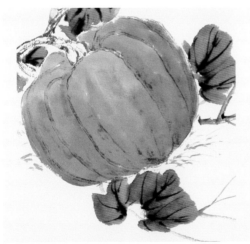

8 Add some dark-green grasses at the bottom and on the left of the pumpkin to complete.

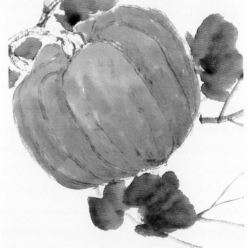

7 Continue to paint the pumpkin toward the top.

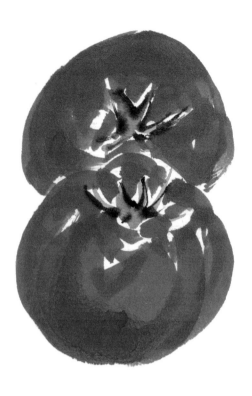

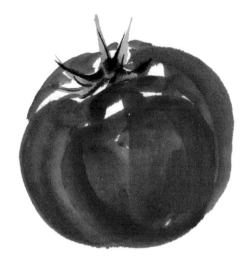

Tomato

The tomato is a red or orange sphere or oblate sphere. Its smooth surface and tender, juicy flesh make it a very popular fruit. When painting the tomato, pay attention to the sheen on the surface. It requires a certain skill to achieve the lifelike texture.

1 Draw the dark-green sepals.

2 Mix vermilion and eosin to paint the top of the tomato with two strokes. Add two strokes in the middle to emphasize the highlight.

3 Use two strokes on the left and right to outline the tomato.

 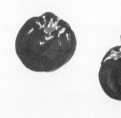

4 Color the tomato. Add two more strokes, one on each side, to make it flatter. Be sure to leave highlight.

5 Add one more stroke above the sepals to complete the whole body.

 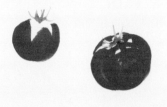

6 Repeat the steps to paint another tomato.

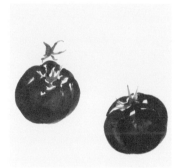 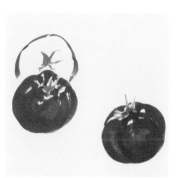 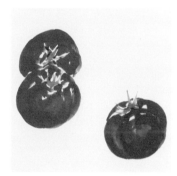

7 Paint the sepals to define the position for the third tomato above the second one.

8 Due to the different orientation, the painting technique of the third tomato is different. Outline a circle first.

9 Fill the tomato, leaving highlight.

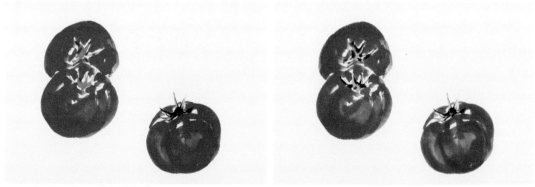

10 Outline the sepals in dark ink to complete.

3. How to Paint Grass Insects

Caochong (grass insect) painting is a sub-genre of bird-and-flower painting. It has a wide range of objects including crustaceans, mollusks, reptiles, amphibians and fishes. *Caochong* are tiny but structurally complex creatures. It is not easy to do them justice in a vivid portrayal. Beginners must assiduously practice drawing from life. Only when learners have acquired a feel for the physical shape, anatomy, colors, dynamics, habits and characteristics of these animals are they equipped to face the challenging process of painting these animals.

In the *xieyi* style of *caochong* painting, the pictorial composition, colors, strokes and ink use should be kept simple. Focus should be on just a few essential physical components. Basically, the artist is expected to paint one component in one neat stroke without revisiting or being bothered with trivial details. The main thing is to communicate the animal's lively spirit.

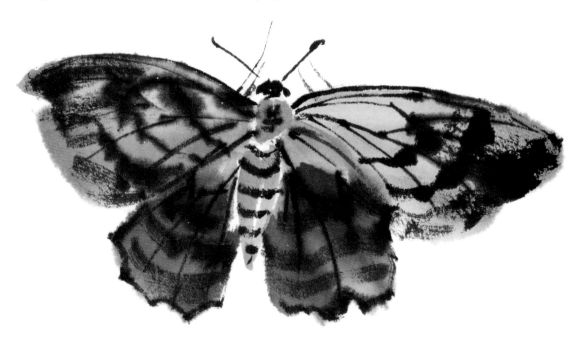

Butterfly

A butterfly usually ranges from 5 to 10 centimeters in length. The body is divided into three sections: head, thorax and abdomen. It has three pairs of legs and two pairs of wings. The abdomen is long, and there's a pair of hammer-shaped antennae above the head. The wings are vertically held above the body when resting. There are lots of Chinese paintings with butterflies as a theme. For example, *Butterflies Playing in the Sunny Spring* by Song Dynasty painter Li Anzhong is composed of 15 butterflies and one wasp. The simple outlines vividly illustrate the scene of butterflies playing.

People love butterflies for their charming appearance, and traditional Chinese literature always depicts butterflies in pairs as a symbol of sweet love and blissful marriage.

1 You can sketch with a pencil first. Paint the light-ocher and ink wing with two strokes.

2 Add another two strokes on the other side as the second wing. A pair of wings is done.

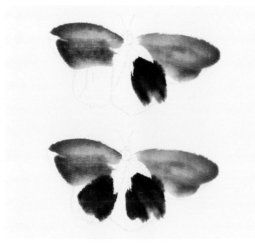

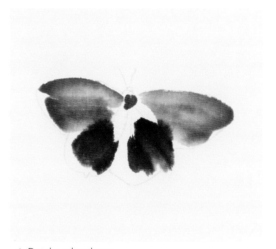

3 Refer to the previous steps; paint a pair of hindwings with ink to contrast with the forewings.

4 Dot the ocher thorax.

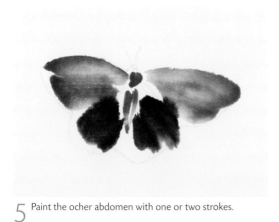

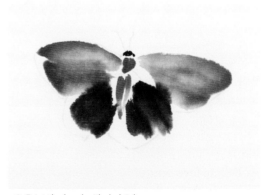

5 Paint the ocher abdomen with one or two strokes.

6 Paint the head with dark ink.

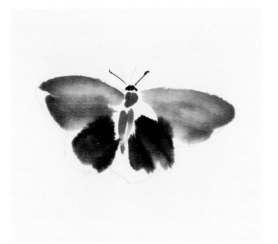

7 Paint the antennae with dark ink.

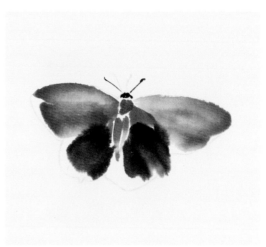

8 Dot vermilion and eosin onto the wings.

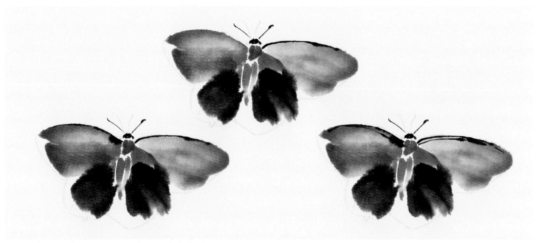

9 Outline the forewing's top edges with dark ink.

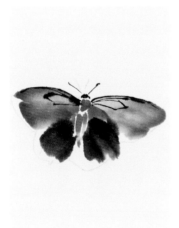

10 Draw a pair of hexagons on the forewings.

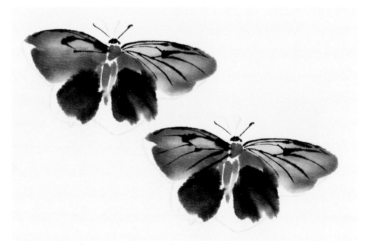

11 Draw the forewing patterns and be sure the patterns on the two wings are symmetrical.

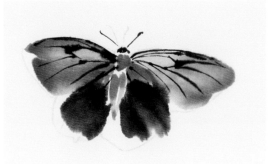

12 Repeat the steps to paint the patterns on the hindwings.

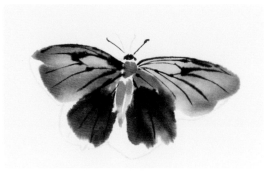

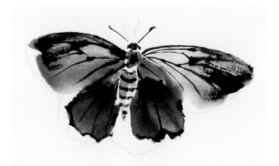

13 Draw the segments on the abdomen.

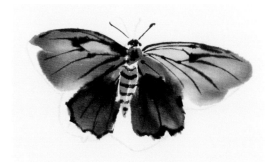

14 Outline the hindwings' bottom edges with ink.

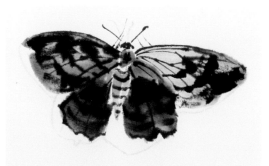

15 Touch up the wings with dark ink.

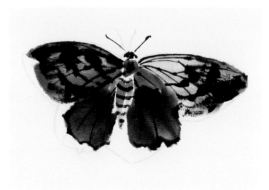

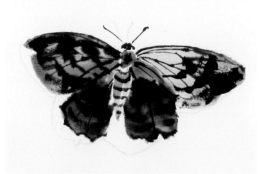

17 Draw feet near the antennae, two on each side. The butterfly is complete.

16 Paint the stripes on both pairs of wings with dark ink.

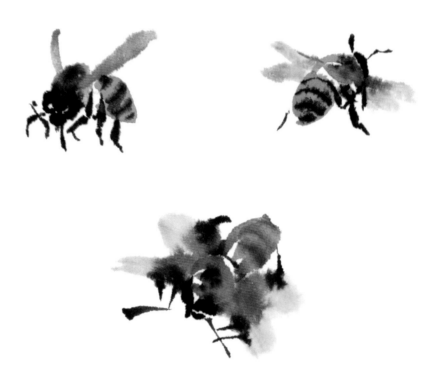

Bee

A bee usually ranges from 8 to 20 millimeters in length. It is yellowish-brown or black-brown and covered with hairs. The head and thorax are almost the same width, and the bee has antennae and mouthparts. The hindlegs are pollen-carrying legs; the forewings are bigger than the hindwings. The abdomen is like an elongated egg with a stinger at the end, which is too small to be drawn.

In this section, we will introduce three types of bees: a standstill bee, a bumblebee and a flying bee. Take care to paint the correct proportions, which is difficult because of the bees' small size.

Standstill Bee

Notice the color combination and painting techniques of the wings.

1 Dot the ocher thorax.

2 Dot the gamboge abdomen.

3 Paint the head, eyes, and mouthpart with dark ink.

4 Dye the thorax and paint the abdomen stripes with dark ink.

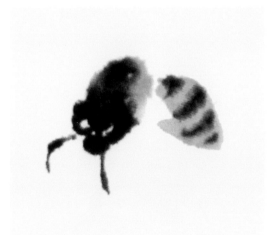

5 Paint the pair of antennae with dark ink.

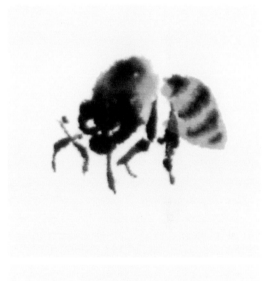

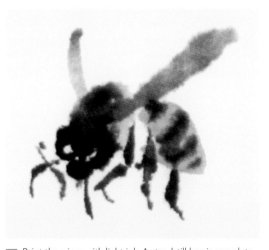

7 Paint the wings with light ink. A standstill bee is complete.

6 Draw the legs with dark ink; the upper part is thicker than the lower part. The hindlegs are the thickest.

Bumblebee

A bumblebee is covered in hair. It is big with a colorful body. In this section, we will paint the bumblebee from the back side and adjust the positions of other body parts to fit.

1 Paint the gamboge thorax and head.

2 Paint the azurite abdomen.

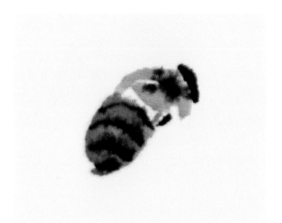

3 Add ink dots on the head and thorax. Outline the head on the side, and then paint the abdomen stripes.

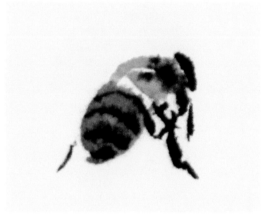

4 Refer to the leg painting of the standstill bee to paint the bumblebee's legs. Pay attention to the different sizes.

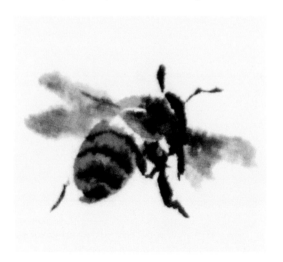

5 Draw the pair of antennae. Paint the two pairs of wings with light ink; each pair forms a Y-shape. The bumblebee is complete.

Flying Bee

The key to painting a flying bee is showing wing movement with brushstrokes and ink. We will paint from a bird's eye view.

1 Paint the ocher thorax and head. With a bird's eye view, this is the back of the body.

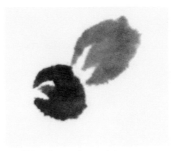

2 Paint the gamboge abdomen.

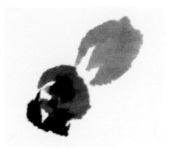

3 Paint the head with dark ink.

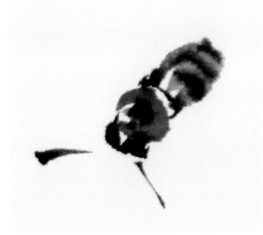

4 Paint the back and abdomen stripes and the antennae with dark ink.

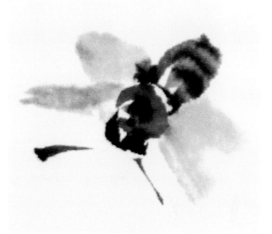

5 Paint the four wings with light ink.

6 Dot ink on the wings close to the body.

7 Paint the legs to complete.

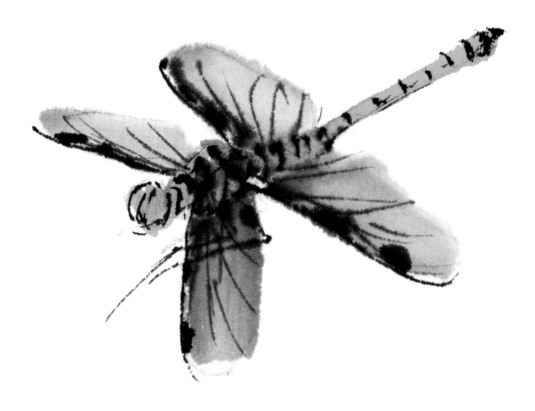

Dragonfly

A dragonfly has a slightly large body with long, narrow membranous wings. The compound eyes are the biggest parts of the head, there are also three simple eyes and a pair of antennae. The prothorax is small, whereas the mesothorax and metathorax are fused. The abdomen is long and segmented. The legs are long and delicate, located near the head. From an artistic perspective, many of the details can be modified to produce a more interesting painting.

1 You can start with pencil sketching. Paint the dark-green (with more gamboge) head.

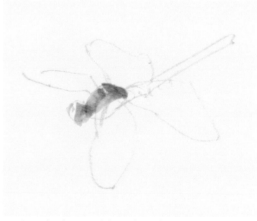

2 Paint the thorax and the surface of the back.

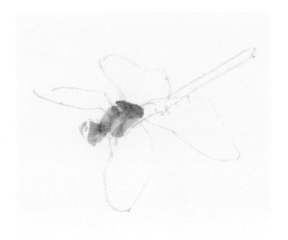

3 Continue to paint the thorax.

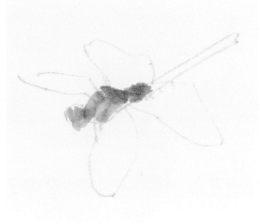

4 Paint the abdomen.

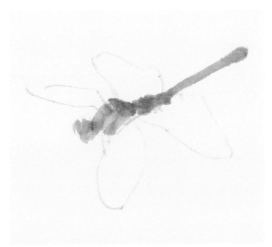

5 Continue to paint the abdomen and the tail.

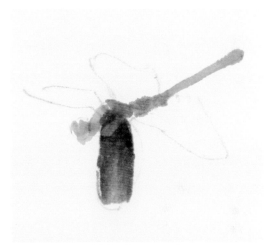

6 Paint a wing with light ink in one stroke.

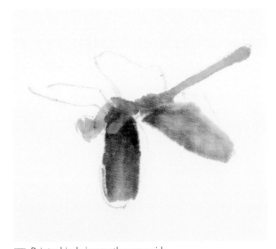

7 Paint a hindwing on the same side.

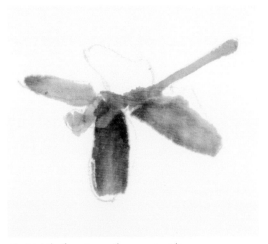

8 Paint the forewing on the opposite side.

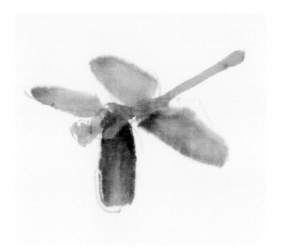

9 Paint the hindwing on the opposite side.

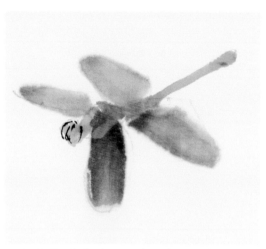

10 Outline the head, eyes and mouthparts with ink.

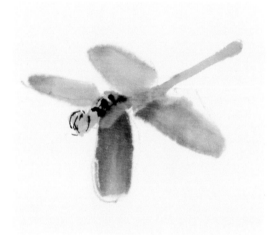

11 Draw the stripes on the back with dark ink.

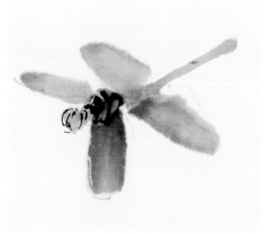

12 Paint the lateral side of the thorax with dark ink.

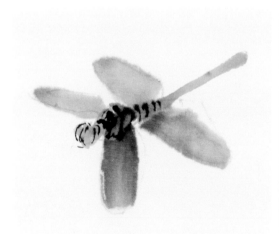

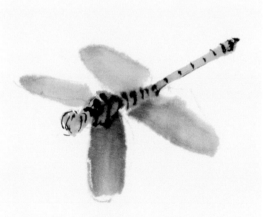

13 Continue to paint the back and the abdomen with dark ink. Note that the stripes on the abdomen and the tail are more separated.

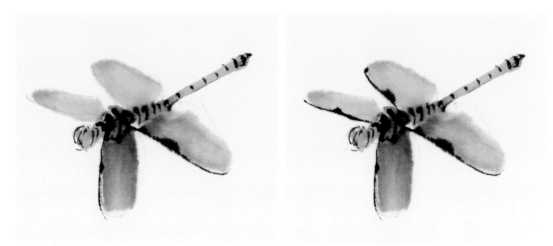

14 Outline the edges of the wings with dark ink. Pause in the middle to let the ink bleed slightly to form the nodi.

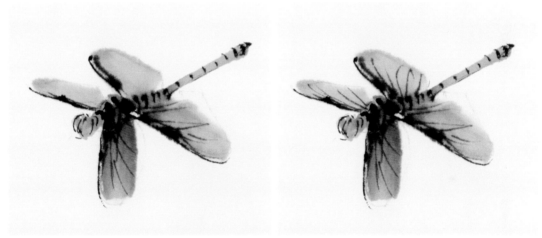

15 Draw the veins on the wings. The veins must be delicate since the wings are very thin.

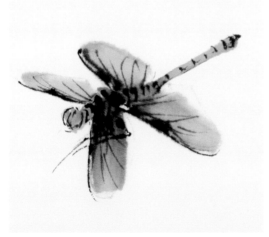

16 Paint legs that are thin and pointed. Pay attention to the joints.

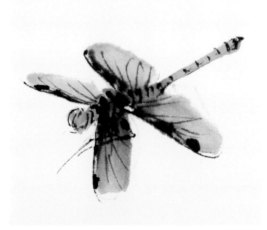

17 Add dots on the wings as the pterostigmata to complete.

Goldfish

The goldfish originated in China, bred from crucian carp as an aquarium fish. It looks like carp but without the barbels. There are various species and colors, including red, orange, purple, blue, black and silver. In Chinese, fish is a homophone of "surplus"; therefore, the fish has a meaning of "surplus year after year." In Chinese New Year, people like to have a couple of goldfishes at home as a wish for prosperity.

Among all the species, we have selected three to be studied below. Some are like crucian carps; some have bubble eyes. Be sure to portray the movement and different shades of the body. Do not create a mechanical fishtail.

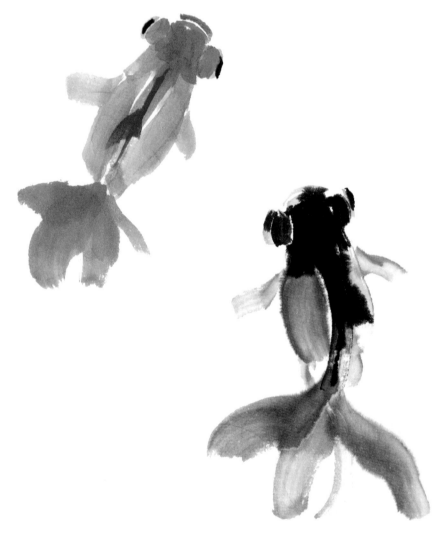

Dragon-Eye Goldfish

The dragon-eye goldfish is a popular species in the goldfish family. It has protruding eyes and double tails. In this section, we will paint two fishes of different colors from a bird's eye view.

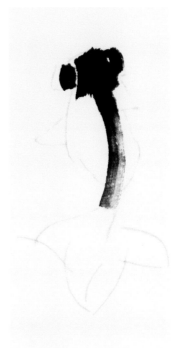

1 You can sketch with pencil first. Paint the head with dark ink.

2 Use dark ink to paint the eyes with two strokes, one on the left and one on the right.

3 Make a stroke starting from the head and running along the dorsal fin.

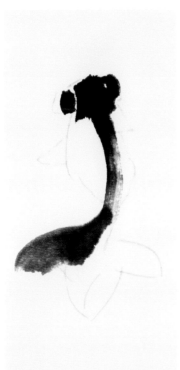

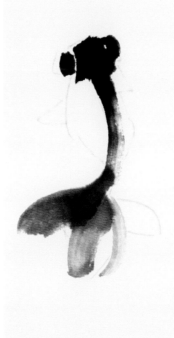

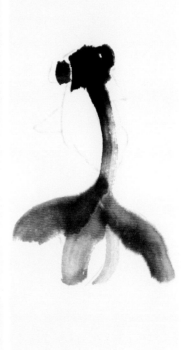

4 Paint the tail with four strokes; the ink becomes lighter gradually.

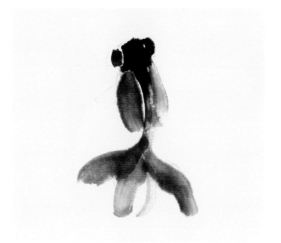

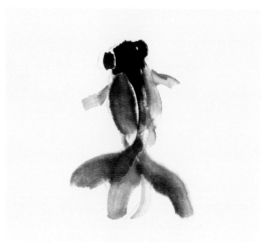

5 Add two strokes on the sides with light ink to finish the body.

6 Paint a pair of fins.

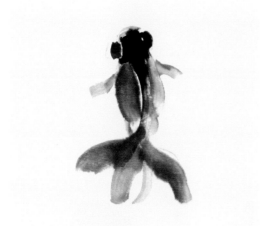

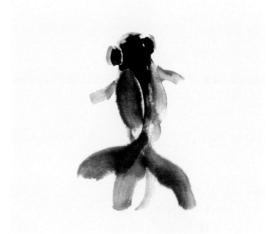

7 Paint the mouth with light ink.

8 Mix gamboge and vermilion to paint the eyeballs.

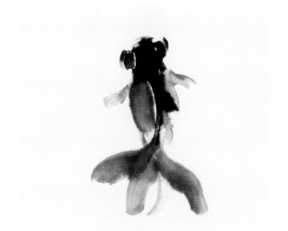

9 Dot the eyes with dark ink. Paint the dorsal fin with dark ink. The black dragon-eye goldfish is complete.

10 Repeat the steps to paint the red dragon-eye goldfish. Mix vermilion and eosin to paint the head.

11 Paint the eyes.

12 Paint the body with one stroke.

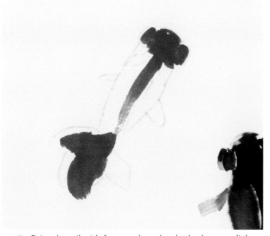

13 Paint the tail with four strokes; the shades become lighter and lighter.

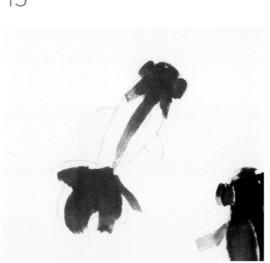

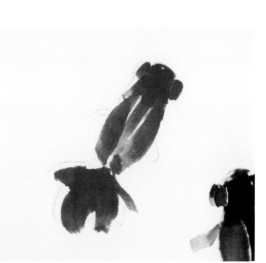

14 Add two strokes, one on each side, to paint the light-red body in diluted ink.

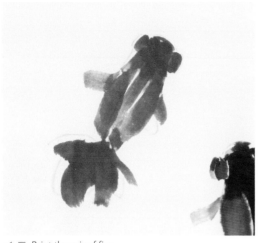

15 Paint the pair of fins.

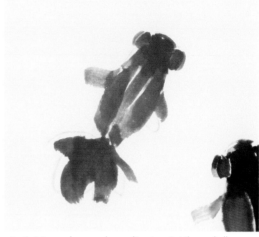

16 Mix gamboge and vermilion to paint the eyeballs.

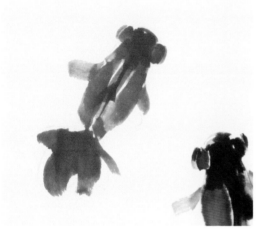

17 Paint the red dorsal fin.

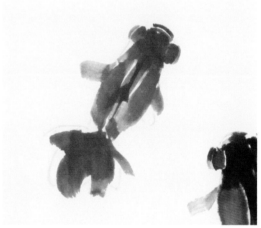

18 Paint the mouth with ink.

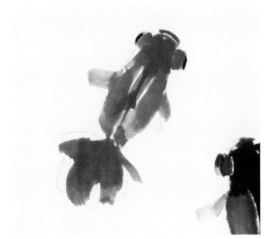

19 Dot the eyes with ink at last.

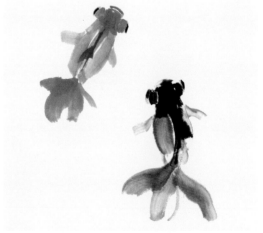

20 The dragon-eye goldfishes are complete.

Butterfly Tail

The butterfly tail has red, black, white, blue and yellow spots and stripes on body. It has colorful fins and protruding eyes. In this section, we will paint the butterfly tail from a side view.

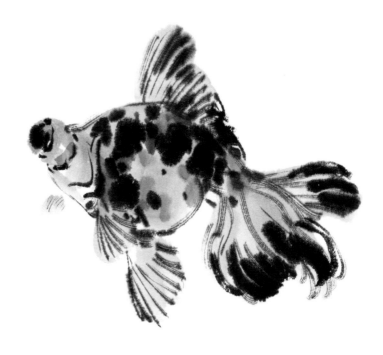

1 Paint the protruding eye with light ink.

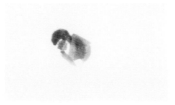

2 Paint the head.

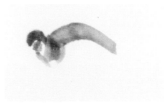

3 Paint the back with one stroke.

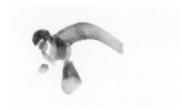

4 Paint the pair of pectoral fins; the front one is bigger than the back one to show perspective.

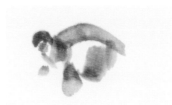

5 Paint the belly with light ink.

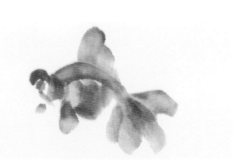

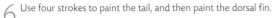

6 Use four strokes to paint the tail, and then paint the dorsal fin.

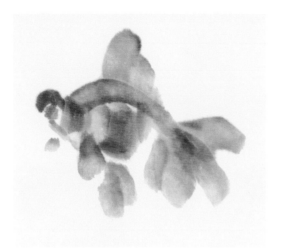

7 Paint the pelvic fins at the bottom with two strokes.

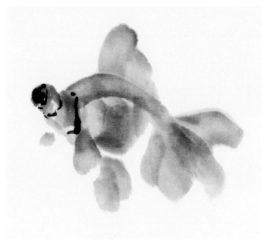

8 Paint the eye and outline the gill with dark ink.

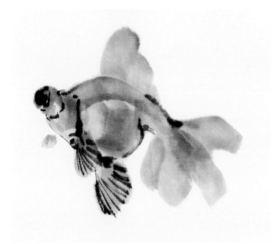

9 Outline spines on the fins with dark ink.

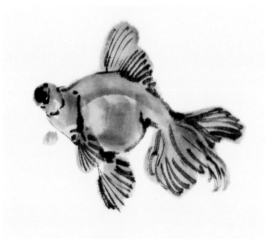

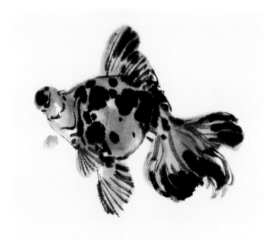

10 Dot spots on the fish body with dark ink.

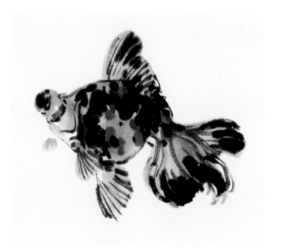

11 Dot eosin, rouge and gamboge spots on the body to complete.

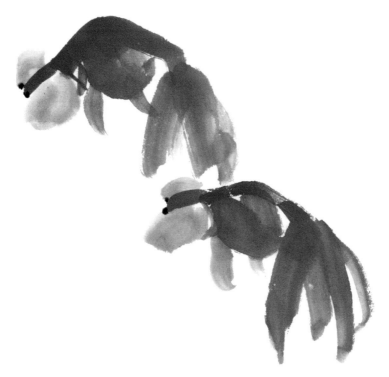

Bubble-Eye Goldfish

The bubble-eye goldfish has a dominant characteristic: the large fluid-filled sacs under the eye sockets. This is the key focus when painting the fish. In this section, we will paint two bubble-eye goldfishes from a side view using the *xieyi* style. Be sure to capture the form using simple strokes.

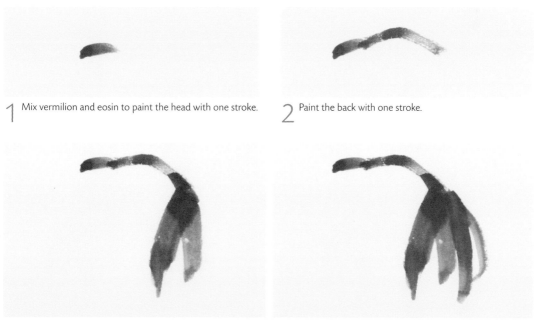

1 Mix vermilion and eosin to paint the head with one stroke.

2 Paint the back with one stroke.

3 Use four strokes to paint the tail.

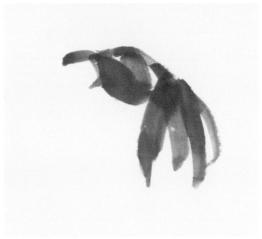

4 Paint the gill.

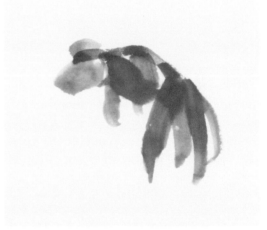

5 Use two centered-tip strokes to paint the body. The color on the brush is getting lighter.

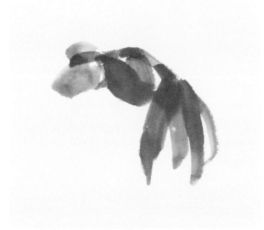

6 Dip the brush into water and paint the light-eosin eyes, making the front eye bigger than the back eye.

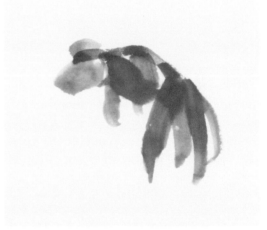

7 Use the remaining color on the brush to paint the pectoral fins. The first bubble-eye goldfish is complete.

8 Repeat the steps to paint the other fish. Start with the head.

9 Then paint the body.

10 Use three strokes to paint the tail. One tail is not shown because of the side perspective view.

11 Use the centered-tip stroke to paint the belly.

12 As the color on the brush gets lighter, paint the pair of pectoral fins.

13 Use the remaining color on the brush to paint the bubble eyes. Again, the front one is bigger than the back one.

14 Dot the eyes with dark ink to complete.

Carp

The carp is a type of aquarium fish. It has many patterns and colors, the main colors being white, yellow, orange, red and black. Some even have a luster. The carp has a long breeding history in China. It was the ornamental fish for royals and nobles in early days and gradually became available to the ordinary people. There is a folktale of *Carp leaping over the Dragon Gate*, telling how the carp would become a dragon when it leaped over the Dragon Gate. This teaches us that hard work leads to success. Thus, the carp is an auspicious symbol.

In this section, we will introduce two carp painting techniques.

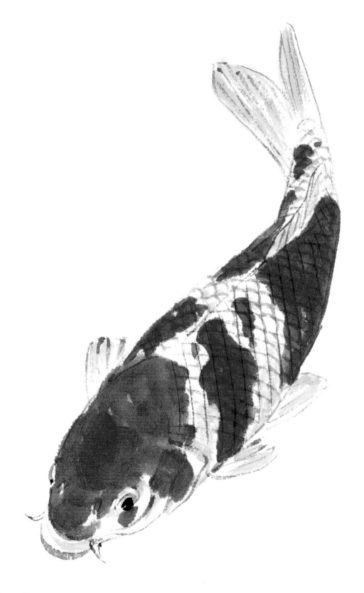

Carp Type I

First is the traditional carp painting techniques. We will paint a red-and-white carp from the front view.

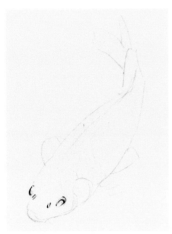

1 Roughly outline the carp with a pencil. Use light ink to paint the eyes.

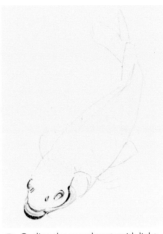

2 Outline the mouthparts with light ink.

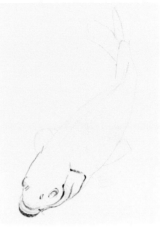

3 Outline the gills with light ink.

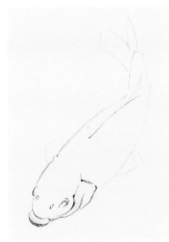

4 Outline the back with light ink.

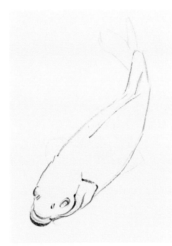

5 Outline the body with light ink.

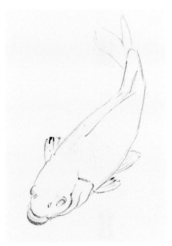

6 Outline the pair of pectoral fins and a pelvic fin with light ink.

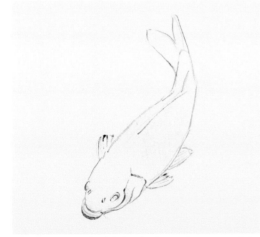

7 Outline the tail with light ink. The rough structure of the carp is done.

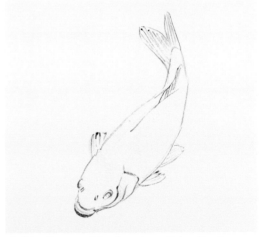

8 We will start outlining the patterns. First, outline the stripes on the tail.

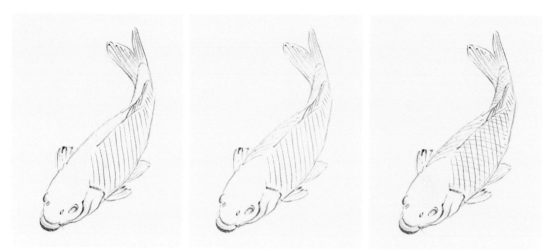

9 Draw oblique lines on the body. They are in the opposite direction on the other side of the body. Then paint diagonal lines to form the scales.

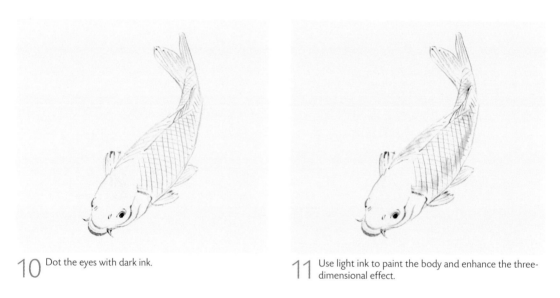

10 Dot the eyes with dark ink.

11 Use light ink to paint the body and enhance the three-dimensional effect.

12 Add curved lines on the scales to make them more rounded.

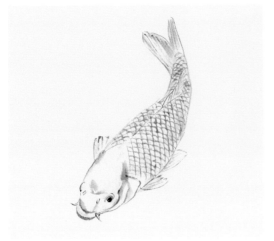

13 Dye the head with light ink.

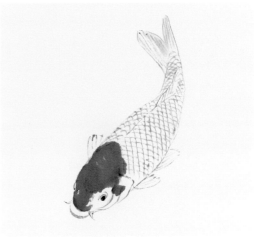

14 Mix vermilion and eosin to color the head.

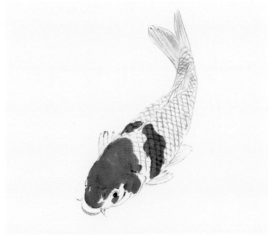

15 Then paint the patterns on the body.

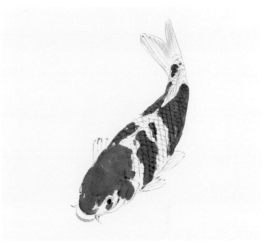

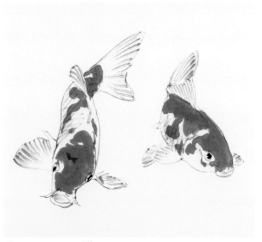

16 Dye the tail and fins with ocher to complete.

These are carps in different postures.

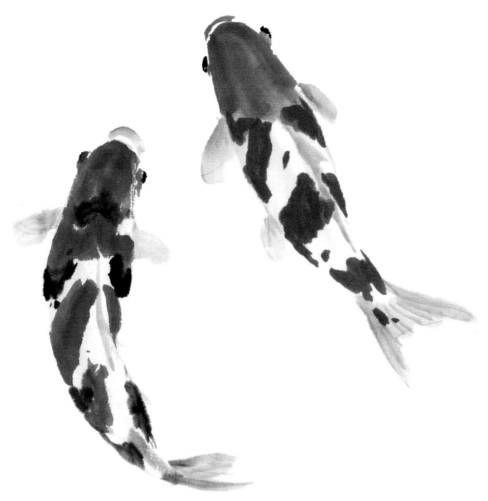

Carp Type II

The preceding carp painting technique focuses on details, even outlining the body pattern. This second one is a more *xieyi*-style technique, which produces a completely different effect.

1 First, paint the fish on the left. Mix light ocher and ink to paint the head.

2 Paint the body with light ink.

3 Paint the tail with light ink.

4 Paint the pectoral fins from a bird's-eye perspective.

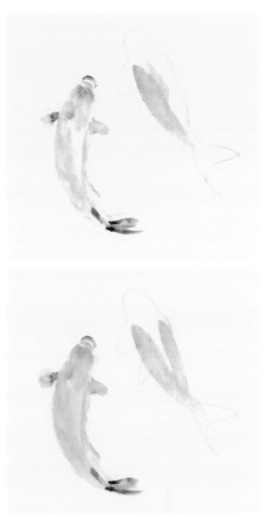

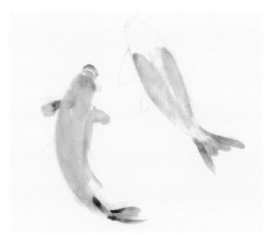

6 Paint the light-ocher and ink tail with four strokes.

5 Next, paint the fish on the right. Paint the light-ocher and ink body with two strokes and add another stroke in the middle.

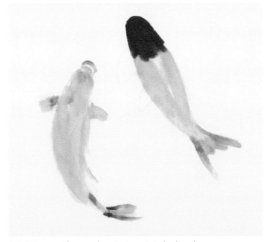

7 Mix vermilion and eosin to paint the head.

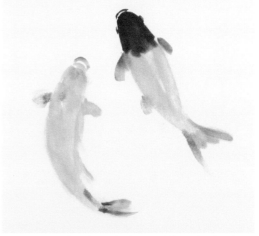

8 Paint the light-ocher and ink pectoral fins and pelvic fin.

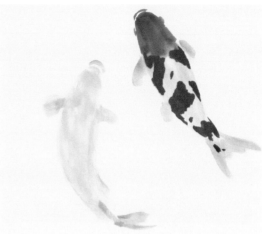

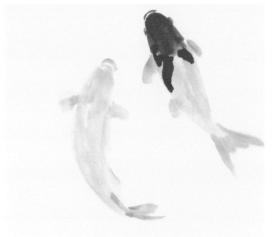

9 Mix vermilion and eosin to dot the patterns.

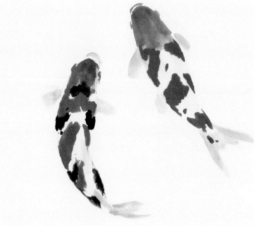

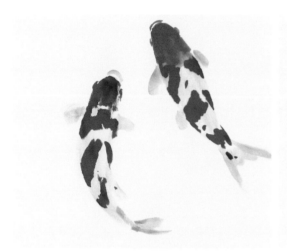

10 Repeat the step to paint the black and red patterns on the left fish.

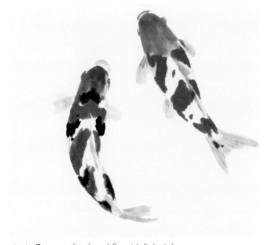

11 Deepen the dorsal fin with light ink.

12 Dot the eyes with ink to complete the two fishes.

Angelfish

The angelfish is a type of tropical fish with elongated triangular dorsal and anal fins. It is usually 12 to 15 centimeters long and 15 to 20 centimeters high. The pelvic fins have developed into a long antennae-like fringe. The caudal fin is relatively shorter with extensions on the top and bottom. The fish can be divided into long-tailed, medium-tailed and short-tailed varieties. Their pectoral fins are transparent. Looking at the angelfish from the side, you can see that it swims like a flying swallow, elegant and calm.

In this lesson, we will paint an angelfish from the side perspective.

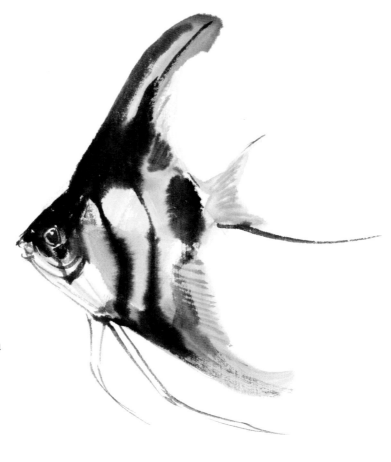

1 Paint the back with a downstream stroke in ocher and ink.

2 Very gently draw a diamond.

3 Use light ink to paint the body with two strokes, but do not fill it in.

4 Dip the brush into ink, and paint the anal fin in a triangular shape.

5 Paint the tail.

6 Mix gamboge and vermilion to color the body.

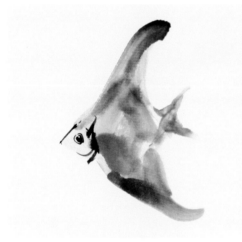 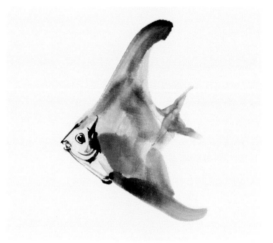

7 Outline the head and draw the eye with dark ink.

8 Outline the mouthparts with dark ink.

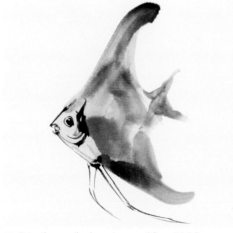 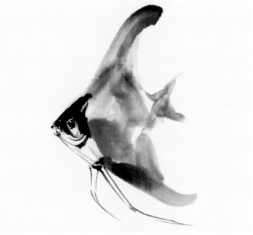

9 Paint the needle-shaped pectoral fins with ink.

10 Paint the head and cheek with dark ink.

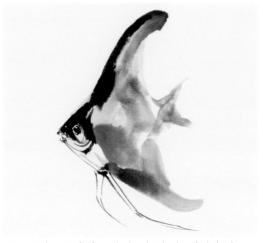

11 Make a stroke from the head to back with dark ink.

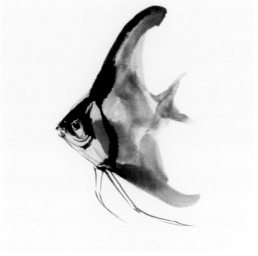

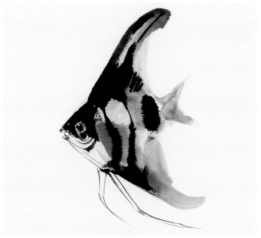

13 Paint a stripe near the tail.

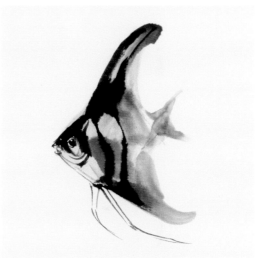

12 Paint the body patterns with dark ink.

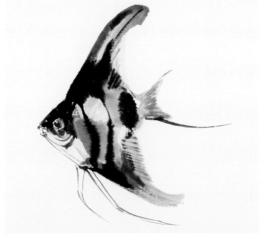

14 Paint the extension on the tail and spines on all fins.

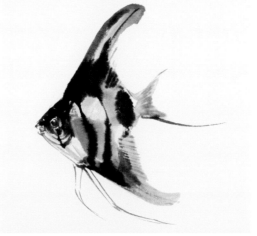

15 Add golden yellow on the eye by mixing gamboge and vermilion to complete.

Crab

Crab is a type of crustacean with a symmetrical body and a hard shell. It has a pair of pincers and four pairs of legs. It has an interesting movement, typically walking sideways. The claws are strong to firmly hold things and not easy to let go, which represents keeping money securely, and the eight legs imply achieving wealth from all directions. Crab, therefore, is a symbol of prosperity.

This lesson will present the painting techniques of two kinds of crabs, one still active in the water and the other cooked.

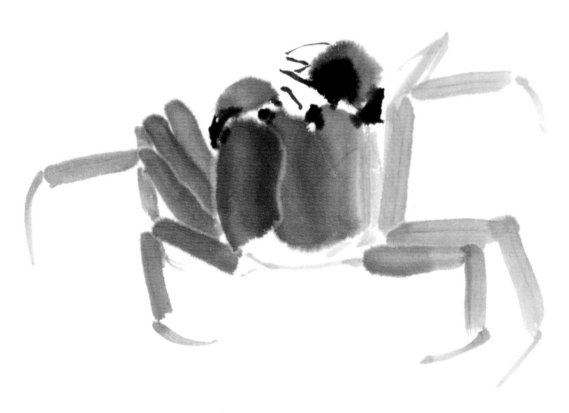

Live Crab

Pay extra attention to the use and shades of ink since this is a monochromatic painting.

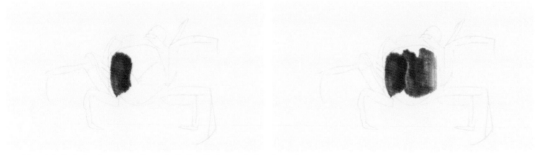

1 Use slightly dark ink to paint the crab shell with three side-brush strokes.

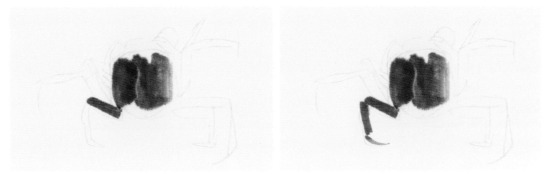

2 Use a centered-tip stroke to paint a leg. It has three segments; the first section is the thickest and the last section is the slimmest.

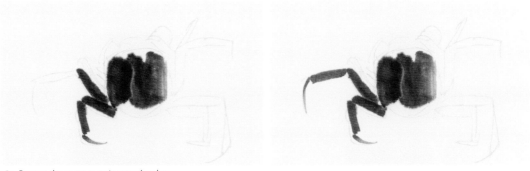

3 Repeat the steps to paint another leg.

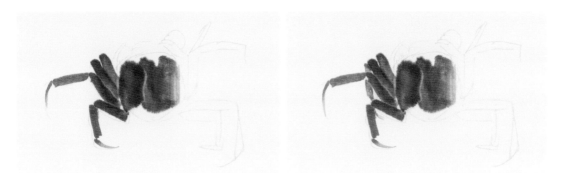

4 Paint the other two legs. You don't need to paint the whole legs since they are folded. Pay attention to the position and orientation of the four legs.

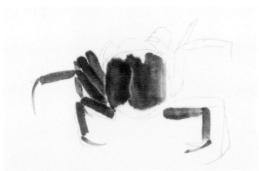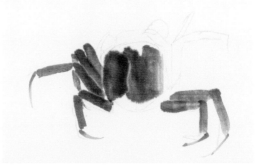

5 Paint the four legs on the right. As in the preceding steps, start with the first leg. Note the difference of the position.

6 Paint a second right leg that slightly overlaps the first leg.

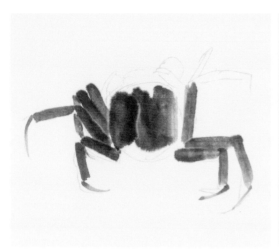

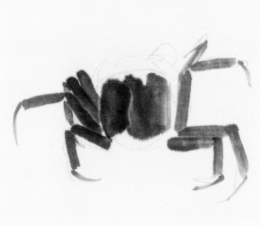

7 Paint the remaining two legs. Note the variations on the second and the last segments.

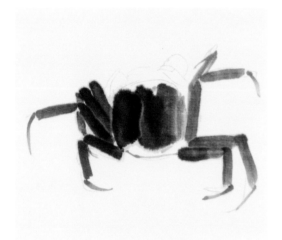

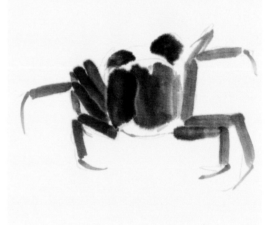

8 Paint the bottom edge of the shell with light ink.

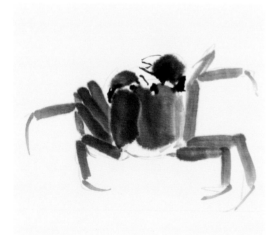

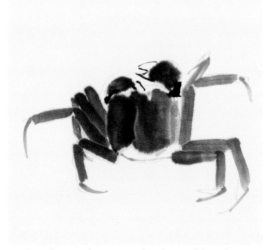

10 Dot the eyes of the crab on the upper edge with ink to complete.

9 Paint the pair of pincers. Outline the tip of the right one.

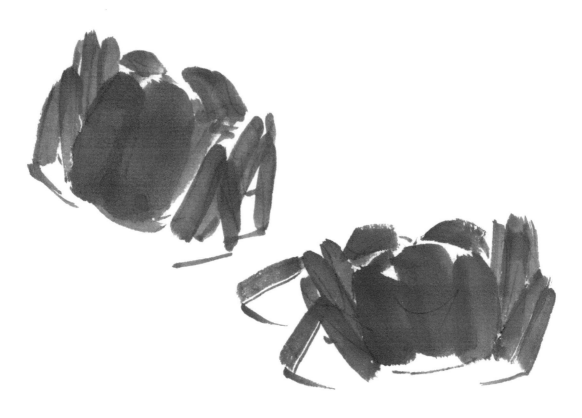

Cooked Crab

The main difference between the live and the cooked crabs is the color. The cooked one is red, so we use vermilion to paint it.

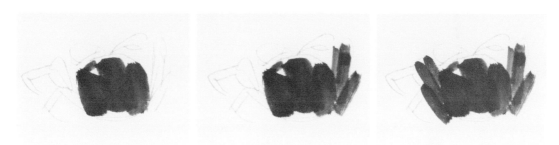

1 Refer to the live crab painting techniques to paint the vermilion shell with three strokes. Then paint the first segments of the eight legs.

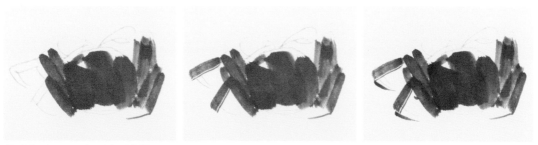

2 Paint the second and the third leg segments.

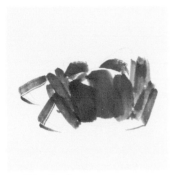

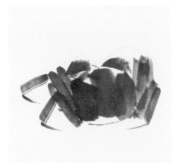

3 Paint the pincers.

4 Add one stroke on the bottom edge of the shell.

5 Create another crab on top. First, paint one leg.

6 Paint the other three legs. Pay attention to the orientations.

7 Use side-brush strokes to paint the shell.

8 Paint the four legs on the other side. Note that they are all folded. Then paint the pincers.

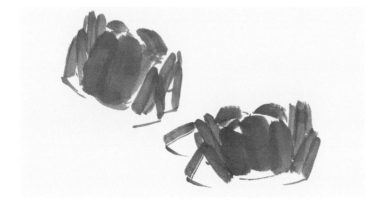

9 The cooked crabs are complete.

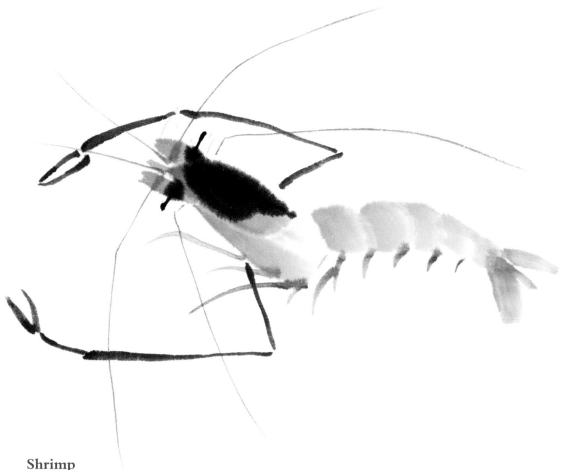

Shrimp

The shrimp has a flat, elongated body with a head and an abdomen. There are seven abdominal segments, but presenting five is enough for a painting. The sharp head has a pair of compound eyes and two pairs of antennae. The walking legs are below the head while the swimmerets are under the abdomen. The tail consists of the uropods and telson. Understanding its structure can help us paint a lifelike shrimp.

Qi Baishi (1863–1957) is one of the most famous shrimp painters in China. Under his brush, shrimps are lively and smart-looking. They look like they are playing and swimming in the clear river though there is nothing in the background. Even the antennae look as if they are dancing.

In this lesson, we will learn the basic shrimp-painting techniques.

1 Use one centered-tip stroke to paint the head with light ink.

2 Add one more stroke to finish the head.

3 Paint two antennae on the head.

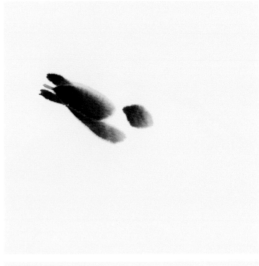

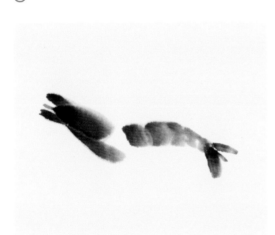

5 To paint the tail, add a stroke in the middle and then two strokes on two sides to form the tailfan.

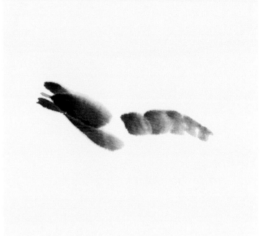

4 Use side-brush strokes to paint the abdominal segments. Be sure the upper edge forms an arc.

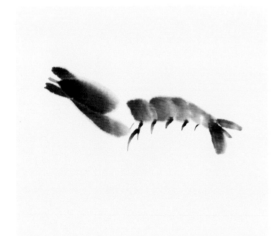

6 Draw five pairs of swimmerets, decreasing in length from left to right.

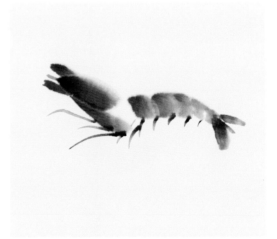

7 Add pairs of walking legs. Pay attention to the orientations and lengths.

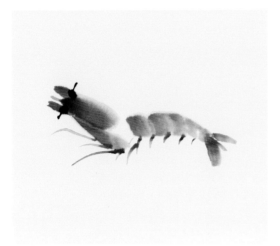

8 Paint the eyes with dark ink.

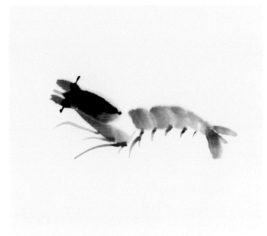

9 Paint the brain with dark ink.

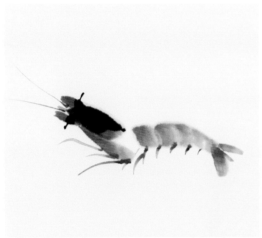

10 Paint the first two antennae extending forward.

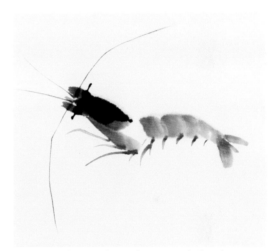

11 Paint the second pair of antennae, which are longer, on the sides.

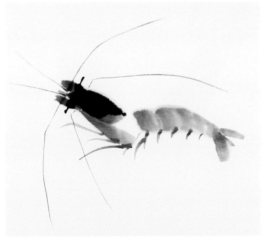

12 Paint the last pair of antennae pointing to the back.

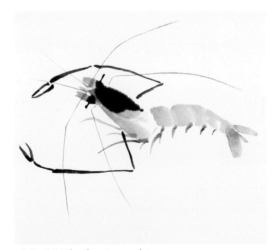

13 Paint the claws to complete.

4. How to Paint Birds

All birds are physically egg-shaped. Start with an egg form in its characteristic perspective, add the head, neck, wings, tail, legs and feet to the appropriate spots of the ovoid, and you have a basic painting of a bird.

The fully-deployed wing of a bird consists of two parts: the fan-shaped primary flight feathers and the trapezoidal secondaries. Bird flight is largely dependent on the wing feathers; they are functionally more complex than the plumage on the bird's back. An important principle in the *xieyi* style of flower-and-bird painting is to avoid overdoing a brush stroke if one single stroke of the brush can do the job. When painting birds, the bird's body language must be accurately captured; select the poses and the body angles with an artist's eye toward enhancing the aesthetics of the painting. A well-executed tail is essential to a vivid portrayal of a bird.

A basic technique in bird painting employs the *simao* (feather-edging) stroke, which will be introduced below.

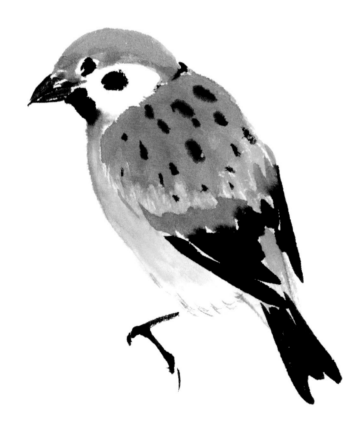

Sparrow

Sparrows are small and live everywhere. Their main characteristics are a black throat, brown head, and dark spots on white cheeks. Their wings are short and round and their beaks are short, thick, strong and conical in shape. Sparrows are very common in our daily life. More observations will help us paint better.

How to Paint a *Simao* Stroke and Feathers

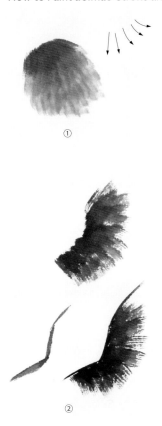

①

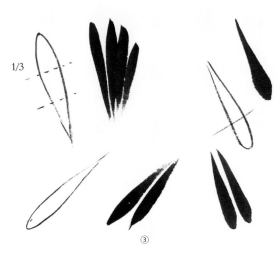

1/3

③

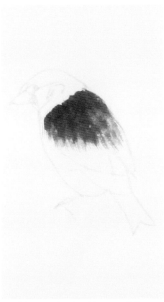

②

A basic technique in bird painting employs the *simao* (feather-edging) stroke: First the brush is pressed open in the palette. With the brush tipped with thick ink and the direction of the brush unchanged, the feather-edging should have a radiating look. Note the variation in shape and size and the progression from darker to lighter ink tones (①). The edge of the wing should have a smooth and even finish. It is a good idea to outline the upper edge of the wing as a starting line for feather-edging to avoid a "disheveled" look (②). Tilt the pressed brush on the paper and press gently to make a pointed brush tip. Now you can paint the covert feathers.

To paint the feather, start with centered-tip stroke at one third of the feather, entering the stroke by slightly pressing down on the brush; exit the stroke by gradually lifting the brush. A lot of practice is required to learn to paint a feather in one brushstroke (③).

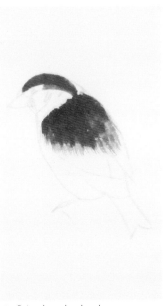

1 You can sketch with a pencil first. Mix ocher and ink to paint the back radially using the *simao* stroke.

2 Paint the ocher head.

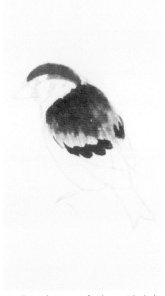

3 Paint the covert feathers with dark ocher.

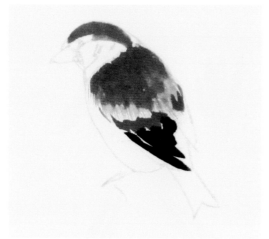

4 Paint the flight feathers with dark ink.

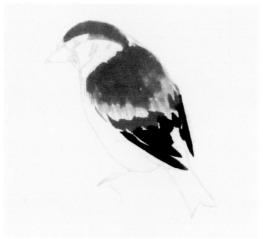

5 Paint the flight feathers of the other wing with dark ink.

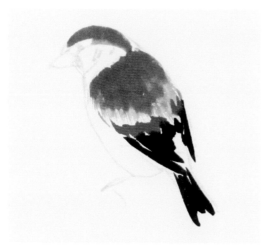

6 Paint the tail with dark ink.

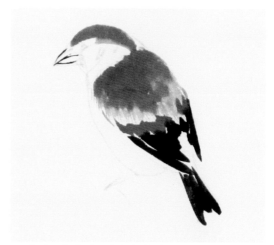

7 Outline the beak with dark ink. The beak is a wide conical shape.

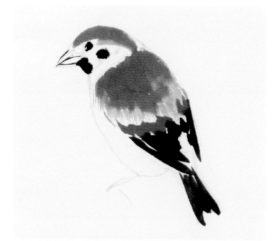

8 Paint the eye with dark ink. Be sure to leave highlights. Paint the spots on the cheek and the chin with dark ink.

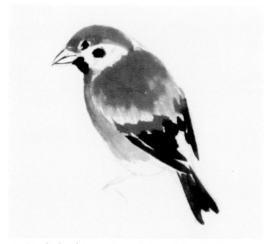

9 Dip the brush into water and then ink. Starting from the top, paint the breast, belly and down to the tail.

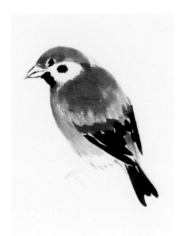

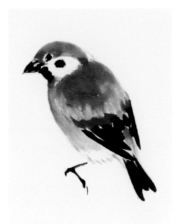

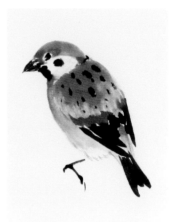

10 Add the undertail coverts with light ink.

11 Paint the foot with dark ink and the beak with medium ink.

12 Dot the spots on the body following the growth orientation of the feathers to complete.

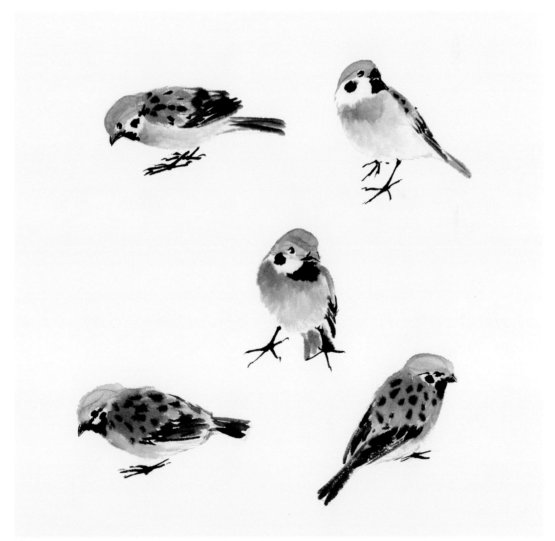

Various postures of sparrows.

How to Paint Birds in Various Postures

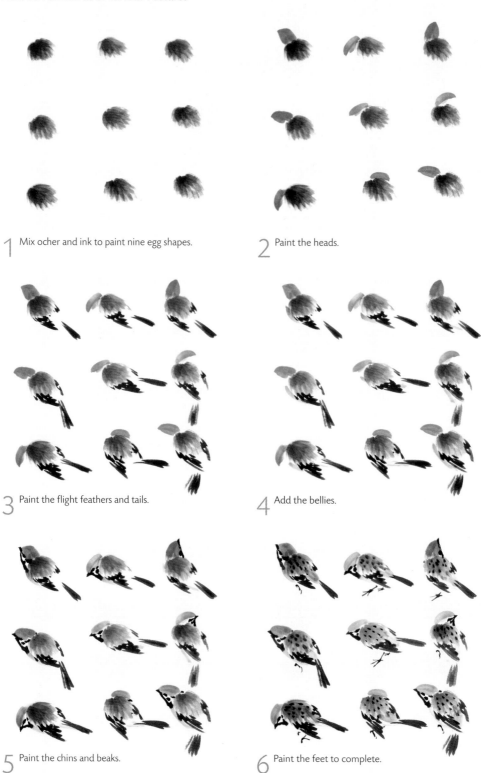

1 Mix ocher and ink to paint nine egg shapes.

2 Paint the heads.

3 Paint the flight feathers and tails.

4 Add the bellies.

5 Paint the chins and beaks.

6 Paint the feet to complete.

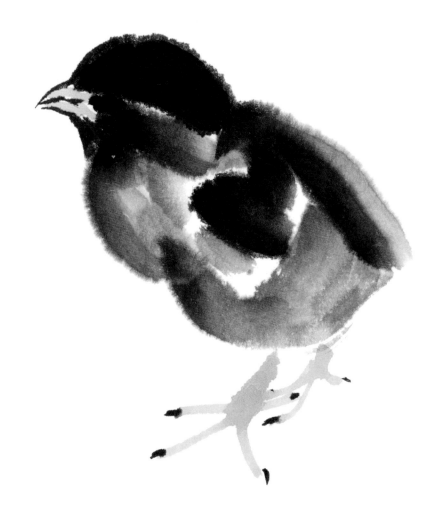

Chick

Chick is covered with a layer of neat yellow fluffy fur with a sheen. It is innocent and lively. Let's learn the techniques for representing a chick's fluffiness.

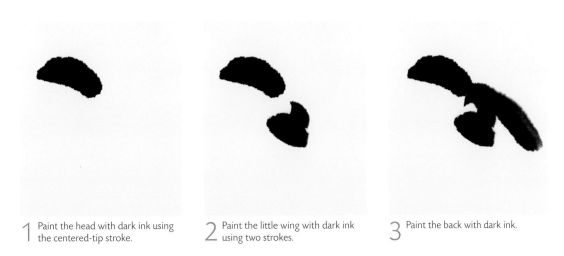

1 Paint the head with dark ink using the centered-tip stroke.

2 Paint the little wing with dark ink using two strokes.

3 Paint the back with dark ink.

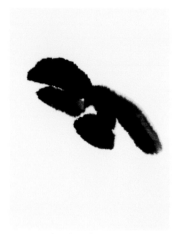 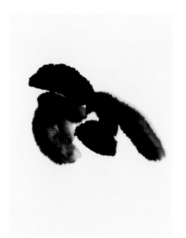 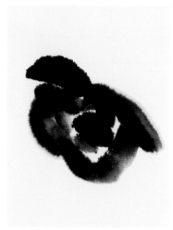

4 Paint the chin when the ink on the brush turns lighter.

5 Paint the breast with light ink.

6 Continue to paint the thigh and the belly. The ink is getting lighter and lighter.

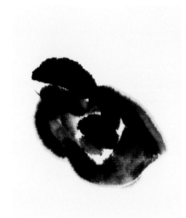 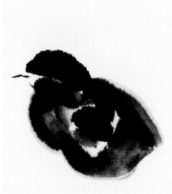 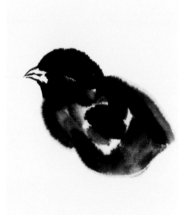

7 Draw the bill with dark ink using three strokes. Dot the eye and outline the chin with dark ink.

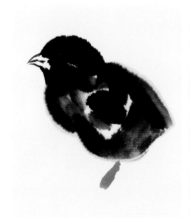 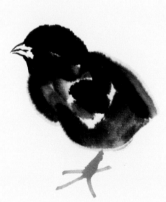 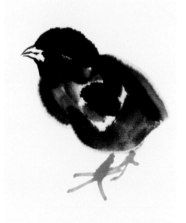

8 Mix gamboge and vermilion to paint the feet. The shanks are thick and the toes are thin.

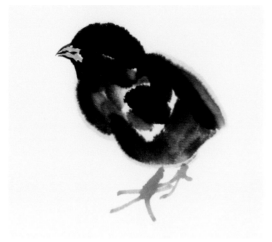

9 Mix gamboge and vermilion to color the bill.

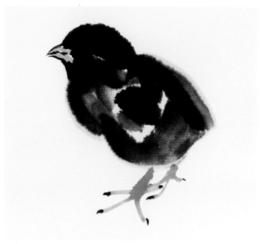

10 Dot the toenails with ink to complete.

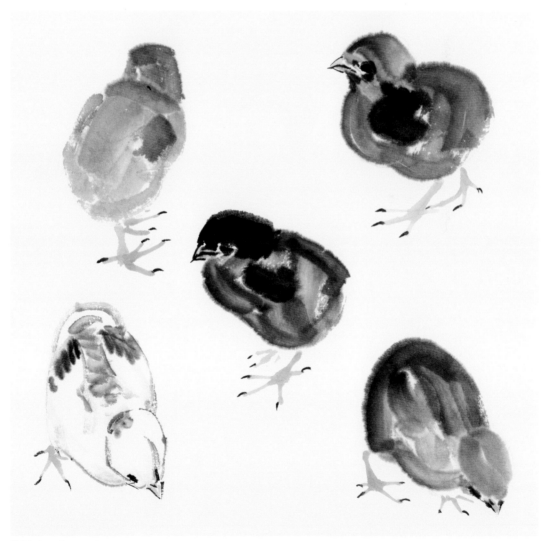

Chicks in various postures.

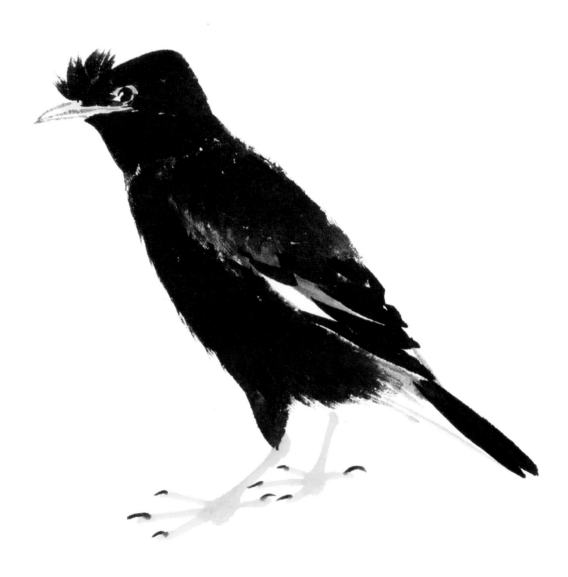

Crested Myna

The crested myna is around 23 to 28 centimeters long with a black body and a crown-like plume on the forehead. The tail feather and the undertail covert are white, and the beak and feet are yellow.

Five Lines on Bird's Head

When painting a bird, pay attention to the five lines on its head: brow line, eye line, face line, cheek line and chin line. Grasping the positions of these lines is conducive to painting a well-proportioned structure for the bird's head.

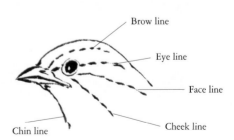

Brow line

Eye line

Face line

Cheek line

Chin line

1 Sketch with a pencil first. Outline the beak with light ink. Outline three lines if the beak is closed, four lines if the beak is open.

2 Paint the eye with dark ink. Leave an empty spot in the center to make it look livelier.

3 Use dark ink to paint the head top till the eye line.

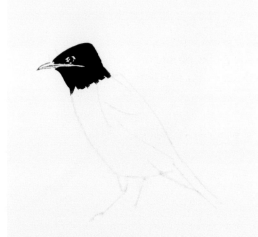

5 Paint the plume on the forehead with dark ink.

4 Paint the head, cheek and throat with dark ink.

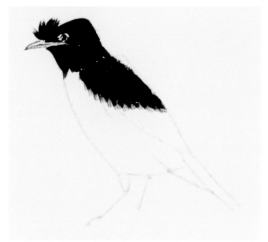

6 Dip the brush tip in dark ink and press the brush flat onto the palette. Use the *simao* stroke to paint the back feathers.

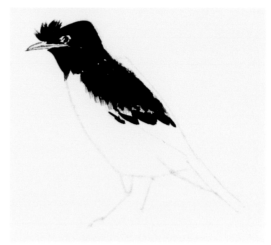

7 Paint the covert feathers with dark ink.

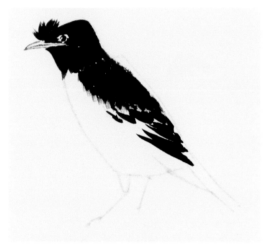

8 Paint the flight feathers with dark ink. Leave a gap between the covert feathers and flight feathers.

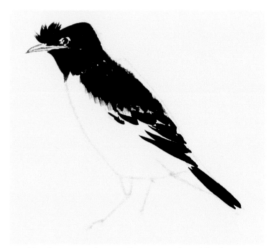

9 Use the centered-tip stroke to paint the tail feather.

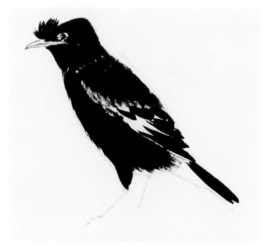

10 Dip the brush into water and then dark ink. Use the *simao* stroke to paint the breast, belly and leg.

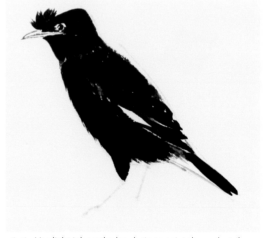

11 Use light ink on the brush tip to paint the undertail coverts.

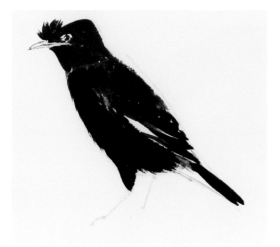

12 Mix gamboge and vermilion to paint the beak.

14 Paint the eye with eosin or vermilion. Paint the claws with dark ink to complete.

13 Mix gamboge and vermilion to draw the feet.

Crested mynas in various postures.

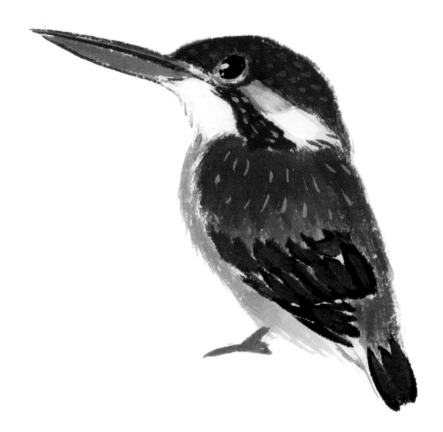

Kingfisher

Kingfisher is a medium-sized waterfowl. It has a large head, a short neck, and a long, strong bill. The feathers are colorful and lustrous, commonly in blue and green. There are light-colored barred patterns on the head and white marks on the side of the neck. The breast is chestnut while the bill and feet are crimson.

The kingfisher tends to live in the sparse forest near a clear and tranquil river or mountain stream. It usually rests alone on a tree or rock near the water. It boasts strong fishing skills. The kingfisher, therefore, commonly appears in paintings along with water plants.

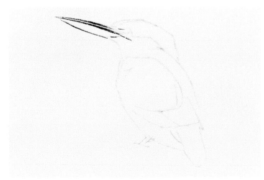

1 You can use pencil to sketch out the overall shape first. Draw the bill using three strokes with lines of varying thickness. Be sure the bill is long and wide.

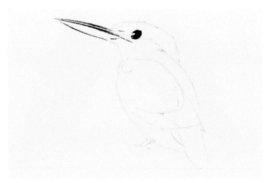

2 Paint the eye with dark ink. Leave an empty spot as the highlight to make the eye look brighter.

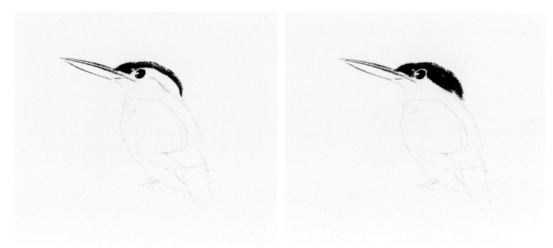

3 Paint the crest with dark ink, leveling it with the eye line.

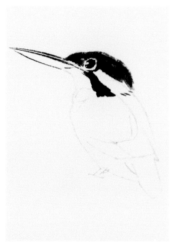

4 Leave the space behind the eye blank. Paint the black cheek.

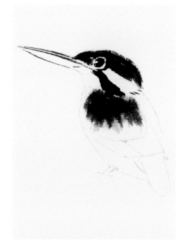

5 Use the *simao* stroke to paint the wing with light ink.

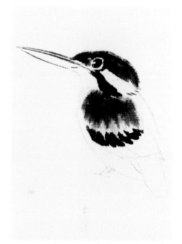

6 Paint the covert feathers with dark ink.

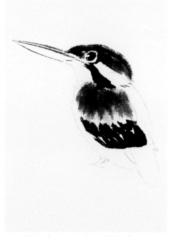

7 Paint the secondary flight feathers with dark ink.

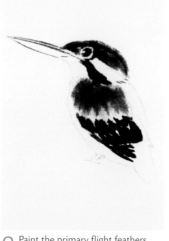

8 Paint the primary flight feathers with dark ink.

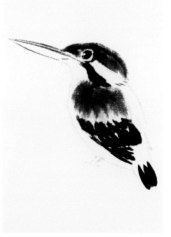

9 Paint the tail with dark ink.

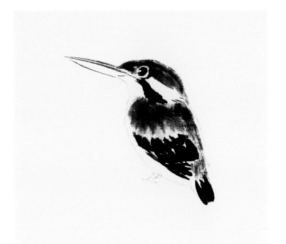

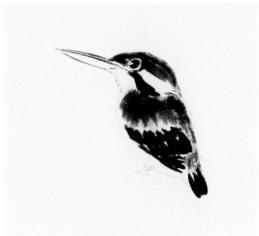

10 Paint the back from the top to the undertail coverts with light ink.

11 Outline the chin line with light ink.

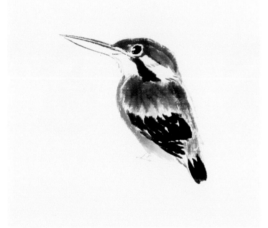

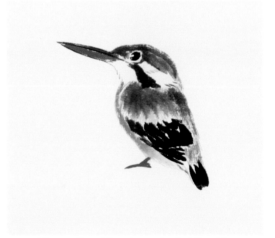

12 Mix gamboge with vermilion to paint from the breast to the belly.

13 Mix vermilion with eosin to paint the bill and foot.

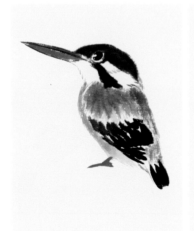

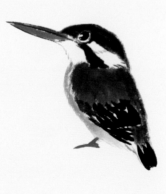

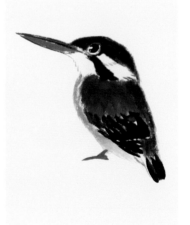

14 Paint the head, body and wing using azurite after the ink is dry.

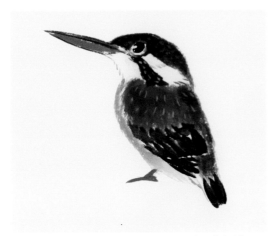

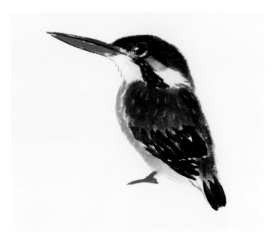

15 Mix azurite and titanium white to produce light blue to dot the crested head, cheek and back as the white pattern.

16 Mix gamboge and vermilion to color the cheek. Use titanium white to fill in the blank space on the body to complete the kingfisher.

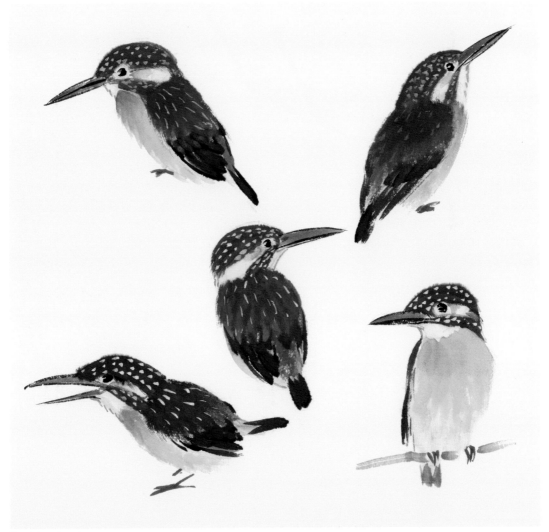

Kingfishers in various postures.

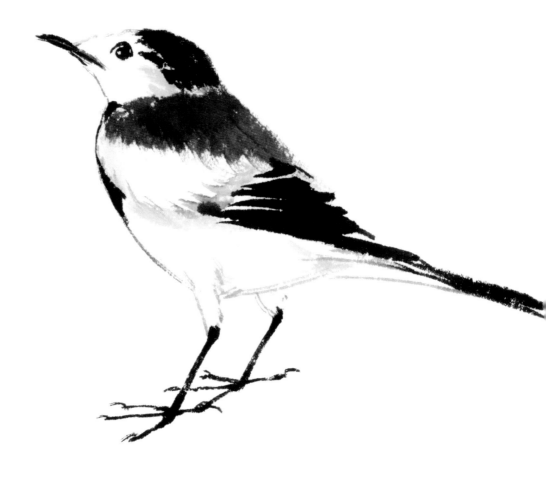

Wagtail

Wagtail ranges from 170 to 180 millimeters. The tiny body is composed of a black crown, white forehead, white belly, long and thin bill, long tail and wings. Common wagtails are white, gray and yellow. They are active near water sources and their tails wag when they're standing.

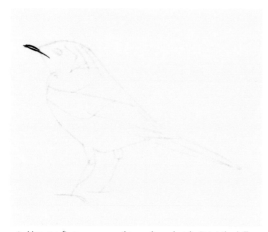

1 You can first use a pencil to make a sketch. Paint the bill with three strokes of lines.

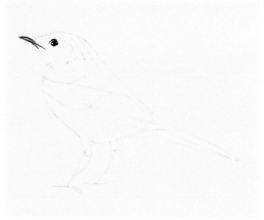

2 Paint the eye with dark ink. Be sure to leave the highlight to make the eye look brighter.

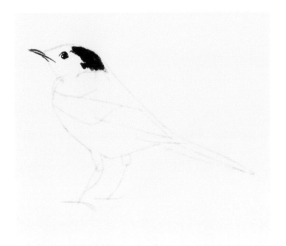

3 Paint the crown with dark ink and leave the empty space on the head.

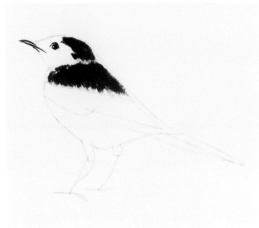

4 Use the *simao* stroke to paint the back.

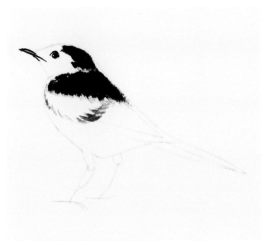

5 Paint the wing with lighter ink.

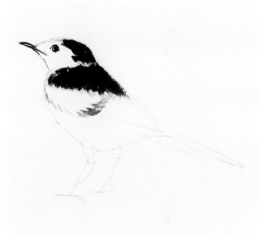

6 Outline the head and the chin line with light ink.

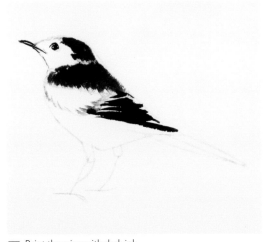

7 Paint the wing with dark ink.

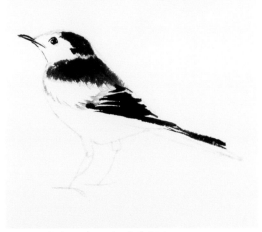

8 Paint the long, thin tail with dark ink.

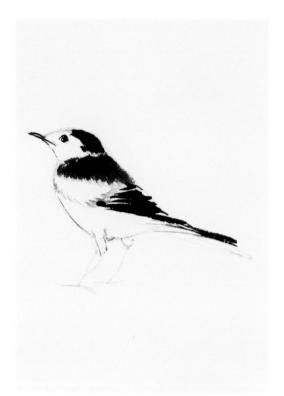

9 Outline the belly and undertail coverts with light ink.

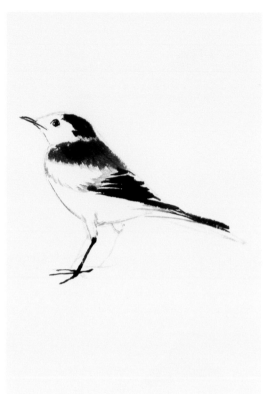

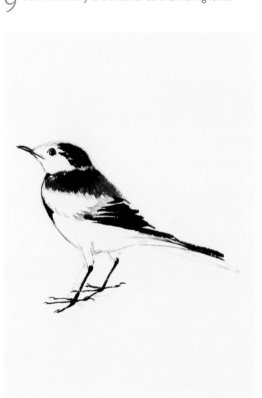

11 Paint the breast feathers with dark ink.

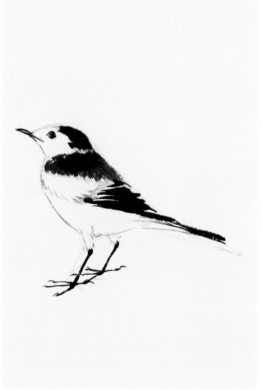

10 Paint two feet with dark ink. Pay attention to their relative positions.

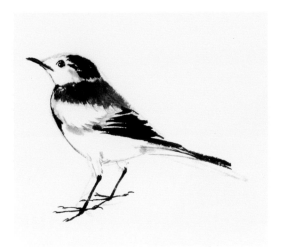

12 Use a light touch with light ink on its body to make it more three-dimensional.

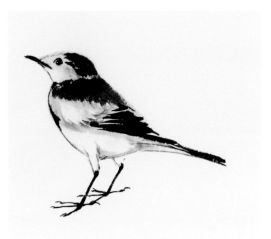

13 Use titanium white to fill in the white parts. Then fill in the bill with dark ink to complete.

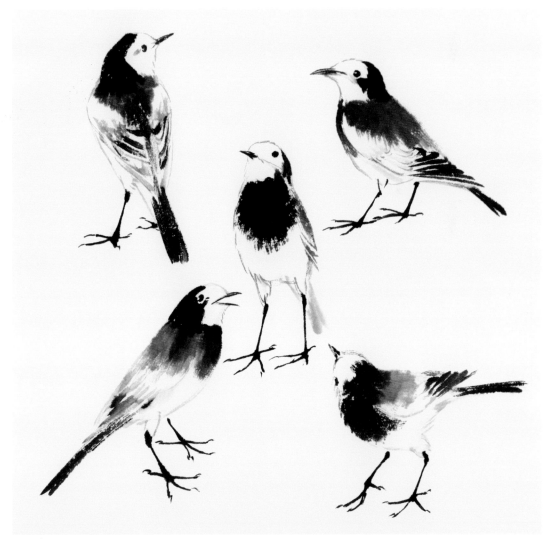

Wagtails in various postures.

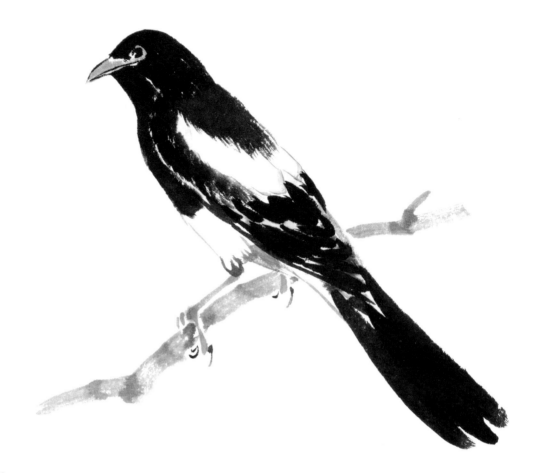

Magpie

Magpie ranges from 40 to 50 centimeters in length. The head, neck, back and tail are black, presenting a purple, greenish-blue and green sheen from head to tail. The wings are also black but have a large white mark. The wedge-shaped tail is longer than the wings. The bill, legs and feet are pure black. The belly is white while the breast is black.

The magpie commonly appears in areas of human activity. In China, it represents prosperity, and is often paired with plum blossoms in painting.

1 You can use a pencil to sketch first. Paint the bill with dark ink.

2 Paint the eye with dark ink. Be sure to leave the highlight.

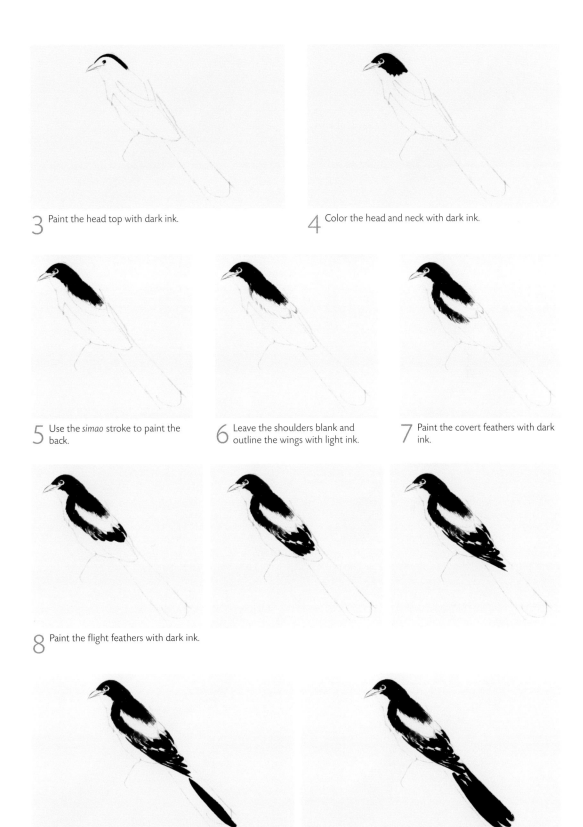

3 Paint the head top with dark ink.

4 Color the head and neck with dark ink.

5 Use the *simao* stroke to paint the back.

6 Leave the shoulders blank and outline the wings with light ink.

7 Paint the covert feathers with dark ink.

8 Paint the flight feathers with dark ink.

9 Paint the tail with three strokes. Be sure to make it long.

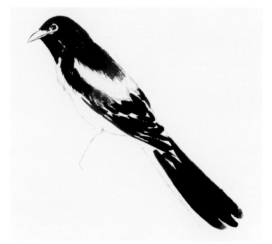

10 Paint the throat with dark ink.

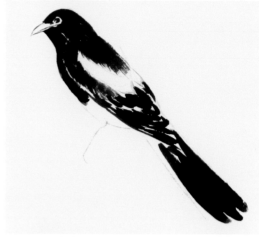

11 Paint the breast with dark ink.

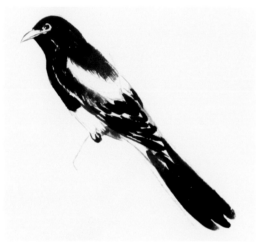

12 Outline the belly and connect it to the tail with light ink.

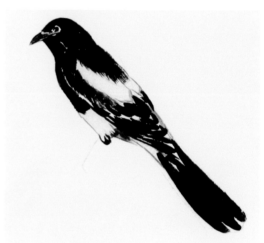

13 Color the bill with indigo.

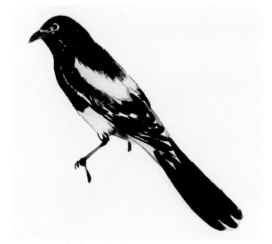

14 Paint the legs with indigo.

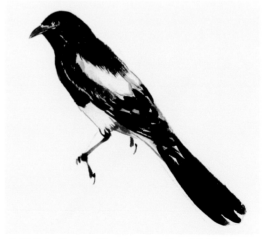

15 Color the eye with eosin or vermilion. Paint the claws with ink.

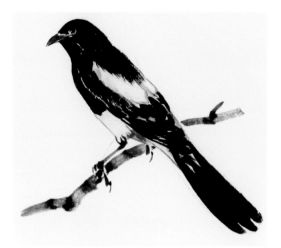

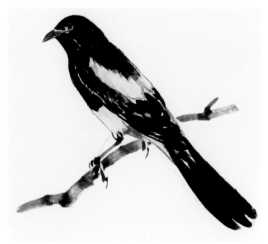

16 Draw a branch for the bird to rest on.

17 Color the white area on the wings with titanium white to complete.

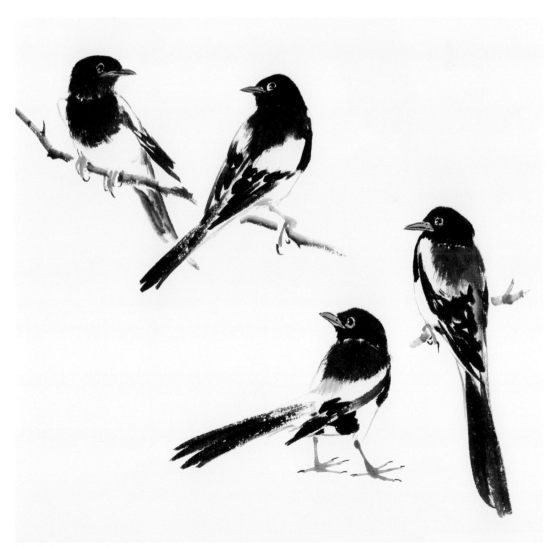

Magpies in various postures.

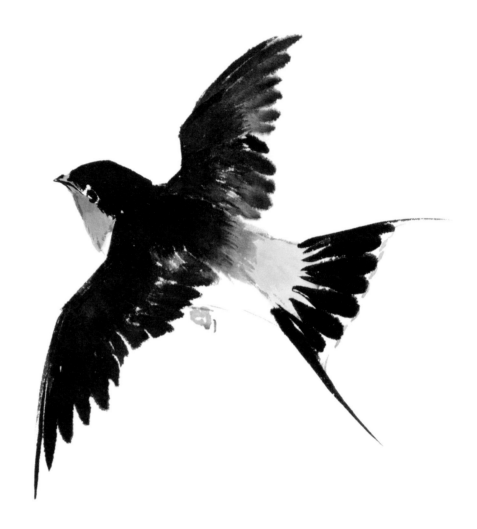

Swallow

Swallow is small and nimble. Its feathers are bluish black with a sheen, the breast is black and brown, and the belly is creamy white. The wings are long and pointed, and the tail is like an open scissors. Its bill is short and flat. It's a beneficial bird with a high flight speed.

Swallows are summer resident birds, travelling with the changing seasons, and usually appear in pairs under the eaves. Since the ancient times in China, swallows have been popular in poems to express lovesickness or emotion about departure. They are always presented together with plants in Chinese paintings.

1 Paint the head top with dark ink.

2 Use the *simao* stroke to radially paint the neck and leave space for the eye.

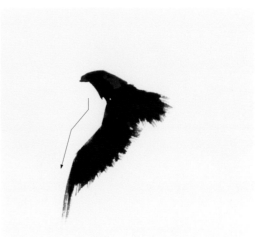

3 Use the *simao* stroke to radially paint the back.

4 Draw a zigzag line with dark ink to outline the upper part of the wing. Then use the *simao* stroke to paint the wing.

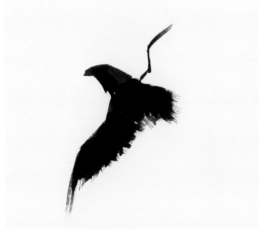

5 Repeat the steps to paint the opposite wing. Pay attention to the proportions to create a sense of perspective.

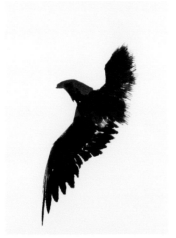

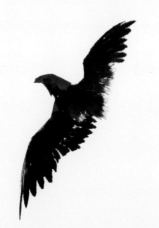

6 Paint different levels of flight feathers with dark ink.

7 Then paint different levels of flight feathers on the opposite wing.

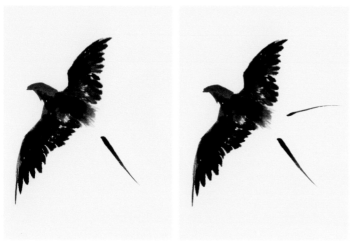 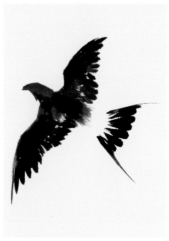

8 Paint the tail with dark ink. Draw the scissors-shaped tail with two strokes.

9 Complete the tail by adding a few strokes with dark ink.

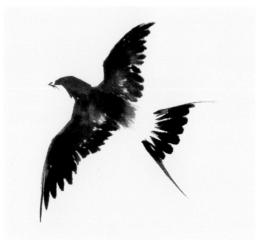 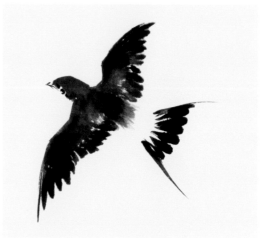

10 Paint the bill with dark ink.

11 Paint the eye with dark ink and be sure to leave the highlight.

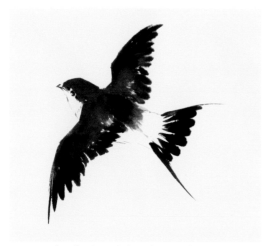 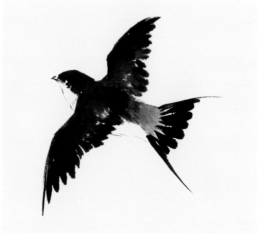

12 Outline the throat, belly, and undertail coverts with light ink.

13 Paint the ocher uppertail coverts.

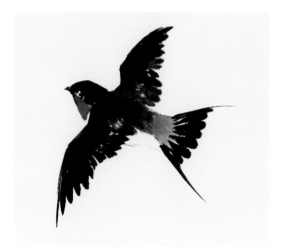

14 Mix vermilion and eosin to paint the throat. Then fill in the bill with indigo.

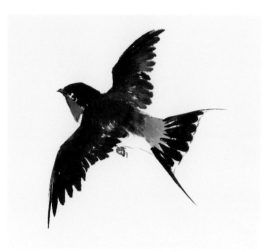

15 Paint the indigo feet. Paint the belly with titanium white to complete.

Swallows in various postures.

Fig. 32 *Munia and the Red Leaves*
Height 50 by width 50 centimeters

The white munias stand on the twigs. Their red bills and the red leaves complement each other, forming a simple and yet interesting composition.

CHAPTER FOUR
Advanced Lessons

After learning how to paint flowers, birds, fishes and shrimps from the Introductory Lessons, we will practice the common combinations of various objects in this chapter.

1. Magpie on Plum Blossoms

A magpie resting on a plum tree is a symbol of happiness. Chinese believe a magpie can bring joy and luck; thus, "magpie on plum blossoms" is a popular auspicious theme for Chinese painting.

We have learned how to paint magpie (see page 166) and plum blossom (see page 27) in the Introductory Lessons. When combining them, you need to pay attention to their positions.

1 Determine the position of the magpie. You can outline the body with a pencil first and then outline the beak with ink.

2 Paint the eye with dark ink.

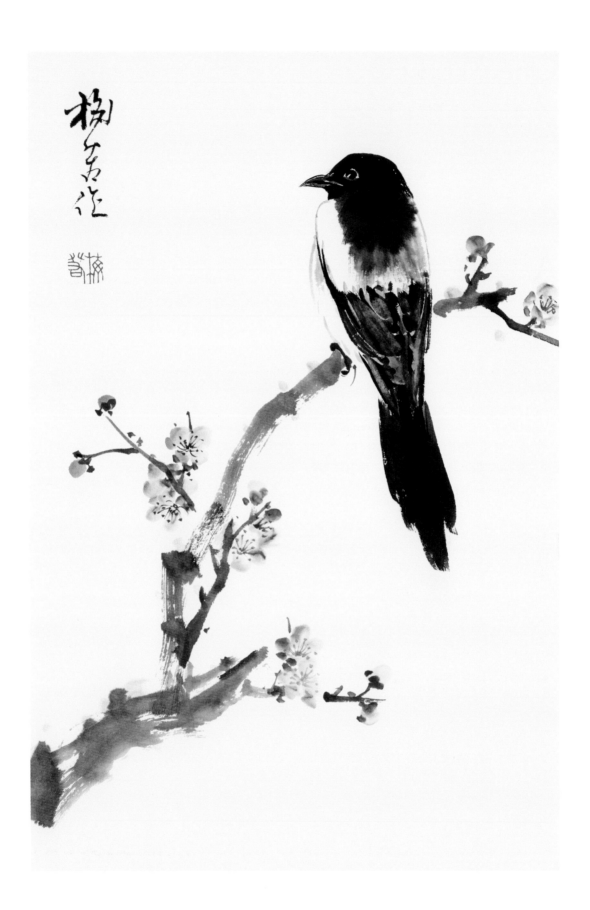

3 Paint the head with dark ink.

4 Paint the chin with dark ink.

5 Paint the back with dark ink.

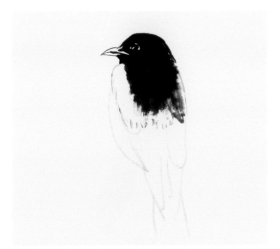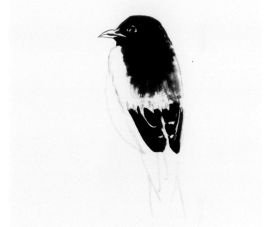

6 Outline the shoulder with light ink and leave it empty of color.

7 Paint the covert feathers with dark ink.

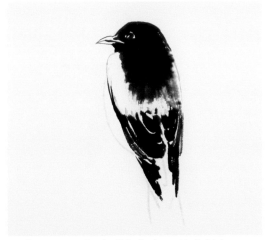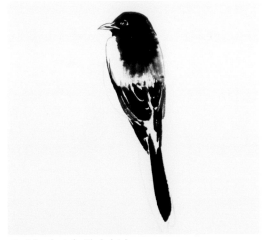

8 Continue to paint the flight feathers with dark ink.

9 Paint the tail with dark ink.

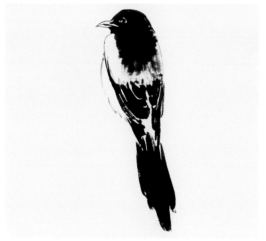

10 Paint the belly with light ink.

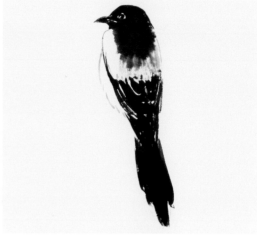

11 Fill the empty space of the wings with ink. Then fill the bill with ink.

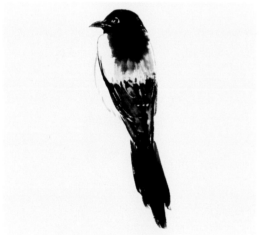

12 Color the wings with azurite.

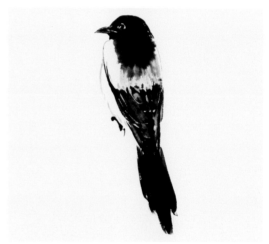

13 Add the foot.

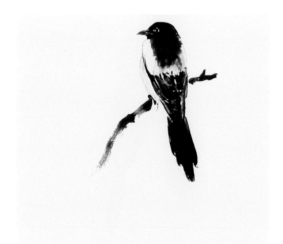

14 Add the plum branch below the foot to illustrate the scene of a magpie resting on a tree.

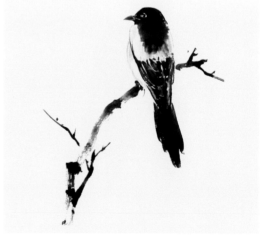

15 Add more branches on the right and the bottom.

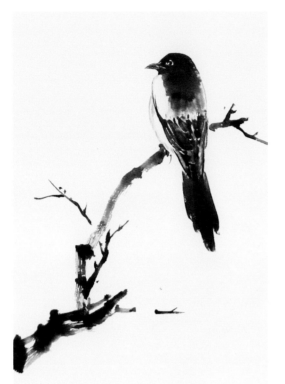

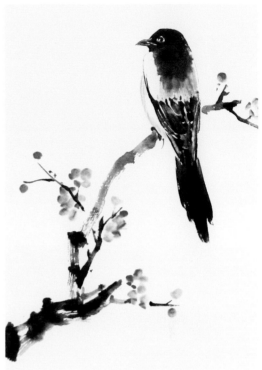

16 Add the thick branch at the lower left. Be sure to leave some empty spaces for plum blossoms.

17 Mix titanium white with eosin to paint the plum blossoms.

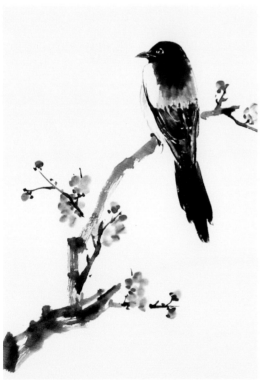

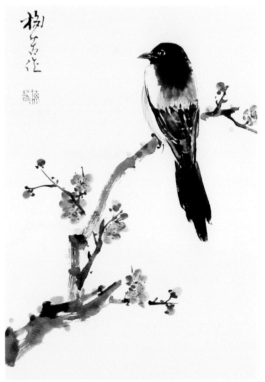

18 Paint flower centers with dark green and receptacles with rouge.

19 Paint the stamens with rouge or eosin. Add dark-green moss on the branches to complete.

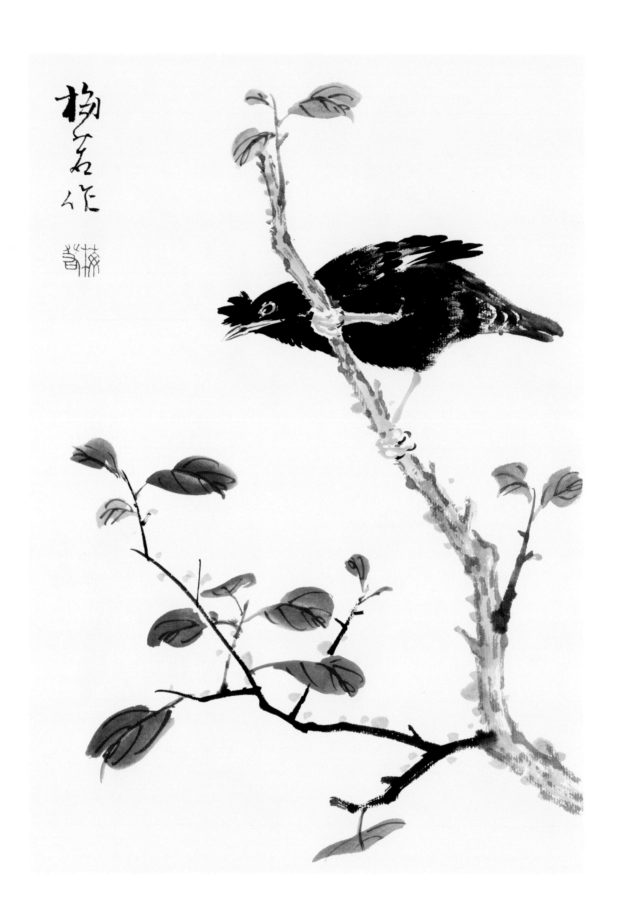

2. Crested Myna with Red Leaves

The crested myna with red leaves is a popular theme in Chinese painting. The red leaves are brightly colored while the black crested myna seems like it will leap from the branch any time, forming a vivid contrast of activity and inertia.

Refer to the painting techniques of crested myna (see page 154), camellia leaf (see page 44) and plum branch (see page 27) in the Introductory Lessons for this painting.

1 Sketch the shape of the bird with a pencil. Mix gamboge and ocher to draw the claws of one foot first.

2 Draw the other foot's claws.

3 Paint the branch and pay attention to the variation of color shades.

4 Outline the bill with light ink using three strokes.

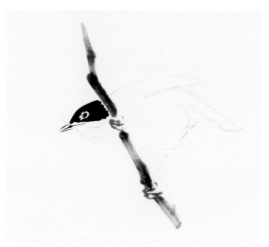

5 Paint the eye with light ink, being sure to leave the highlight. Outline around the eye.

6 Paint the head with dark ink.

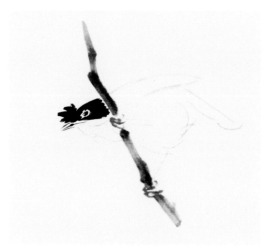

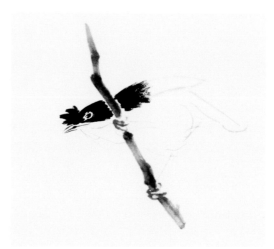

7 Paint the crest on the head with dark ink.

8 Paint the back using the *simao* stroke.

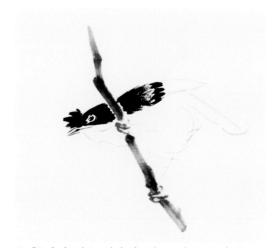

9 Dip the brush into dark ink and paint the covert feathers.

10 Paint the flight feathers with dark ink.

11 Mix gamboge and ocher to paint the legs.

12 Paint the cheek and throat with dark ink.

13 Paint the upper part of the body with dark ink.

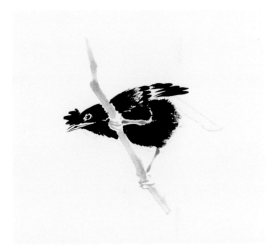

14 Paint from the breast and belly to the tail using the *simao* stroke.

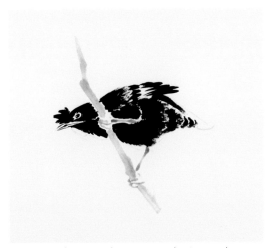

15 Paint the uppertail coverts using the *simao* stroke.

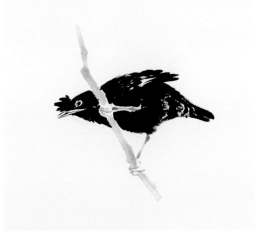

16 Paint the tail with dark ink.

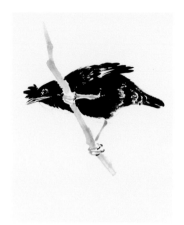

17 Paint the eye with vermilion or eosin. Color the bill with gamboge and the empty space with titanium white.

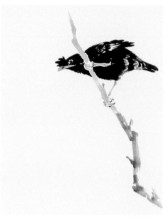

18 Extend the branch to the lower right.

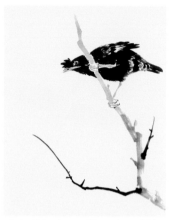

19 Paint the small branches, which are darker.

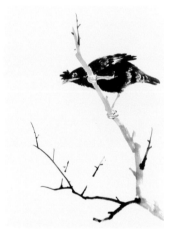

20 Paint the twigs in the pattern of the Chinese character 女, and leave spaces for the red leaves.

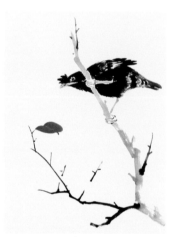

21 Mix vermilion and eosin to paint the red leaf using two strokes, one up and one down.

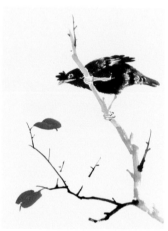

22 Add another leaf at the lower left.

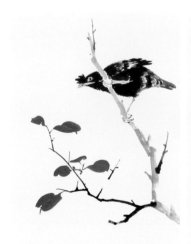

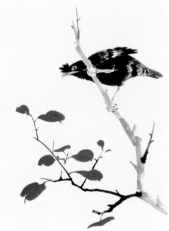

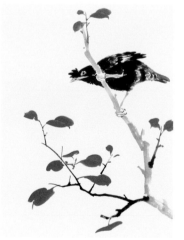

23 Continue to add more red leaves in different sizes and orientations.

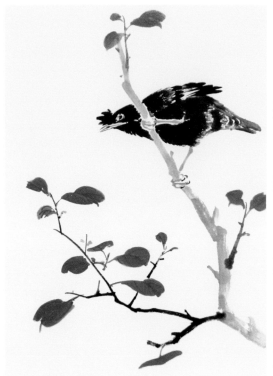

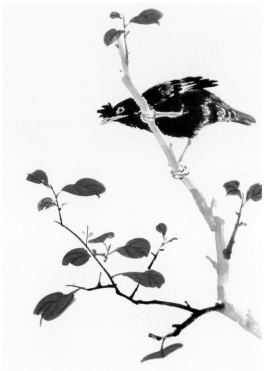

24 Outline the leaf veins using eosin.

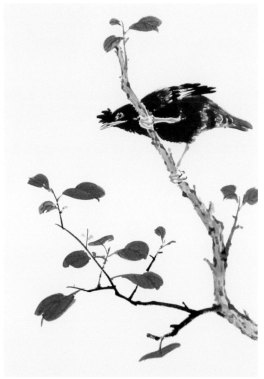

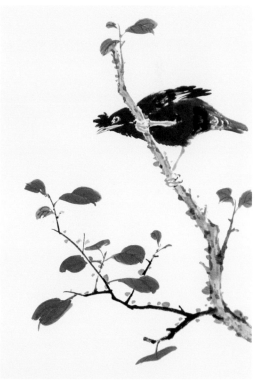

25 Partially outline the branch with light ink to emphasize the rough surface texture.

26 Add dark-green moss on the branches to complete.

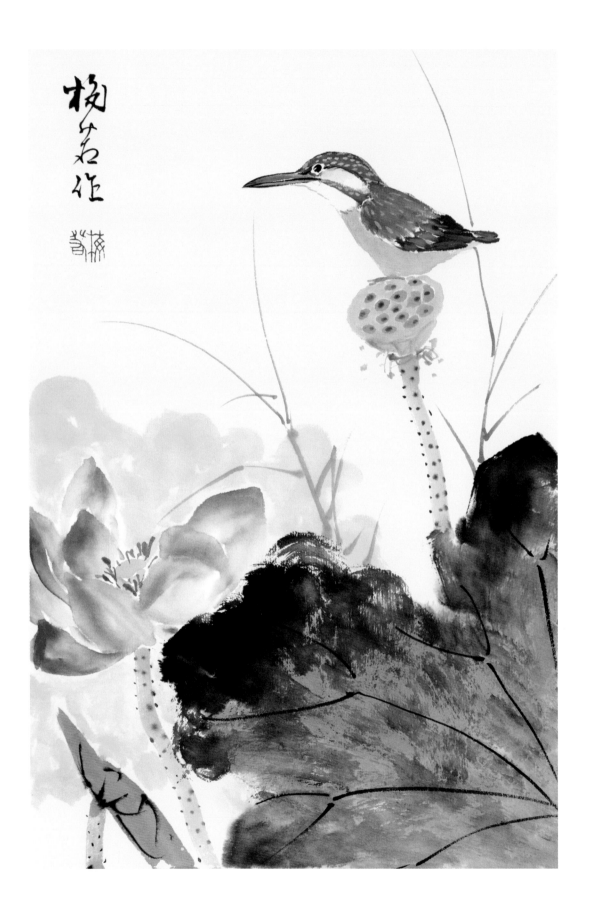

3. Kingfisher with Lotus

The kingfisher and the lotus are both popular themes in Chinese painting. The brightly colored kingfisher is playing among the blooming lotus, erect seedpod and fluttering water plants, forming a vivid natural scene.

The painting techniques of lotus and kingfisher can be found in the Introductory Lessons (see pages 56 and 158). In this lesson, we will also introduce painting techniques for the lotus leaf and seedpod.

How to Paint Lotus Leaf

To paint a big lotus leaf, start from the edge and paint toward the center to shape the leaf with charred ink. It is like sweeping the floor to gather the dust. This is a highly *xieyi*-style painting technique.

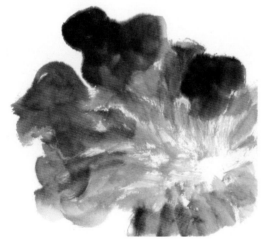

1 Let's paint the kingfisher first. Draw the bill with three strokes. Paint the eye with dark ink and leave the highlight.

2 Paint the head and cheek. Be sure to leave the empty space in the middle.

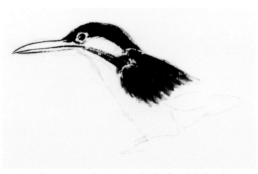

3 Use the *simao* stroke to paint the back with light ink.

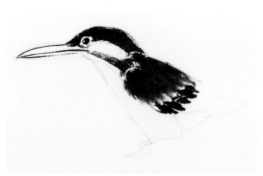

4 Paint the covert feathers with dark ink.

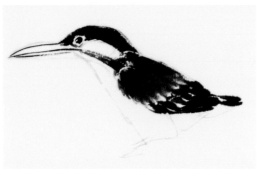

5 Paint the flight feathers and tail with dark ink.

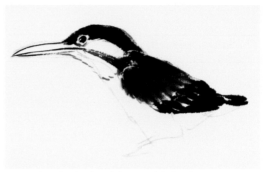

6 Outline the cheek and throat with light ink.

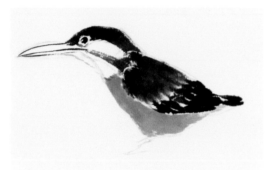

7 Mix gamboge and vermilion to paint the breast and belly from the top downward.

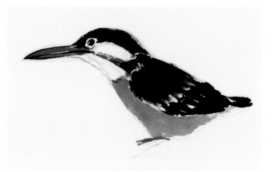

8 Mix vermilion and eosin to paint the bill and feet.

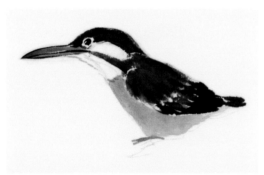

9 Cover the black feathers with azurite after the ink on the feathers is dry.

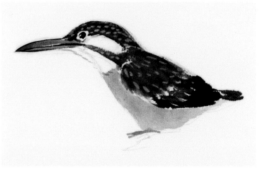

10 Mix azurite and titanium white to dot the head, back and wing. Pay attention to the orientations of the dots.

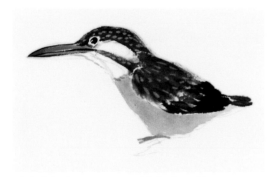

11 Paint the empty spaces with titanium white.

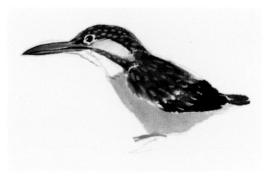

12 Paint half of the white space next to the eye with gamboge.

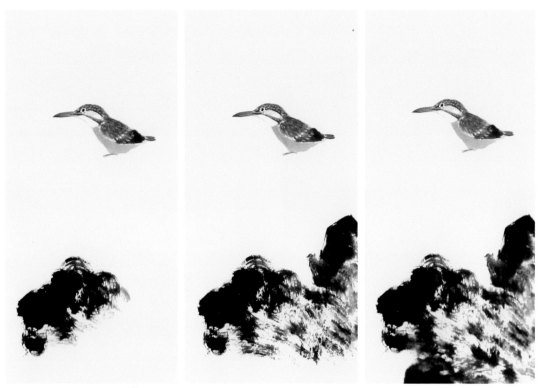

13 Next, paint the lotus leaf.

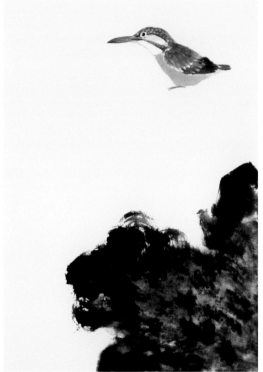

14 Add dark green when the ink of the leaf is still wet.

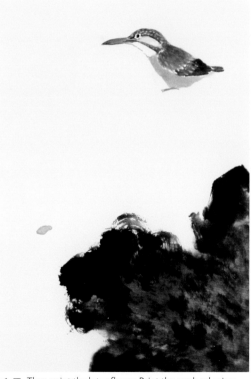

15 Then paint the lotus flower. Paint the seedpod using dark green (with more gamboge) first.

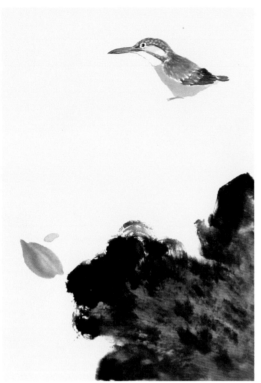

16 Mix titanium white with eosin to paint the lotus petal with two strokes.

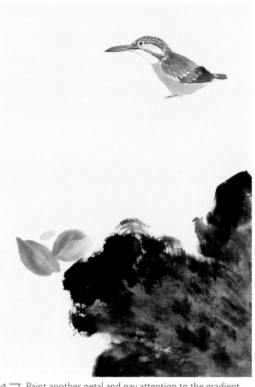

17 Paint another petal and pay attention to the gradient color.

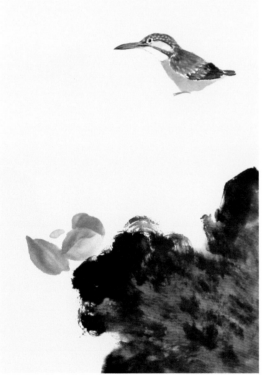

18 Paint the first layer of petals.

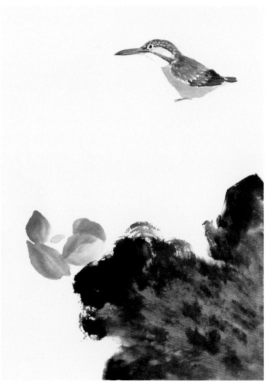

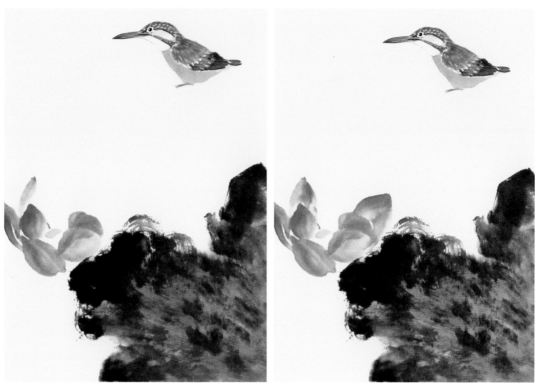

19 Paint the outer layer of petals and note the sizes and orientations.

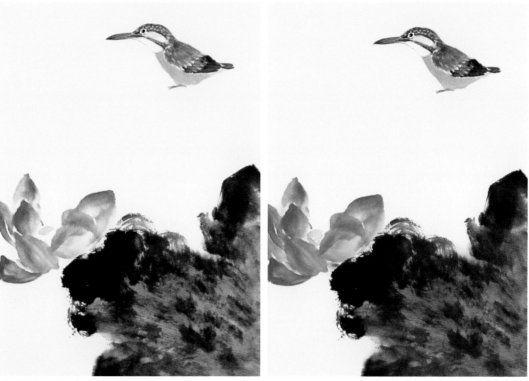

20 Complete the lotus.

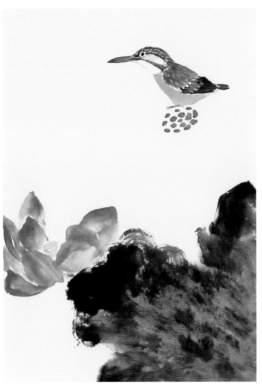

21 Paint the dark-green seedpod below the feet of the kingfisher, starting with the lotus seeds by dotting.

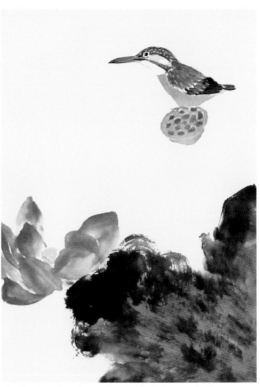

22 Complete the seedpod with dark green (with more indigo).

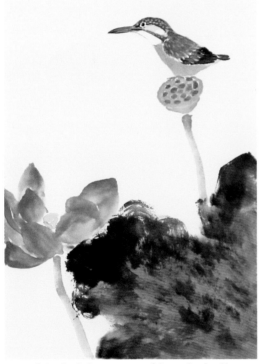

23 Paint the dark-green stems of the seedpod and lotus.

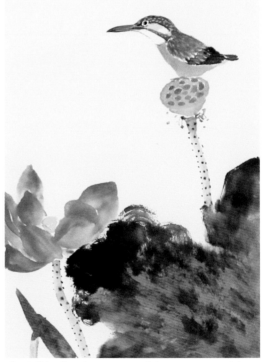

24 Paint the ocher remnants of the stamens around the seedpod. Add ocher dots on the stems as thorns. Paint one more leaf at the lower left with dark green.

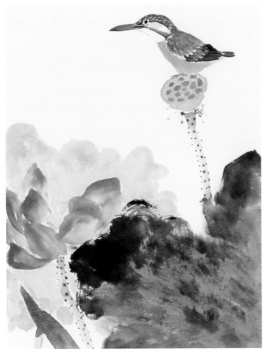

25 Paint a light-green leaf behind the lotus.

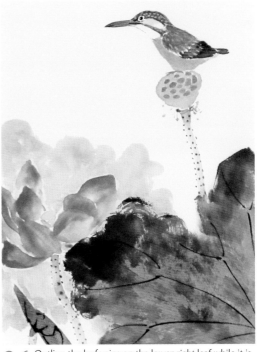

26 Outline the leaf veins on the lower-right leaf while it is still wet.

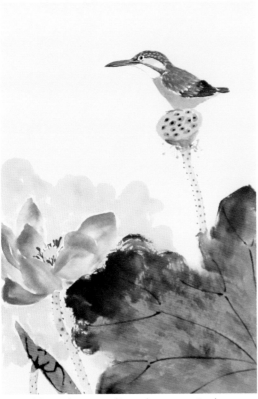

27 Mix gamboge, vermilion and rouge to paint the stamens. Add dots on the seedpod using ink as the protruding seeds.

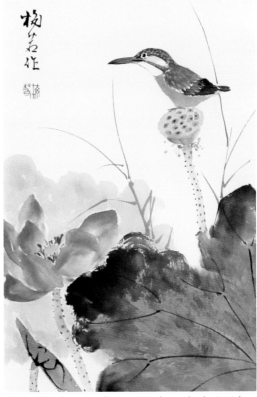

28 Paint the water plants next to the seedpod using ink or indigo to complete the picture.

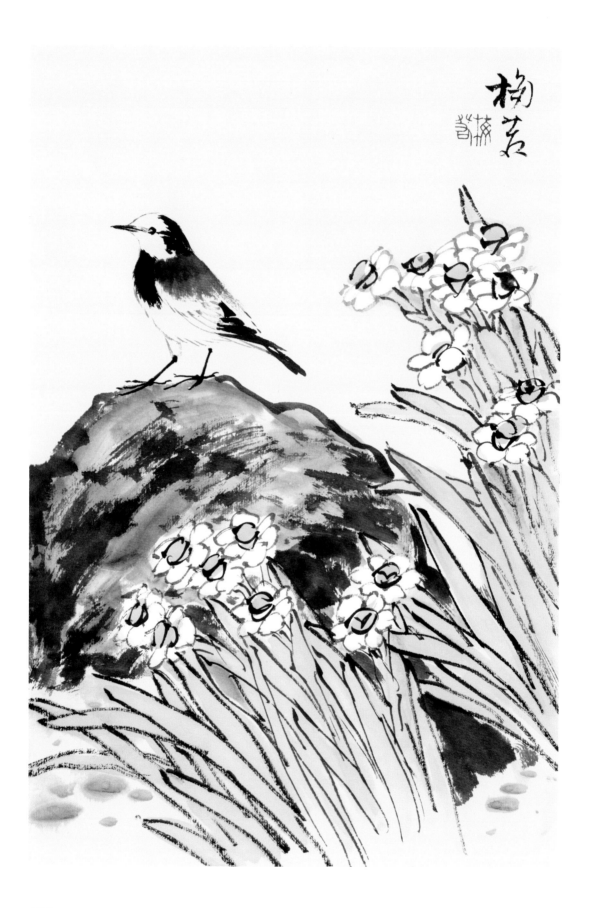

4. Wagtail on the Shore

Narcissi are usually planted in a pot. In this lesson, the narcissi appear in a natural setting with a wagtail to create a more interesting scene. The flowers bloom among the straight green leaves, and the golden coronas on top are like lights illuminating the picture. In the middle of the painting, the nimble black-and-white wagtail stands on the rock, ready to fly away at any moment.

You can refer to the Introductory Lessons on page 162 and page 63 for the painting techniques of wagtail and Chinese narcissi. This lesson also includes painting techniques for rocks.

1 Let's draw the wagtail first. Use three strokes to draw the long, thin bill.

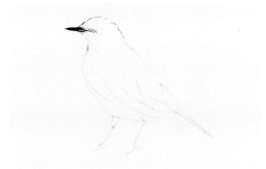

2 Outline the head and throat with light ink.

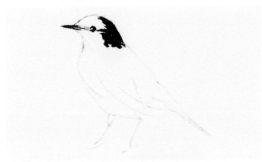

3 Paint the eye with dark ink, being sure to leave the highlight. Paint the head with dark ink and leave the empty space on top.

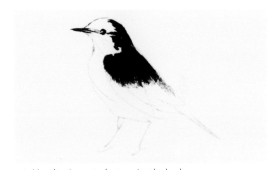

4 Use the *simao* stroke to paint the back.

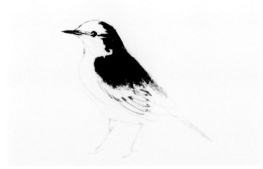

5 Outline the covert feathers with light ink as the ink on the brush gets lighter.

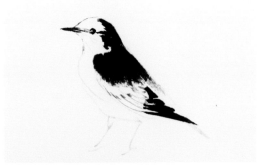

6 Paint the flight feathers with dark ink.

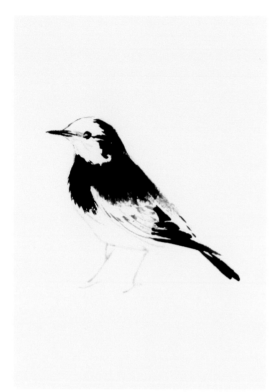

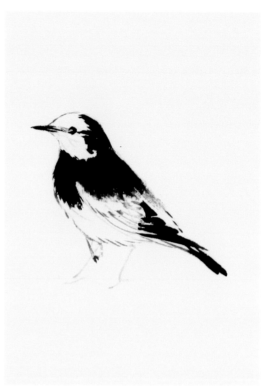

7 Paint the long, thin tail with dark ink. Use the *simao* stroke to paint the breast.

8 Outline the belly, the undertail coverts, and the leg with light ink.

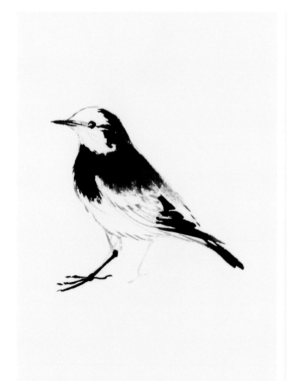

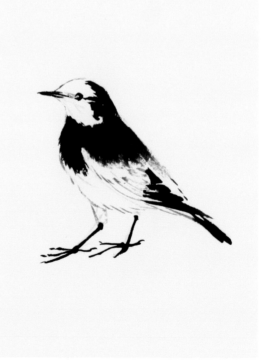

9 Paint the feet with dark ink. Gently color the body with light ink to make it more three-dimensional. Color the empty space with titanium white and the bill with ink.

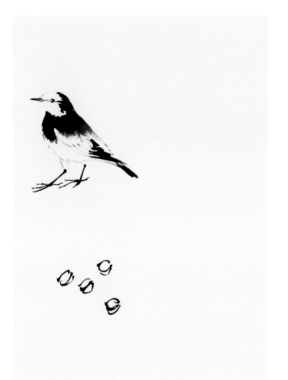

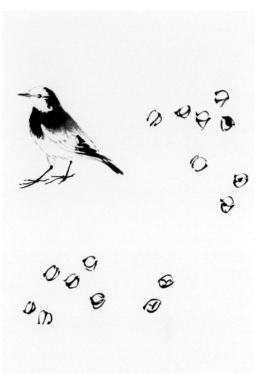

10 The next is to draw the narcissi. Draw four coronas with dark ink.

11 Draw twelve more coronas at the lower left and upper right. Be sure to have variations in size and orientation.

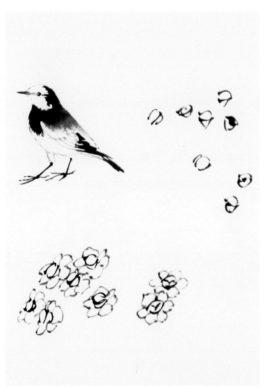

12 Use the nail-head rat-tail stroke to outline the six petals around each corona on the lower left with light ink.

13 Outline the petals around the coronas on the right side of the wagtail. Then paint the stems with light ink.

14 Use the nail-head rat-tail stroke to paint the long and upright leaves. Make sure they are facing one direction as if fluttering in the breeze.

15 Paint the rocks among the narcissi.

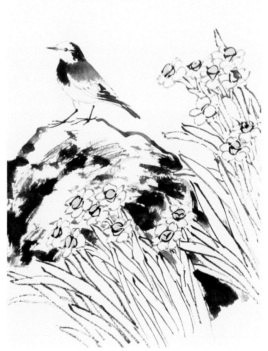

16 Paint the rock below the feet of the wagtail with ink so the wagtail is standing on the rock. Touch up the rock to create the texture and shadows.

17 Mix gamboge and vermilion to color the coronas.

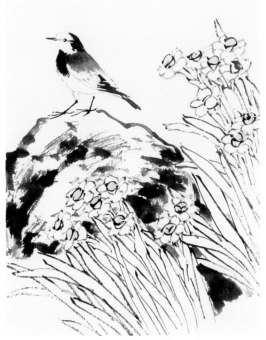

18 Use light green to color around the petals.

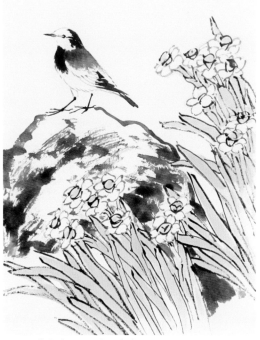

19 Fill the leaves with malachite.

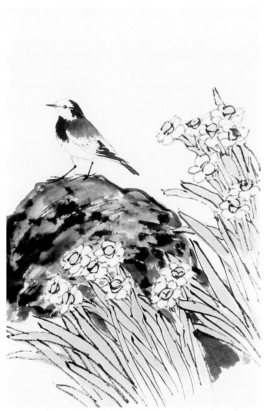

20 Fill the rocks with light ink when it is dry. The rock is complete.

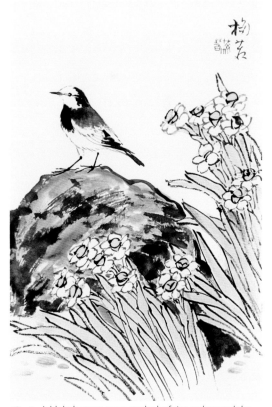

21 Add dark-green moss on the leaf tips and around the bottom of the rocks to represent the water surface and complete the work.

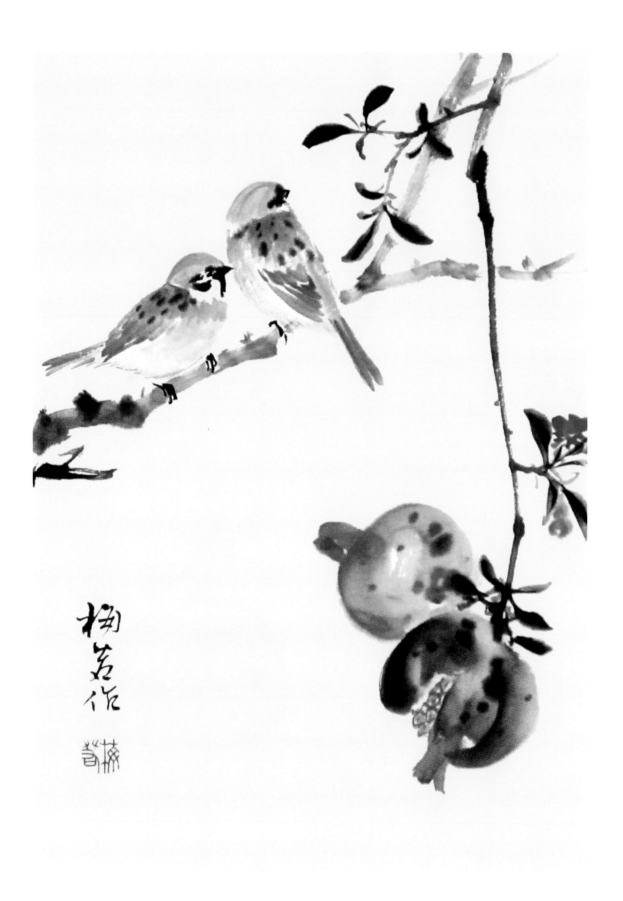

5. Sparrows on the Pomegranate Tree

In this lesson, there are two sparrows standing on the pomegranate tree. One is facing the front while the other is looking backward; one is active while the other is calm. On the other side of the painting, there are two heavy pomegranates. One of them splits off to spread fragrance everywhere, and you can almost smell it through the picture. This painting is full of the scent of fall.

You can refer to the Introductory Lessons of painting sparrow and pomegranate on pages 146 and 74.

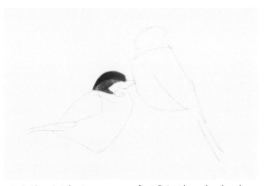

1 Let's paint the two sparrows first. Paint the ocher head.

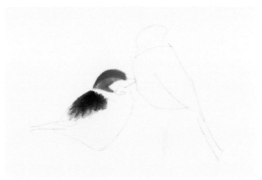

2 Mix ocher and ink to paint the back using the *simao* stroke.

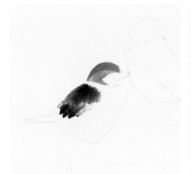

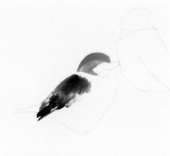

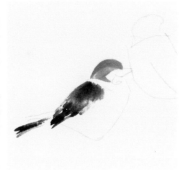

3 Paint the covert feathers, flight feathers and tail with ink.

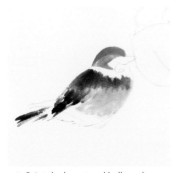

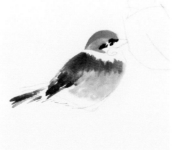

4 Paint the breast and belly and outline the edge of the belly with light ocher.

5 Paint the bill, eye, throat and the stripes on the cheek with dark ink.

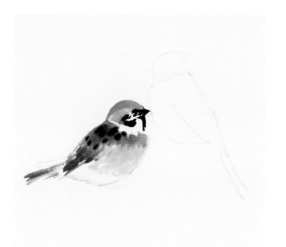

6 Dot spots on the back with light ink.

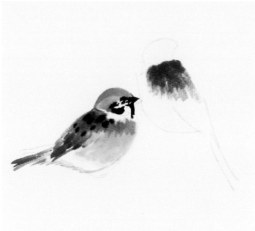

7 Repeat the steps to paint the other sparrow. Mix ocher and ink to paint the back using the *simao* stroke.

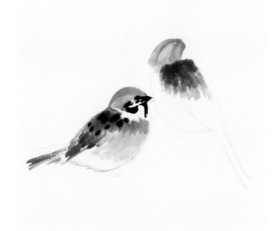

8 Mix ocher with light ink to paint the head using three strokes. Note the different posture of this sparrow.

9 Paint the ocher covert feathers.

10 Paint the ocher flight feathers and tail.

11 Paint the breast and outline the belly when the ocher and ink gets lighter.

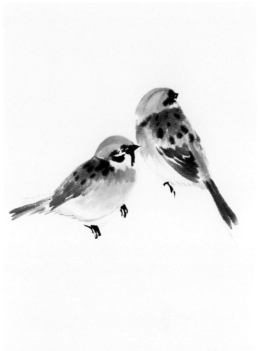

12 Paint the bill and dot the eye with ink.

13 Paint the claws with dark ink.

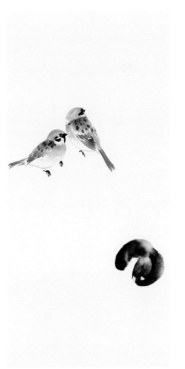

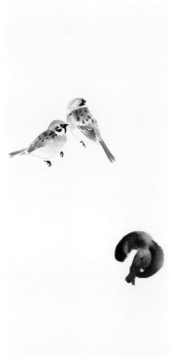

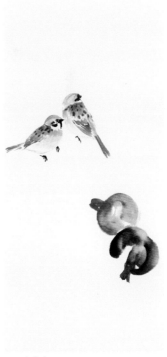

14 Dip the brush tip into dark green and then the brush into rouge to paint the pomegranate at the lower right. Make one stroke on each side and then one in the middle.

15 Dip the brush into dark green and brush tip into rouge to paint a calyx.

16 Paint one more pomegranate as the ink gets lighter.

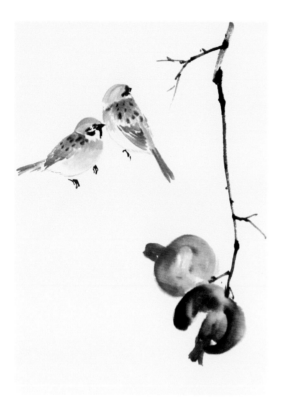

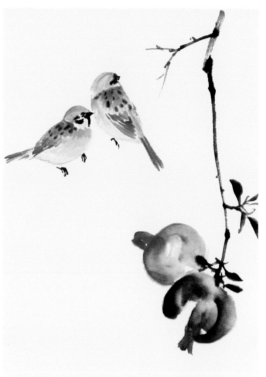

17 Use dark ink to paint the branches growing downward and attaching to the two pomegranates.

18 Dip the brush into dark green and brush tip into ink to paint the leaves.

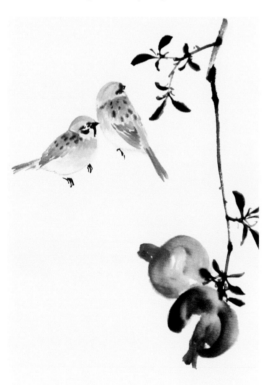

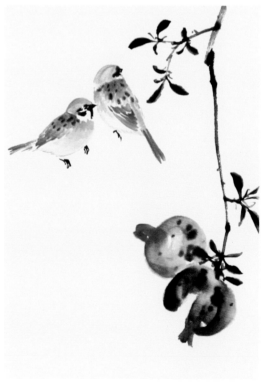

19 Continue to add more leaves. Use dark ink to outline the leaf veins, one vein per leaf.

20 Use ink or rouge to add spots on the pomegranate in different sizes and shades.

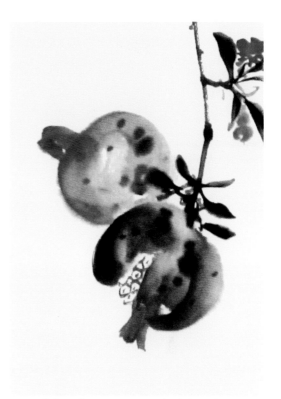

21 Mix vermilion and eosin to dot the flowers among the leaves.

22 Refer to the pomegranate seed painting techniques in the Introductory Lessons. Outline the eosin seeds where the pomegranate splits.

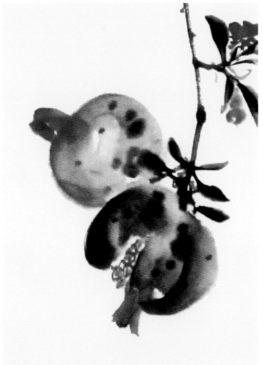

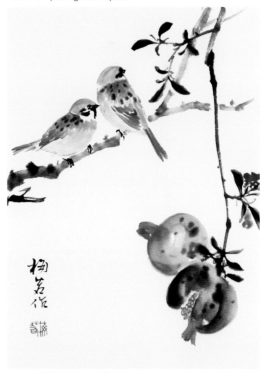

23 Use eosin to color the seeds.

24 Add the branch for the sparrows to stand on. Paint the main branch from left to right with light ink. Create a fork on the right to complete the work.

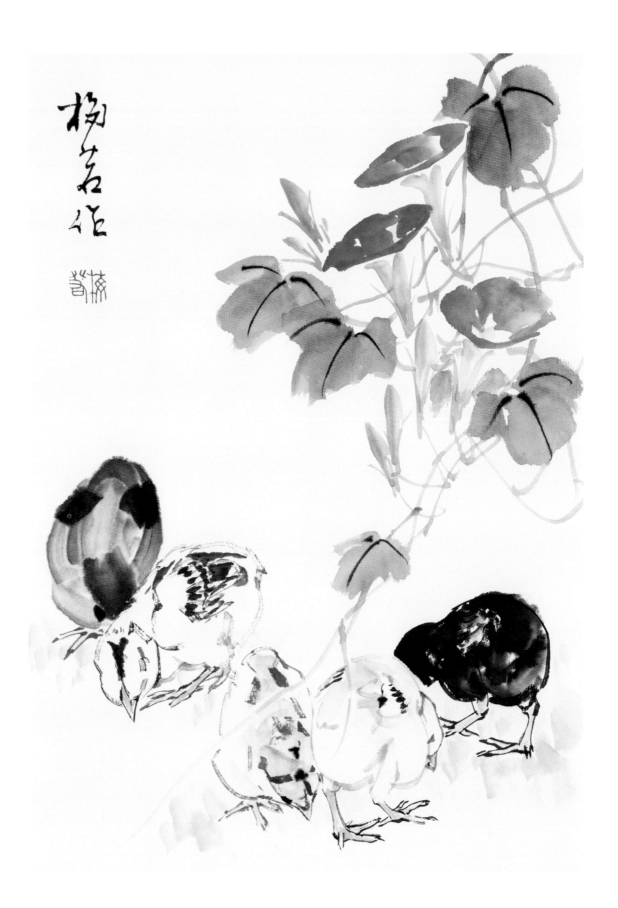

6. Five Sons Passing the Imperial Examinations

"The Five Sons Passing the Imperial Examination" is a Chinese proverb. In ancient time, the five sons of a man named Dou Yujun all had outstanding academic performances. They all passed the imperial examinations. Motifs were created after them as the symbol of a bright future and wealth. One of the motifs is five chickens in one picture.

This lesson incorporates morning glories and chicks, the painting techniques of which can be found on pages (53 and 151) in the Introductory Lessons.

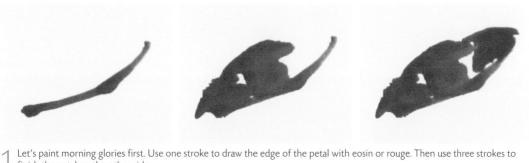

1 Let's paint morning glories first. Use one stroke to draw the edge of the petal with eosin or rouge. Then use three strokes to finish the petal on the other side.

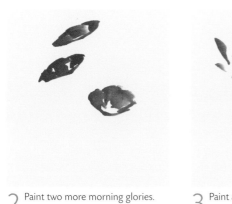

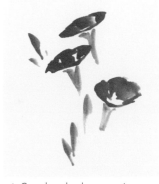

2 Paint two more morning glories.

3 Paint a few buds.

4 Complete the three morning glories.

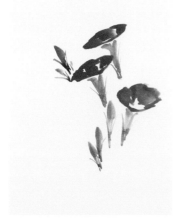

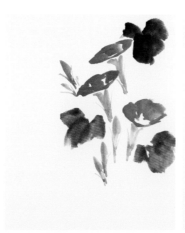

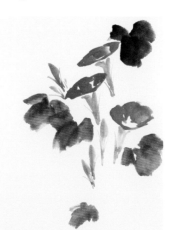

5 Paint the dark-green receptacles.

6 Paint the dark-green leaves.

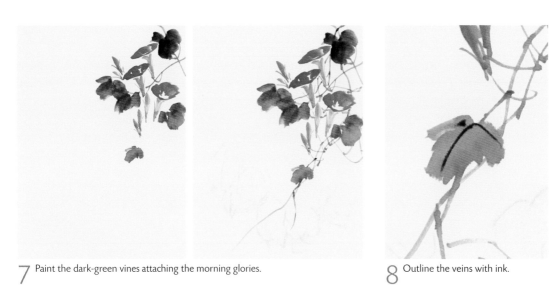

7 Paint the dark-green vines attaching the morning glories.

8 Outline the veins with ink.

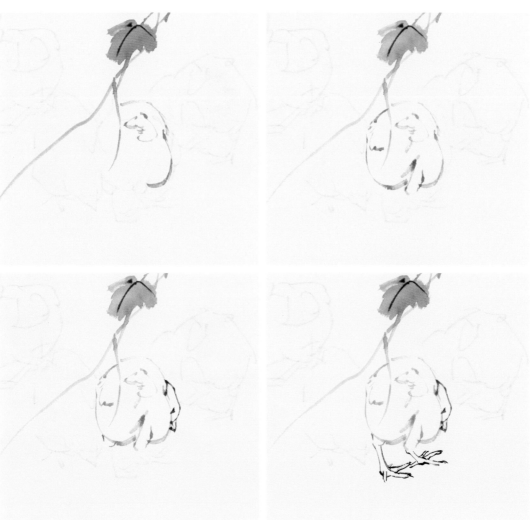

9 Let's paint a white chick with its back to us. Outline the body, head and feet using light ink.

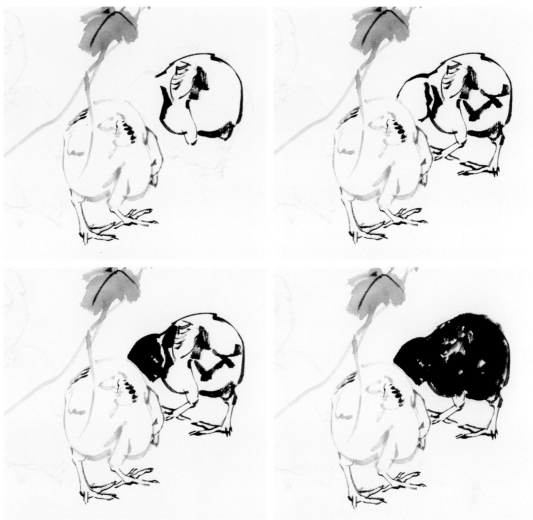

10 Next paint a black chick. Outline the body, head and feet with dark ink. Then color the head and the body.

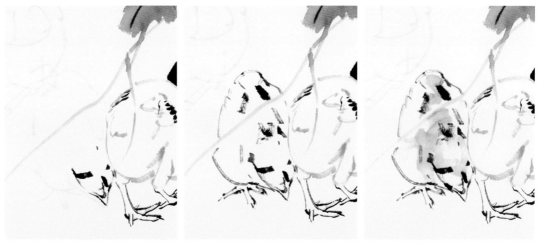

11 Next is a spotty chick. Outline the head, body and feet with light ink. Then color the body with light ink. Be sure to color only a section to highlight the patterns.

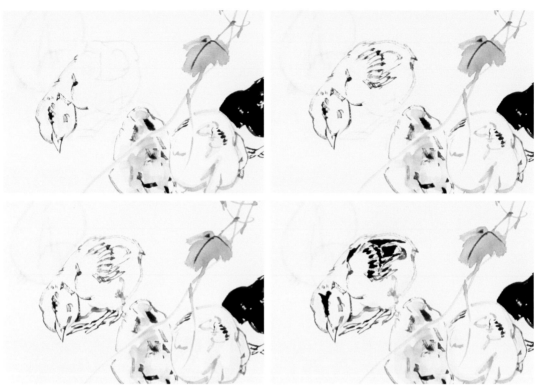

12 Next is the fourth chick. Paint the head, body and feet. Add dots on the wings with dark ink. Every stroke is to be entirely pressed down on the paper, focusing the pressure on the brush belly.

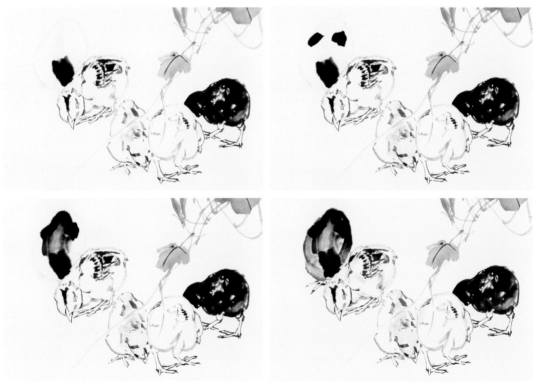

13 Refer to step 12 to paint the fifth chick. Draw the head and tail. Paint the body when the ink gets lighter. Then outline the feet.

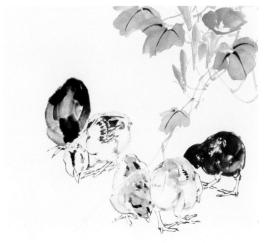

14 Color the two chicks in the middle with light gamboge.

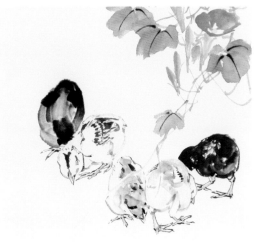

15 Color the bills and feet of all chicks with gamboge.

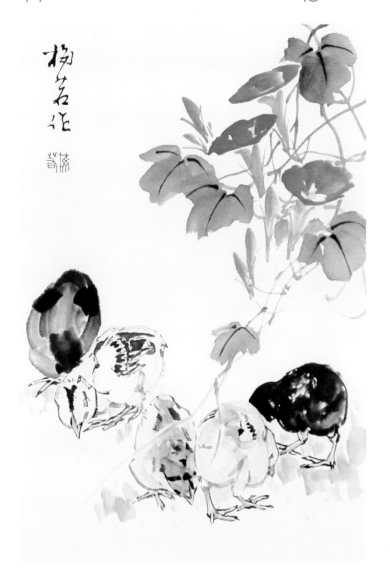

16 Paint the green grass to complete.

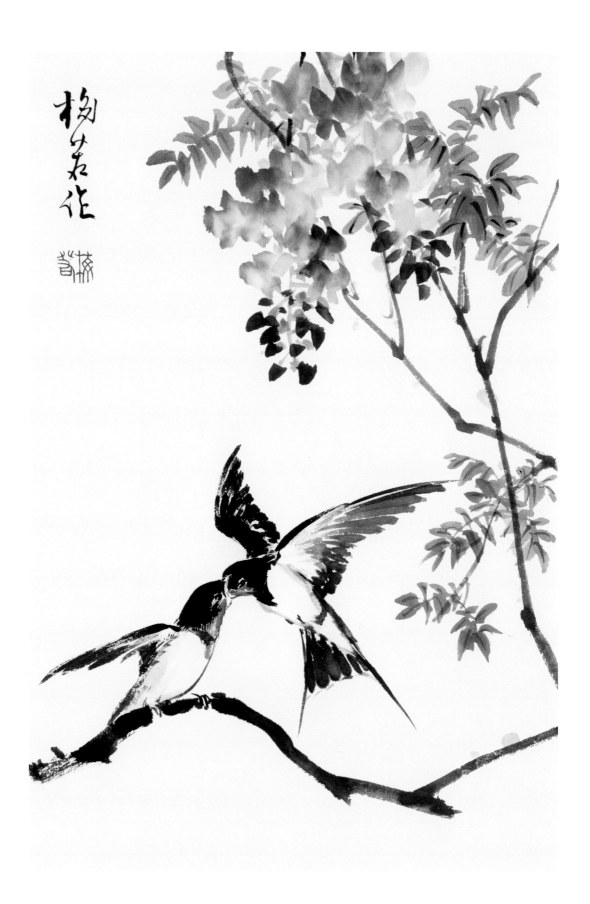

7. Swallows on Wisterias

In this painting, the wisterias are hanging down to create a colorful backdrop. In front is the baby swallow standing on a branch. The mother swallow has just returned and cannot wait any longer to feed her baby with what she has in her bill. Her wings are still in the air, which creates a lovely and dynamic picture.

You can refer to the Introductory Lessons for the painting techniques of wisteria and swallow on pages 50 and 170.

1 Let's paint the baby swallow first. Use the *simao* stroke to paint the head.

2 Paint the wings with dark ink.

3 Outline the throat and belly with light ink.

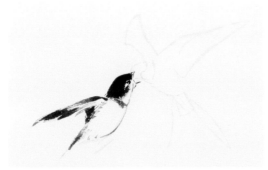

4 Paint the tail with light ink. Outline the opening bill that shows its desire to be fed.

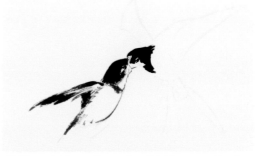

5 Next paint the mother swallow. Paint the eye and head first. No need to draw the entire beak since the mother is feeding the baby and her bill is in her baby's bill.

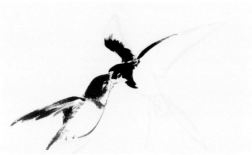

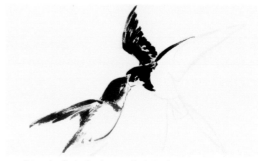

6 Use the *simao* stroke to paint the covert feathers on the upper wing with dark ink. Then paint the edge of the opposite wing with dark ink.

7 Paint the flight feathers with dark ink.

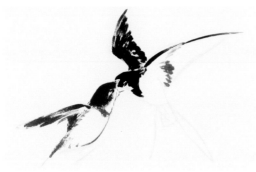

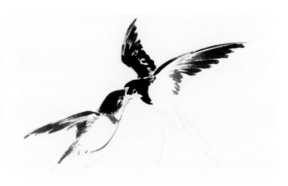

8 Paint the feathers of the opposite wing with light ink.

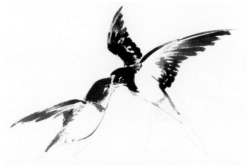

9 Outline the back with light ink.

10 Outline the belly with light ink.

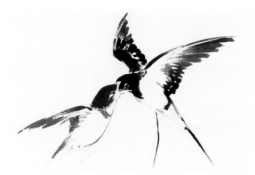

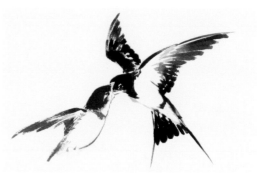

11 Then paint the tail with light ink. First, paint the scissors-shaped tail.

12 Then paint the undertail coverts.

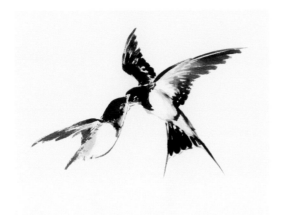

13 Gently dye the bodies with light ink to make them more three-dimensional.

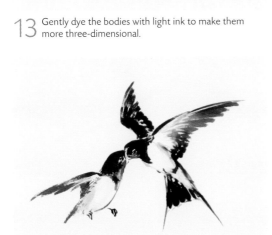

14 Mix vermilion and eosin to color the necks. Paint the bills and feet with indigo.

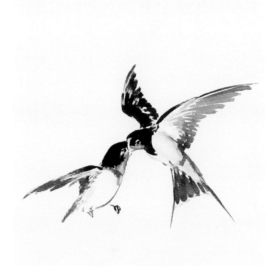

15 Next, paint the wisteria. Paint a wisteria on the top of the picture first.

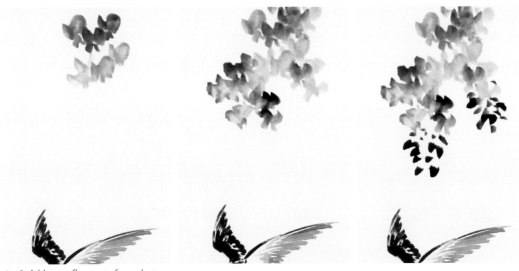

16 Add more flowers to form clusters.

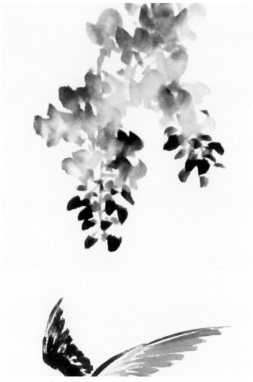

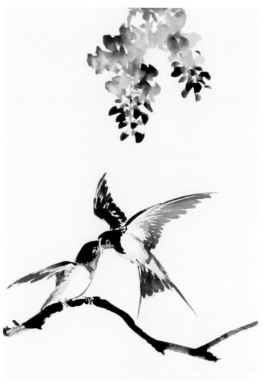

17 Dot the rouge receptacles and attach the flowers with dark-green vines.

18 Use ink to paint the vine for the baby swallow to stand on.

19 Add the vines to attach the wisterias. Be sure to present the dynamic state of the veins.

20 Mix dark green (with more gamboge) and rouge to paint a cluster of leaves on the top right.

21 Add one more cluster of leaves on the left side of the wisterias.

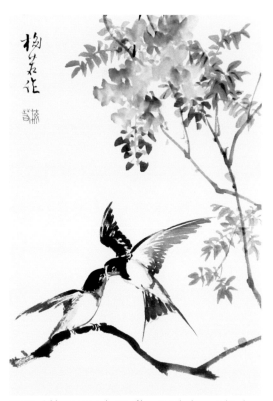

22 Add one more cluster of leaves at the lower right when the color on the brush gets lighter to complete the composition. Outline the rouge leaf veins to complete the work.

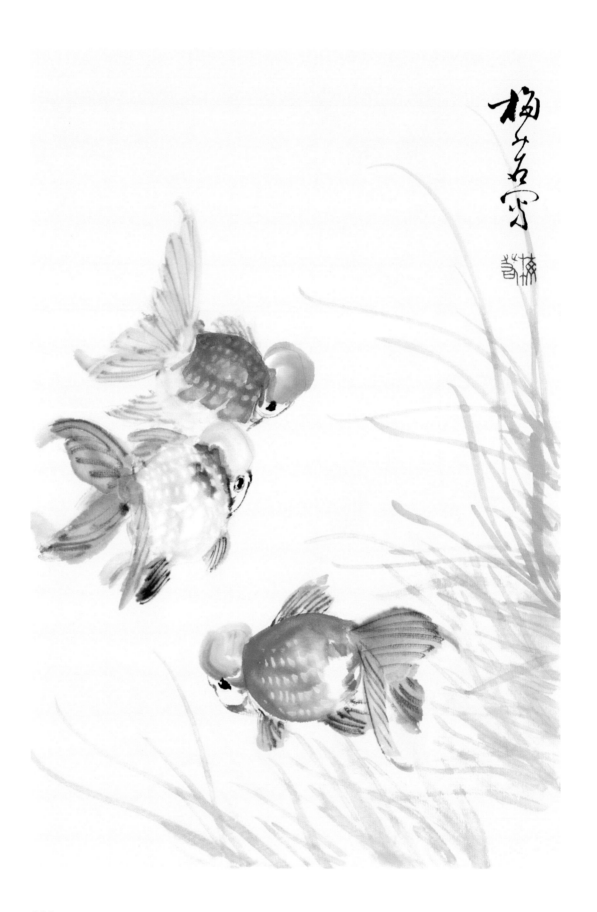

8. Goldfishes Playing in the Water

The pearlscale is a stunning goldfish. Due to accumulated calcium, the scales are hard and domed, looking like pearl inlay, and the pearls look plump and neat. In this painting, leaving the appropriate white space on the painting and portraying the swaying pearlscale tails and fluttering water plants create a scene of pearlscales playing in the water though no water is literally painted. Sometimes, silence is more eloquent than words.

Refer to the painting techniques of goldfish (see page 118) in the Introductory Lessons to paint the pearlscale.

1 Paint the vermilion back with one stroke.

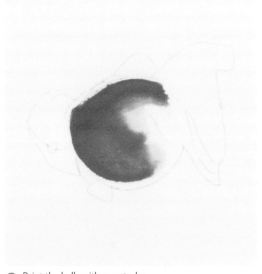

2 Paint the belly with one stroke.

3 Dip the brush into water to paint the head.

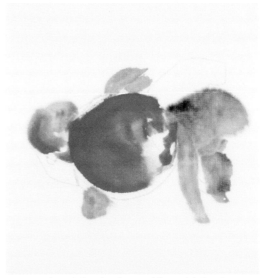

4 Paint the tail, dorsal and pectoral fins with light ink.

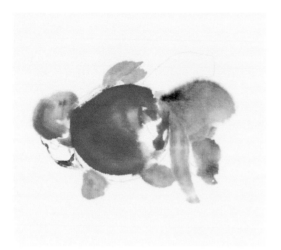

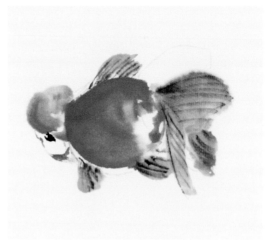

5 Outline the bottom edge of the head and paint the pelvic fin with light ink.

6 Paint the spines on the fins with light ink. Dot the eye with dark ink and be sure to leave highlight.

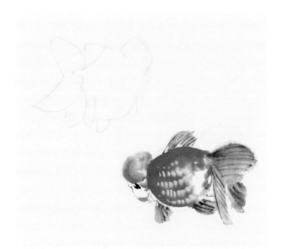

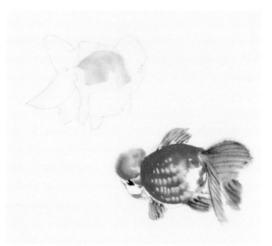

7 Use titanium white to dot the scales.

8 Then paint the other fish on the top left. First, paint the light-vermilion back.

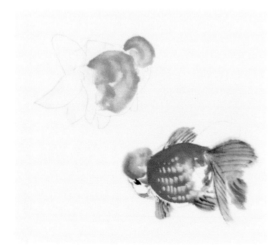

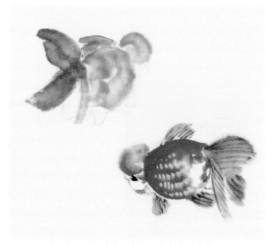

9 Paint the body and add the head. Pay attention to the orientation of the fish head.

10 Paint the tail and dorsal fin with light ink. Pay attention to the movement.

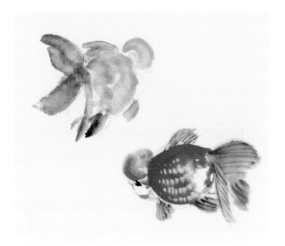

11 Paint the pelvic and pectoral fins with light ink.

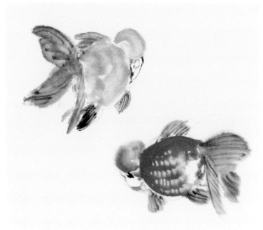

12 Use light ink to paint the spines on the fins, outline the bottom part of the head, and circle around the eye.

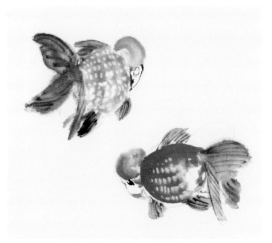

13 Use titanium white to dot the scales.

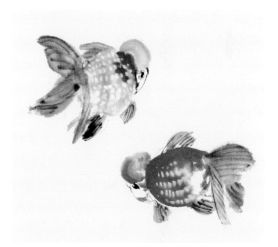

14 Dot the pupil with dark ink. Add the vermilion pattern on the body.

15 Then paint the third fish. Paint the vermilion back with one stroke.

16 Add a few more strokes to complete the body.

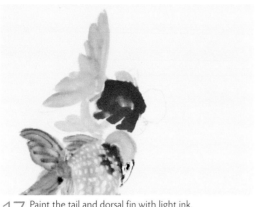

17 Paint the tail and dorsal fin with light ink.

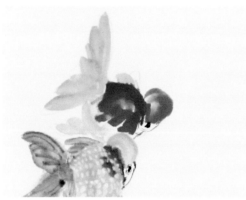

18 Outline the head with light ink and dot the eye with dark ink.

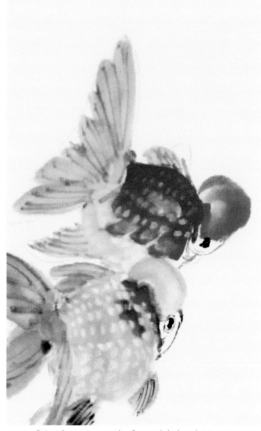

19 Paint the spines on the fins with light ink. Use titanium white to dot the scales.

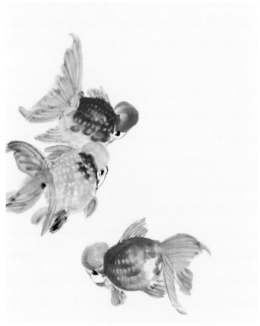

20 The three fishes look different in color and posture.

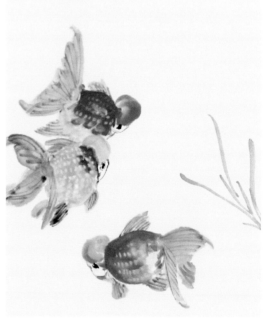

21 Paint the curved water plants on the right using dark green.

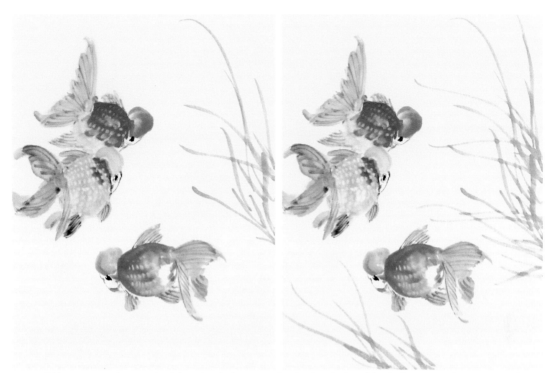

22 Add more water plants on the right and at the bottom and make them look as if they're fluttering in the water. Note the different lengths and the overlapping positions of the water plants.

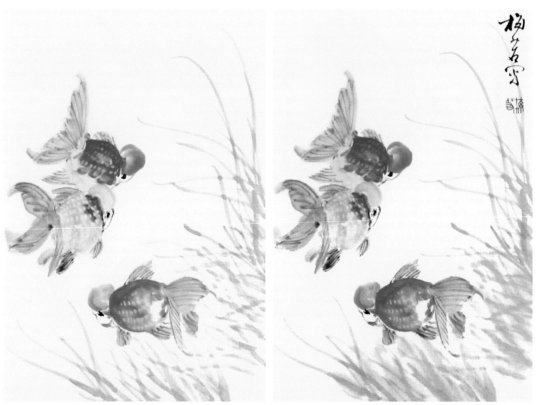

23 Add more water plants at the bottom and touch up the water plants with dark green, portraying the flowing effect of water to complete the work.

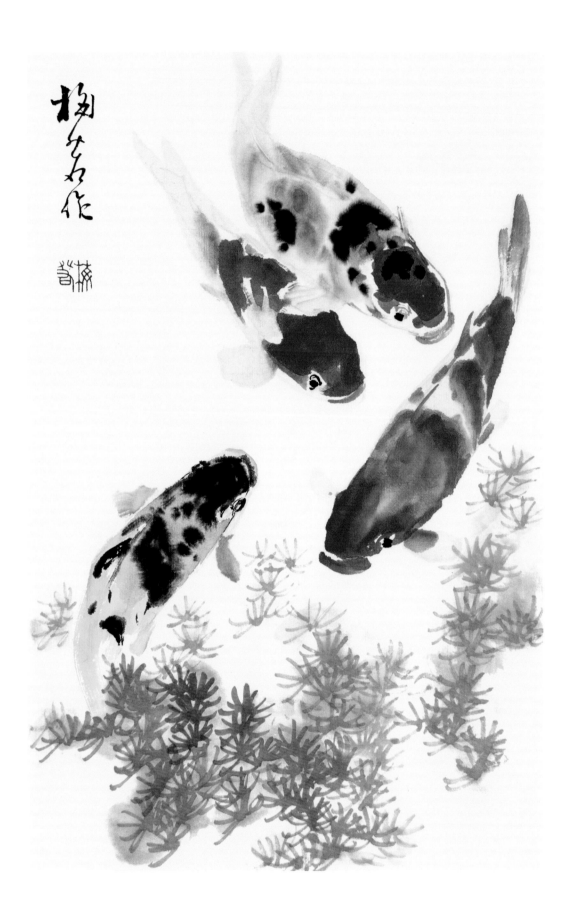

9. Colorful Carps

In this painting, a refreshing scene is composed of four colorful carps playing in the water next to green aquatic plants. Carp is an auspicious symbol. Having four carps together means surplus year after year.

Refer to the painting techniques for carp in the Introductory Lessons (see page 128) and the picture composition of *Goldfishes Playing in the Water* in the preceding lesson.

1 Let's start with the first carp. Paint the light-ocher body.

2 Paint the light-ocher tail.

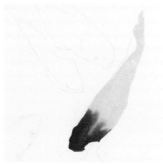

3 Mix vermilion and eosin to color the head.

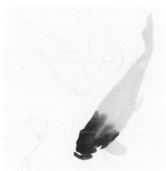

4 Paint the mouth with one stroke and leave a gap between the mouth and the head.

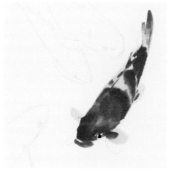

5 Color the body but leave some empty spaces. Dot the eye with dark ink.

6 Next is the second carp on the top left. Mix vermilion and eosin to paint the head.

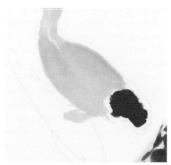

7 Paint the light-ocher body and tail.

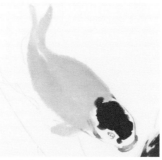

8 Outline the mouth, head and eye using light ocher.

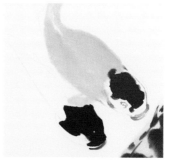

9 Next is the third carp, parallel to the second one. Mix vermilion and eosin to paint the head, and paint the mouth in one stroke.

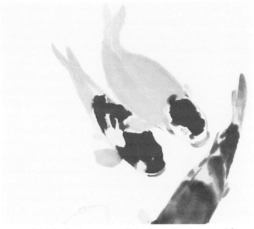

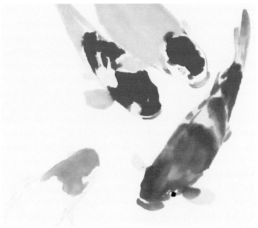

10 Add the body patterns. Paint the tail and pectoral fin with light ocher.

11 Next is the fourth carp. Mix gamboge and vermilion to paint the head.

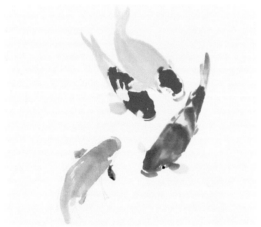

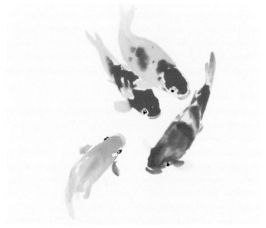

12 Then paint the body. Paint the pelvic and pectoral fins with light ink.

13 Dot the eyes for the carps. The two carps on the top from the side view have only one eye showing. The yellow one at the bottom left is from the top view, which displays both eyes.

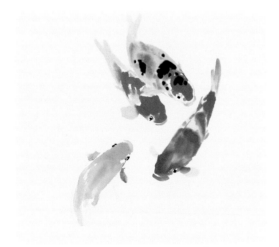

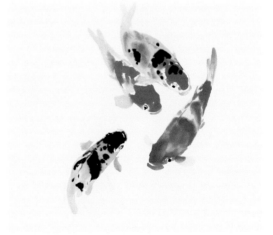

14 Use ink to add spots in various sizes on the uppermost red carp.

15 Use ink to add spots on the yellow carp. They can be in patches or spots.

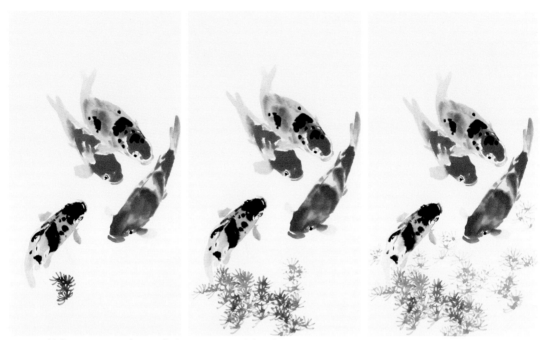

16 Add the green water plants at the bottom using radial strokes in various densities. The farther away the water plants are, the lighter the color is.

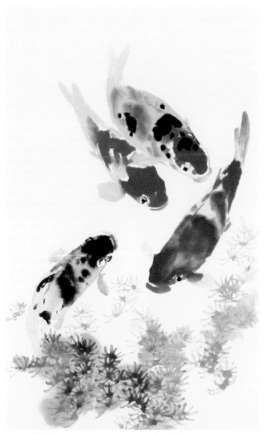

17 Touch up the water plants with dark green.

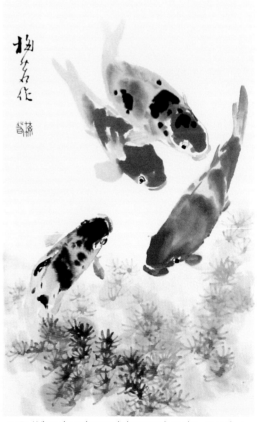

18 When the color gets lighter, touch up the water plants again to give the effect of water. The work is complete.

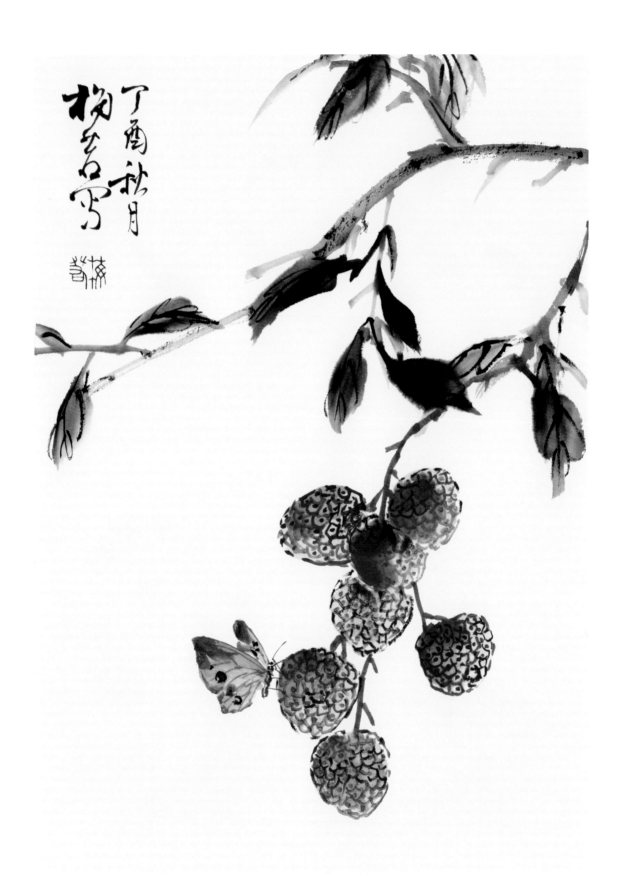

10. Butterfly and Lychees

This art is a typical *caochong* (grass insect) painting. The bunch of lychees attracts a little yellow butterfly. It is landing on the lychee, providing a sense of slight vibration from the wings although the picture is still. The small portion of lychees is enough to present the whole tree that is full of appealing fruits.

1 Use eosin to dot out halves of the lychees. Pay attention that the lychees here are composed of upper half and lower half, which means to create the sense of "bunch."

2 Paint the lower halves of the lychees with dark green to make them complete.

3 Mix ocher with ink to draw the twigs to connect the lychees.

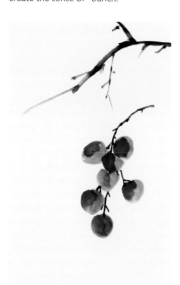

4 Draw the branches on top right with ink.

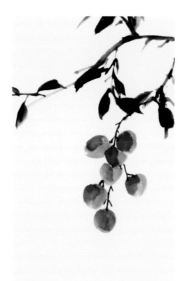

5 Paint the leaves with ink. Use two centered-tip strokes for the broad leaves and one stroke for the narrow ones. Be sure to paint a stroke in one breath to form the natural shades of ink.

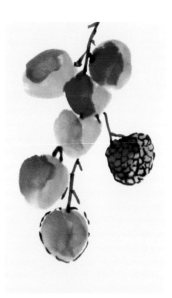

6 Draw a dotted line around the lychee with thick rouge, referring to the bottom lychee. Then draw some irregular hexagons to present the texture, referring to the right lychee.

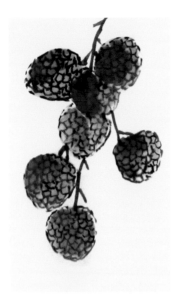

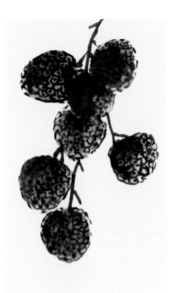

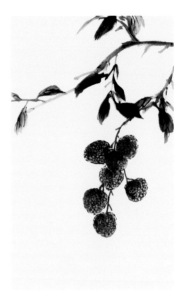

7 Repeat the previous methods to complete the rest of the lychees. This is different from the lychee painting technique in the Introductory Lessons.

8 Add a dark rouge dot in each irregular hexagon. Then use dark rouge to create dark shades on the surface of the lychees to present the overlapping effect.

9 Outline the leaf veins with dark ink.

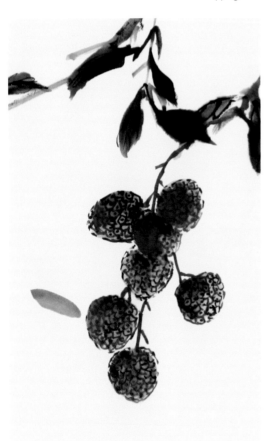

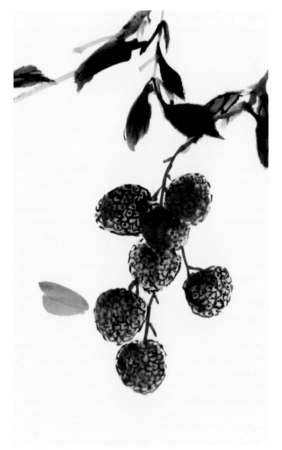

10 Dip the brush tip into gamboge and vermilion to paint the butterfly wing.

11 Add another stroke to form the pair.

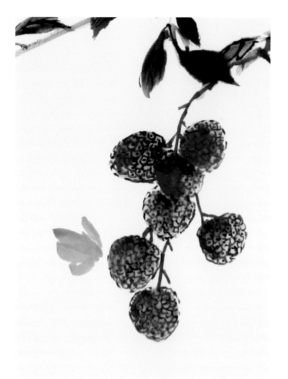

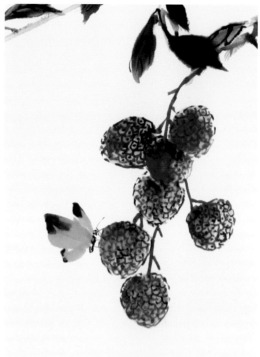

12 Add a stroke on top and at the bottom respectively to create the opposite wing and the hind wing. This is the side view of the butterfly.

13 Mix ocher with dark ink to paint the body and the pair of antennas. Add the remaining ink to the wing tips.

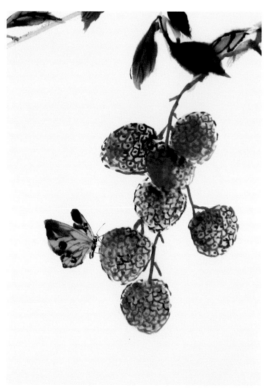

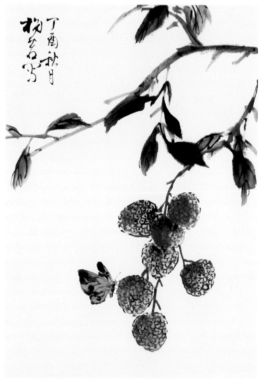

14 Draw the veins on the wings with ink. Add rouge dots for the patterns.

15 The butterfly and the lychees are complete.

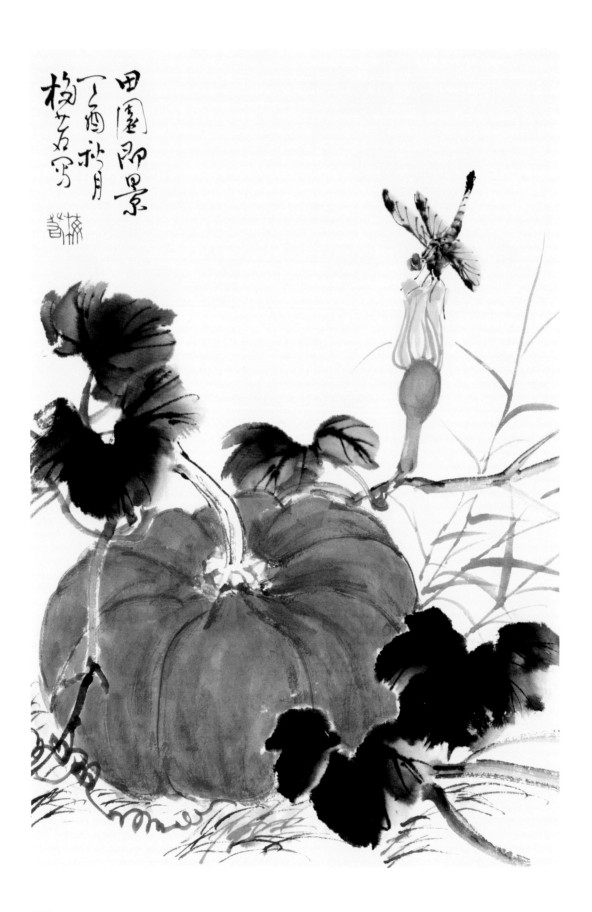

11. Dragonfly and Pumpkin

This painting connects a dragonfly with a pumpkin. The dragonfly is standing on the flower of a plump pumpkin as if it is sniffing its fragrance before fluttering away. The gigantic golden ripe pumpkin epitomizes a harvest scene.

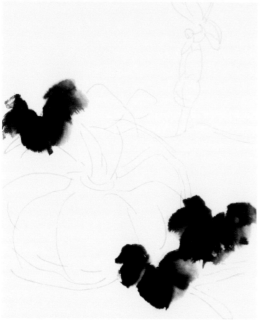

1 Dip the brush tip in dark ink to paint the pumpkin leaves.

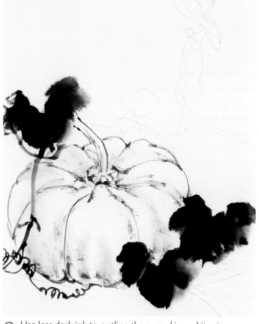

2 Use less dark ink to outline the pumpkin and its vines.

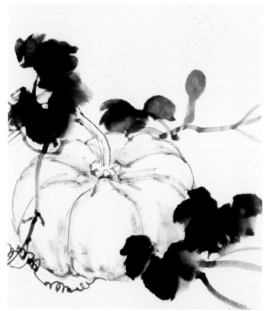

3 Add a leaf on top with ink; then paint the pedicle with dark green.

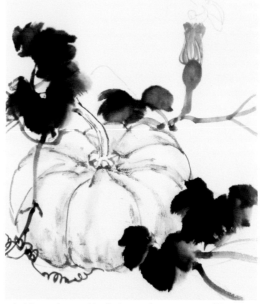

4 Mix gamboge with a little vermilion to create golden yellow to paint the half-open flower for the butterfly to stand on.

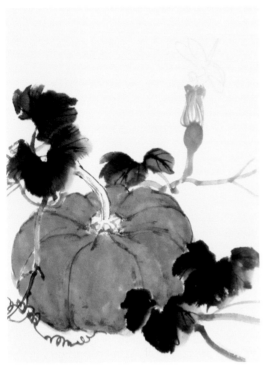

5 Draw the leaf vines with ink. Mix gamboge with vermilion to fill the pumpkin.

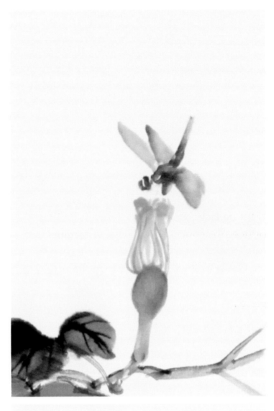

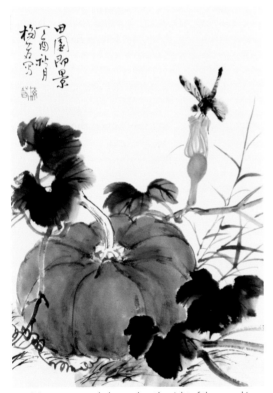

7 Paint some grass below and on the right of the pumpkin with ink or indigo to highlight the effect of the pumpkin sitting on the ground. The painting is complete.

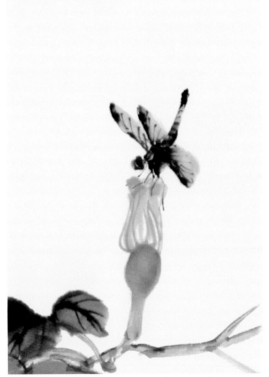

6 Refer to the dragonfly painting technique in the Introductory Lessons (see page 114) to create the dragonfly above the flower. Note the nuance of the posture.

APPENDICES

Brief Glossary of Some Chinese Painting Terms

Many terms in the vocabulary of Chinese painting lack precise equivalents in English or describe concepts that have no parallel in western art. Although the terms are generally explained in the text, it may help the reader to find them more concisely expressed in one place.

Ca 擦
Ca (touch up) is similar to *cun*. It means gently using the side-brush stroke to create broken and blurred texture, leaving a very light brush trace.

Caochong 草虫
Caochong—grass insect. This is a sub-genre of bird-and-flower painting. It has a wide range of objects including crustaceans, mollusks, reptiles, amphibians and fishes.

Cefeng 侧锋
Cefeng (side-brush stroke) is to tilt the brush at an angle, with the tip against one side of the line, point or surface and with the belly of the brush pressed against the paper.

Cun 皴
Cun—roughness of skin. Texture method. A brush technique used to express the texture of rocks and mountains.

Dun 顿
Dun (pause) is to press the brush into the paper or rotate the brush.

Gongbi 工笔
Gong—work, *bi*—brush. Fine-work. The delicate and meticulously detailed depiction of form, e.g. in flowers and plants.

Leave Blank (*Liubai*) 留白
Liu—leave, *bai*—white. To leave blank. Dynamic emptiness. An integral part of the composition of a painting with an active function in relation to the rest of the painting.

Nifeng 逆锋
Nifeng (upstream stroke) is to paint from the bottom upward or from right to left.

Shunfeng 顺锋
Shunfeng (downstream stroke) is to paint from the top downward or from left to right.

Simao 丝毛
Si—silk, *mao*—feather. *Simao* (feather-edging) stroke is a basic technique in bird painting. To exert the stroke, first press open the brush in the palette. With the brush tipped with thick ink and the direction of the brush unchanged, the feather-edging should have a radiating look.

Xieyi 写意
Xieyi, where *yi* means sense, is the abstract manifestation of an image beyond its actual appearance. In its technical sense, *xieyi* may also be termed a simple, spontaneous "freehand" but "painterly impression" conveys more of the overall meaning.

Zhongfeng 中锋
Zhongfeng (centered-tip stroke) is to use the brush tip to paint along the center of the ink line.

Dates of the Chinese Dynasties

Xia Dynasty（夏）...2100–1600 BC

Shang Dynasty（商）...1600–1046 BC

Zhou Dynasty（周）..1046–256 BC

 Western Zhou Dynasty（西周）....................................1046–771 BC

 Eastern Zhou Dynasty（东周）.....................................770–256 BC

 Spring and Autumn Period（春秋）...........................770–476 BC

 Warring States Period（战国）...............................475–221 BC

Qin Dynasty（秦）..221–206 BC

Han Dynasty（汉）...206 BC–AD 220

 Western Han Dynasty（西汉）.....................................206 BC–AD 25

 Eastern Han Dynasty（东汉）......................................25–220

Three Kingdoms（三国）...220–280

 Wei（魏）..220–265

 Shu Han（蜀）..221–263

 Wu（吴）...222–280

Jin Dynasty（晋）..265–420

 Western Jin Dynasty（西晋）..265–316

 Eastern Jin Dynasty（东晋）.......................................317–420

Northern and Southern Dynasties（南北朝）.........................420–589

 Southern Dynasties（南朝）...420–589

 Liang Dynasty（梁）...502–557

 Northern Dynasties（北朝）...439–581

Sui Dynasty（隋）..581–618

Tang Dynasty（唐）...618–907

Five Dynasties and Ten Kingdoms（五代十国）......................907–960

 Five Dynasties（五代）..907–960

 Ten Kingdoms（十国）..902–979

Song Dynasty（宋）...960–1279

 Northern Song Dynasty（北宋）...................................960–1127

 Southern Song Dynasty（南宋）...................................1127–1279

Liao Dynasty（辽）..916–1125

Jin Dynasty（金）..1115–1234

Xixia Dynasty (or Tangut)（西夏）.......................................1038–1227

Yuan Dynasty（元）...1279–1368

Ming Dynasty（明）...1368–1644

Qing Dynasty（清）...1644–1911